DC COMICS

Super Heroines

100

GREATEST MOMENTS

HIGHLIGHTS FROM THE HISTORY OF THE WORLD'S GREATEST SUPER HEROINES

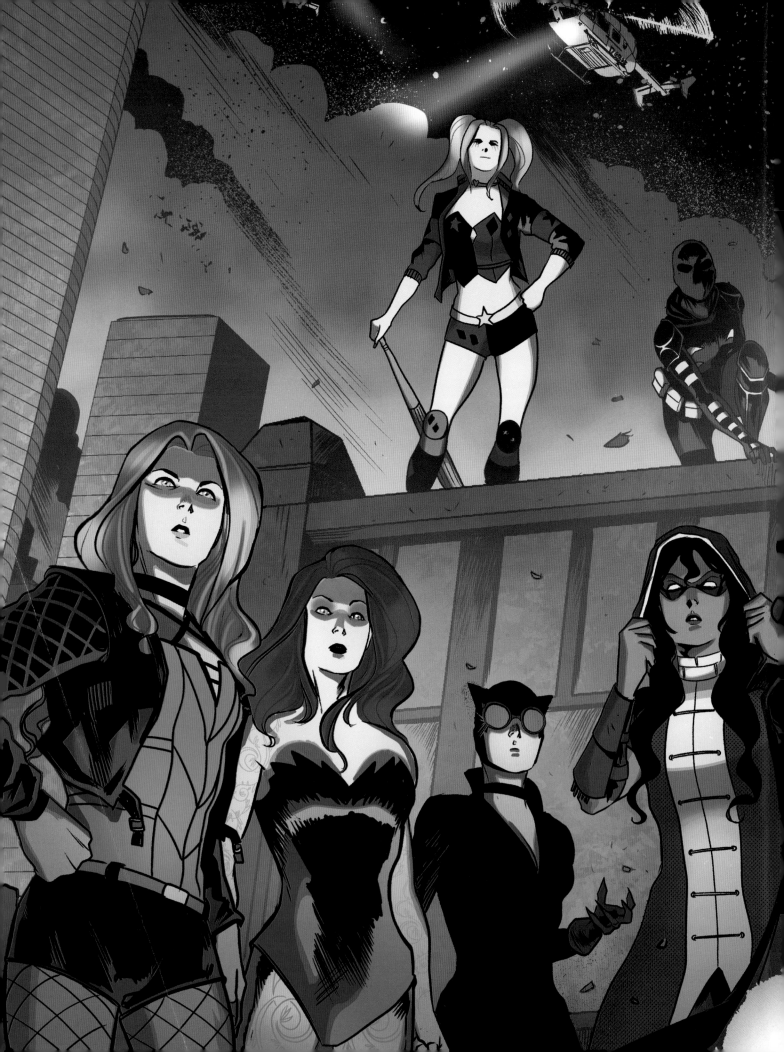

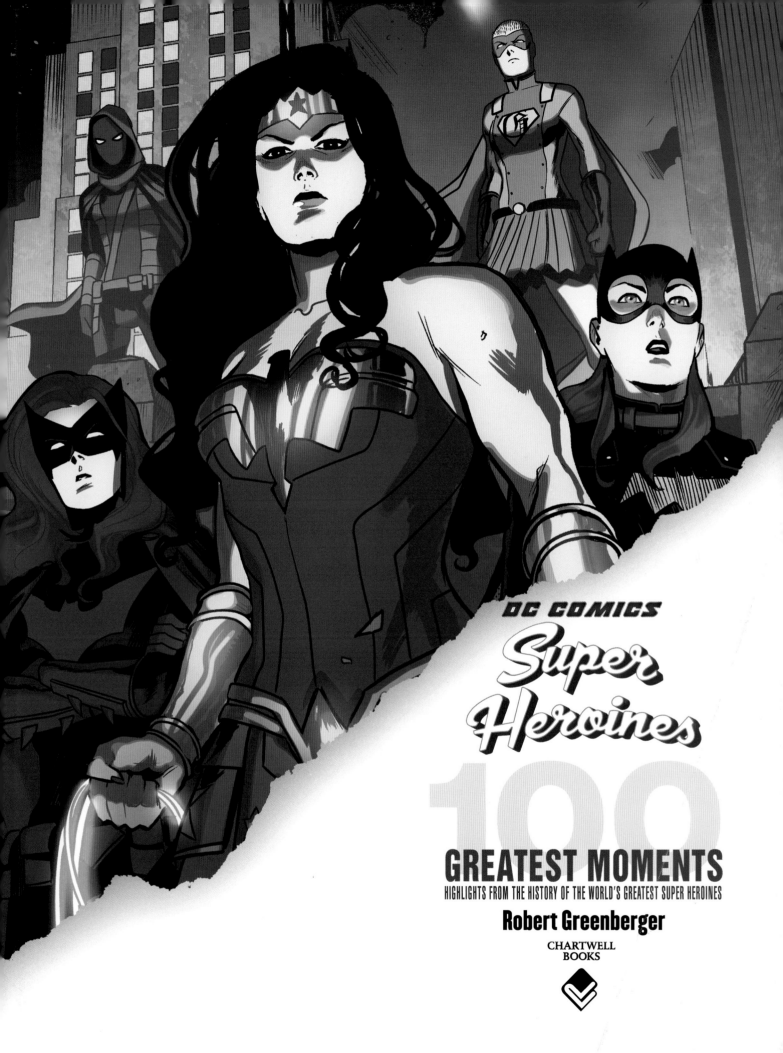

DC COMICS
Super Heroines

100
GREATEST MOMENTS
HIGHLIGHTS FROM THE HISTORY OF THE WORLD'S GREATEST SUPER HEROINES

Robert Greenberger

CHARTWELL
BOOKS

Brimming with creative inspiration, how-to projects, and useful information to enrich your everyday life, Quarto Knows is a favorite destination for those pursuing their interests and passions. Visit our site and dig deeper with our books into your area of interest: Quarto Creates, Quarto Cooks, Quarto Homes, Quarto Lives, Quarto Drives, Quarto Explores, Quarto Gifts, or Quarto Kids.

First published in 2018 by Chartwell Books, an imprint of The Quarto Group,
142 West 36th Street, 4th Floor, New York, NY 10018, USA
T (212) 779-4972 F (212) 779-6058 www.QuartoKnows.com

This edition published with permission of and by agreement with DC Entertainment
2900 W. Alameda Ave, Burbank CA 91505, USA

Chartwell Books titles are also available at discount for retail, wholesale, promotional, and bulk purchase. For details, contact the Special Sales Manager by email at specialsales@quarto.com or by mail at The Quarto Group, Attn: Special Sales Manager, 401 Second Avenue North, Suite 310, Minneapolis, MN 55401, USA.

10 9 8 7 6 5 4 3 2 1

ISBN: 978-0-7858-3618-6

MIX
Paper from responsible sources
FSC® C101537
FSC
www.fsc.org

Editor: Michelle Faulkner
Editorial Project Manager: Leeann Moreau
Cover Designer: Rachael Cronin
Book Designer: Anna D. Puchalski
Design Assistant: Steven Puchalski
Project Editor: Su Wu

Printed in China

All identification of writers and artists in this book utilized information provided by the Online Grand Comics Database.

The author wants to gratefully acknowledge the time and efforts provided me by John Wells, ace researcher, who keeps me honest and has proven a most excellent sounding board.

There have been many wonderful women who have influenced my life, starting with my mother and her mother (who always gave me a quarter to go buy a "joke book") but also including teachers. This one's for the two who continue to influence me daily: my wife, Deb, and daughter, Kate.

CONTENTS

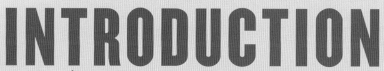

INTRODUCTION

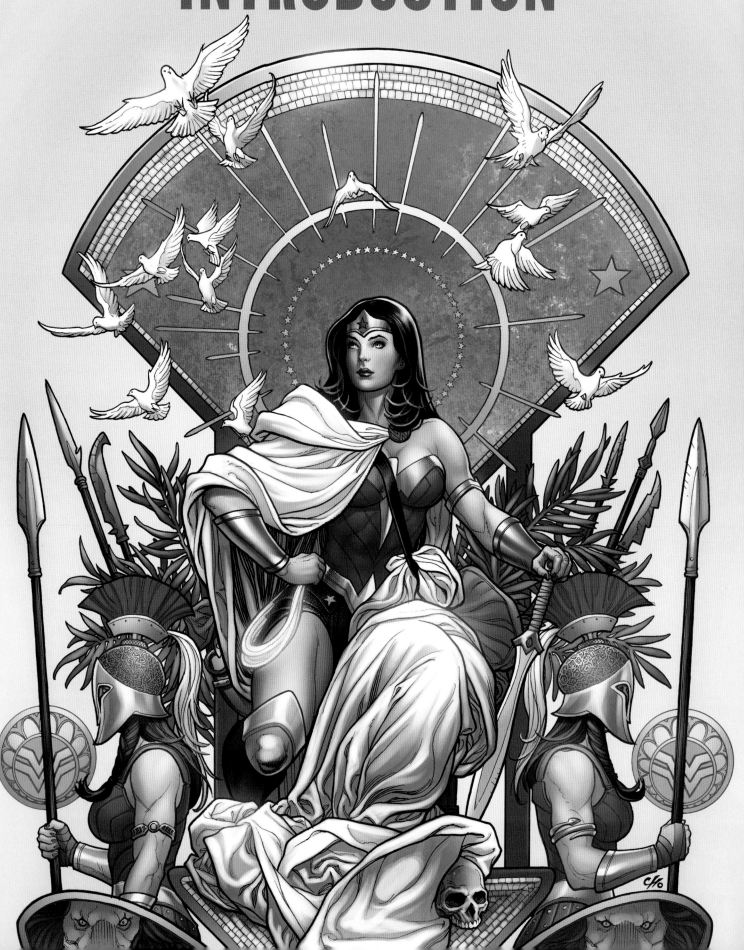

WHEN COMIC BOOKS WERE FIRST RELEASED IN THE 1930s, they were intended for boys and girls, and for the first generation, there were nearly equal numbers of both reading the releases. The features contained within the comics were predominantly male-led, reflecting the commercial bias of the time. Female-led features were rare, and the women in other features tended to be window dressing, a damsel to be rescued, or a romantic interest or a victim.

Before entering comics, Harry Donenfeld and Jack Liebowitz were publishers of pulp magazines with provocative titles that tended to use the adjective "spicy" as a brand. The women were routinely scantily

At this point, Superman had arrived in *Action Comics* #1, as did Lois Lane. She was a strong, independent working woman. Visually, she was modeled after Jolan Kovacs (also known as Joanne Carter), who later married writer and co-creator Jerry Siegel, but her character was certainly closer to Hildy Johnson from the film *His Girl Friday*.

Once the super hero was in vogue, driving sales, it was inevitable that costumed women would take the stage as well. In the spring of 1940, a jewel thief was stopped—but not captured—by Batman and Robin. The character almost immediately returned, now wearing a cat's-head mask and evolving into the

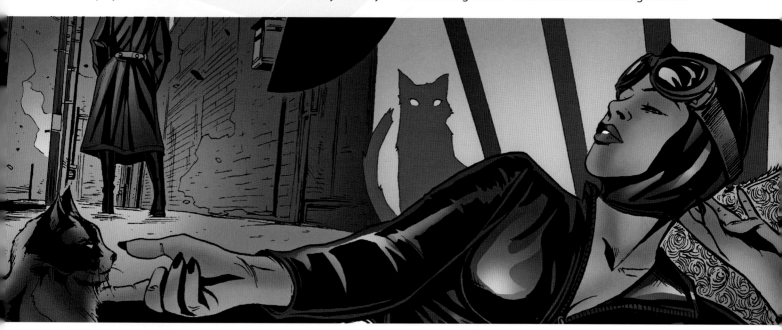

clad and as often the victim as the opponent. In 1935, as comic books began appearing with great regularity, the pulps incorporated short comic features in the magazines, including ones featuring Olga Mesmer.

Never heard of her? Known as the "Girl with the X-Ray Eyes," she had her own comic strip feature in Donenfeld's *Spicy Mystery Stories*, running from August 1937 through October 1938, easily preceding Superman in the super-vision department. What's significant is that Donenfeld and Liebowitz had by this time joined publisher/editor/writer Major Malcolm Wheeler-Nicholson in running his failing National Allied company, which introduced readers to the concept of all-new stories with 1935's *New Fun Comics*.

criminal Catwoman, she of the long purple dress and cat-o'-nine-tails whip.

DC's first costumed heroine was Abigail Mathilda "Ma" Hunkel, a regular player in creator and cartoonist Sheldon Mayer's brilliant *Scribbly* feature then running in *All-American Comics* (published by sister company All-American, which merged with National to form DC in 1946). In 1940's issue #20, she donned red long johns and a cooking pot for a helmet and fought local toughs as the Red Tornado. She was arguably comics' first super heroine as well as an early parody of the new genre.

Slowly but surely, every comic company was offering up costumed (or barely costumed) women to help fight saboteurs and do their part for the war

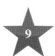

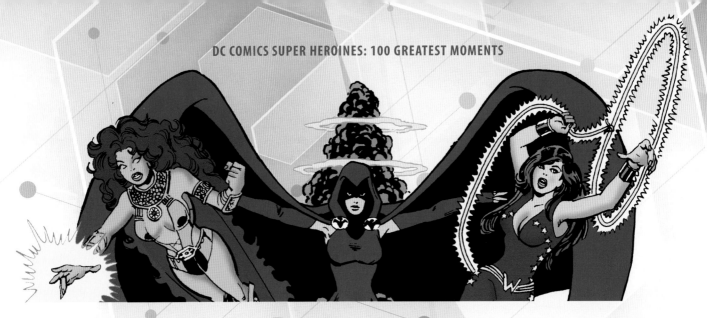

effort. Many had long, healthy runs thanks to creative storytelling, notably the adventures of Phantom Lady, another Quality Comics creation, which ran in *Police Comics* beginning in summer 1941. She wound up making her DC debut as a part of the Freedom Fighters introduced in *Justice League of America* #107.

Of course, the best-known heroine of the Golden Age is Wonder Woman, arriving at the tail end of 1941 and quickly making her way into her own eponymous title, as well as headlining *Sensation Comics* and sharing top billing in *Comics Cavalcade*. William Moulton Marston and Harry G. Peter's creation was unlike anything else being published.

Interestingly, as the super-hero fad was fading in the wake of the Allied victory in World War II, new heroines were arriving and displacing their male counterparts. Black Canary was introduced in Johnny Thunder's feature in *Flash Comics*, and she soon took over, much as Merry, Girl of 1000 Gimmicks, shoved the Star-Spangled Kid from his perch in *Star-Spangled Comics*. However, even they couldn't hang on for long, and the hero business faded for a time.

While Wonder Woman endured, her *Sensation* tried out a variety of female-centric series, such as Astra and Dr. Pat, with little success, and soon she was left with just her eponymous title.

A few years later, the Silver Age arrived with a crack of thunder. A new approach to old characters sparked an interest among readers, beginning with the Flash in 1956's *Showcase* #4. One after another, they came back: Green Lantern, Hawkman, the Atom. It was years before the first heroine, Black Canary, was revived. Interestingly, though, editor Julie Schwartz surrounded his new heroes with accomplished

women: Iris West was a journalist; Jean Loring, a lawyer; and Carol Ferris ran her father's aircraft company. When the new Hawkman arrived from the distant world of Thanagar, he was accompanied by Shayera, his wife and fellow winged champion.

Across the hall, editor Mort Weisinger was busily expanding his line of Superman comics, adding the successful *Superman's Girlfriend Lois Lane* as an ongoing series and introducing readers to the Man of Steel's cousin, Kara Zor-El, another survivor from Krypton who appeared regularly in *Action Comics* as Supergirl. Meanwhile, Jack Schiff had already added Batwoman to Gotham City, as both a romantic interest and deflection from any whiff of homosexuality aroused by the congressional hearings into comic books' role in the rise of juvenile delinquency. But

when Supergirl took off, Schiff did Weisinger one better by adding a Bat-Girl, for Robin.

Not long after, George Kashdan presided over Aquaman's first ongoing comic title and introduced him to Mera, a queen from another dimension, and seven issues later, they wed—a rarity in comics.

Wonder Woman's sales paled in comparison with the other heroes, so in an attempt to shake things up, she was stripped of her powers and remade more like the popular Mrs. Peel from the British series *The Avengers*. Sales leaped, prompting similar moves in books like *Metal Men* and *Teen Titans*, but the novelty faded and an outcry from the burgeoning feminist movement prompted the restoration of the Amazing Amazon's classic look.

Ever since, there have been flashes of female leads, with most headlining a series for a brief period before getting canceled and relegated to a supporting role in some other title. Women readers, though, were returning in growing numbers, attracted to Neil Gaiman's fantasy *Sandman*, which helped launch the Vertigo imprint. Even that line struggled to create enduring female-led series, although their overall subject matter was more palatable to this new generation.

Interestingly, Wonder Woman has continued to show creative flashes over the last twenty years, thanks largely to the vision of artist George Pérez, followed by impressive runs from writer/artist John Byrne, writer Greg Rucka, and writer/artist Phil Jimenez. Still, she struggled to reach the towering sales heights of the Batman books or, to a lesser extent, the Superman titles (which at various times included Supergirl and Superwoman spinoffs).

In the last few years, though, the tide seems to have finally *really* changed. Women are taking control of the narrative, with no better example being set than by the Amazon Princess herself, when movie audiences witnessed Gal Gadot's Wonder Woman smash her way through No-Man's-Land.

In comic books, there were many unsung women who wrote, drew, lettered, colored, or edited comics through the field's first twenty years. Their presence faded to the point where women in the business were the exception until the last decade or so. Comics for and by women of all ages and interests

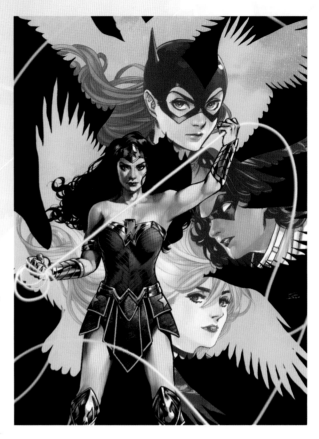

can today be found alongside similar works created by and aimed primarily for men. There's plenty that appeal to both, of course.

On the story pages, women as a creative force have been underrepresented and rarely received the attention they deserved. While we cannot shine a spotlight on all the female heroes dating back to comics' Golden Age (1938–1954 or so), we can certainly explore the most significant exploits of DC Comics' super heroines, women who have shown bravery and courage with or without super-powers.

This volume celebrates the greatest accomplishments in the core DC Universe canon of stories. The following 100 greatest moments were chosen, in large part, from the input of fans on various Facebook pages, in addition to my research and remembrance from growing up reading their adventures. There may be quibbles over which moments made the final cut, but they are most certainly all deserving of inclusion. You will see moments of great bravery and courage, tenderness and compassion, friendship and fierce loyalty. Everything you want from your heroes, regardless of their gender.

AMANDA WALLER

SHE IS THE WALL. AN IMMOVABLE OBJECT THAT WILL DO WHATEVER IT TAKES, MANIPULATE whomever she needs, break any law in her way, all in order to save the world.

It takes a tough person to make these calls, willingly working with the deadliest humans and metahumans wherever they can be found and tasking them to perform a mission, knowing full well they may not return. Yet, thanks to her efforts with the US government's Task Force X, she has preserved the peace, saved countless lives, and helped borderline cases tread the right path.

Amanda Waller was first introduced in DC Comics' second major crossover, 1986's *Legends*. She was heading up Task Force X, sending a collection of criminals dubbed the Suicide Squad after a berserk being called Brimstone. After that success, she completed setting up shop within Belle Reve Penitentiary, designed to hold super-villains and doubling as the Squad's base of operations. Each criminal sent on assignment wore a bracelet that Waller would detonate without hesitation should one of her charges deviate from the mission's parameters.

1. THE WALL VERSUS THE BAT

Not long after the Suicide Squad's creation, Batman became aware of its existence and sought to bring it down. He infiltrated Belle Reve but was found by Waller, who threatened to expose his own alter ego to the world, a scene adapted for the tag at the end of *Batman vs. Superman*. After that classic moment, the two have had a tense relationship despite finding themselves working on the same side more often than not.

Over time, writer John Ostrander explored Waller's background and, with his cowriter/wife Kim Yale, made her such an indelible character that she placed sixtieth on IGN's Greatest Comic Book Villain of All-Time chart in 2009. Waller and her husband were raising their family in the crime-ridden Cabrini-Green section of Chicago, doing what they could to protect them. Death claimed, in short order, her husband, son, and daughter. She put herself through

college and eventually became a congressional aide, where she first discovered the classified files on the original Task Force X.

An idea flickered to life, and she nurtured the flame until she made it a reality. She formed the Suicide Squad, a mixture of criminals and heroes in need of redemption. She selected Rick Flag Jr., the son of the original Force's first commander, to be the field commander, and they not only traveled around

and exiled to a distant world. The plan backfired; she was exposed and forced from Checkmate.

After the reality-altering events leading to a Rebirth, Waller was depicted as the one in sole control over the Suicide Squad, injecting her operatives with micro-bombs. Her experience prior to that was in an undisclosed role as a member of Team Seven. She continued to do as she saw fit, conscience and consequences be damned. At one point, she felt

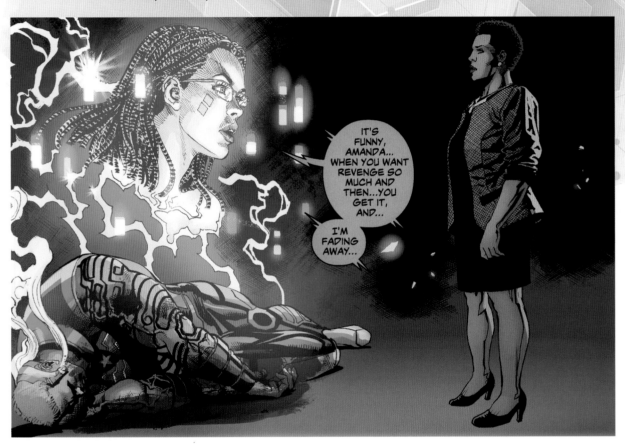

the world but across space and other dimensions to accomplish their goals.

When Lex Luthor became president, Waller was named his Secretary of Meta-Human Affairs, a post that did not last long, as the president's tenure proved brief. Instead, she was charged with reorganizing the espionage agency Checkmate, taking the post of Black Queen. Later, after the United Nations decided to turn it into an international agency, she sat among the leadership as the White Queen. Even there, she had an independent streak, running her Suicide Squad on the side. One venture, Operation Salvation Run, saw Earth's super-villain community rounded up

she needed a team with a higher profile and briefly formed her own Justice League of America.

2. FAMILY FIRST

Since her early days, Waller's family has not been seen, but that changed in 2018 when her surviving daughter, Damita, was threatened in a plot against her. If the Wall was tough to begin with, she was virtually unstoppable when it came to protecting her family, and she made sure everyone knew that family would always come first.

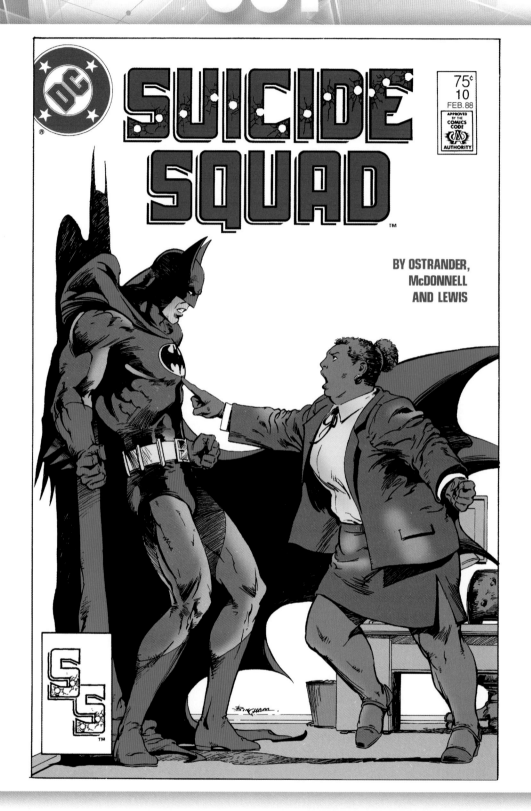

It takes someone with a force of will to dare take on the Batman, and someone even stronger to make him back up. That pretty much describes Amanda Waller.

Suicide Squad #10, February 1988
Artist: Jerry Bingham

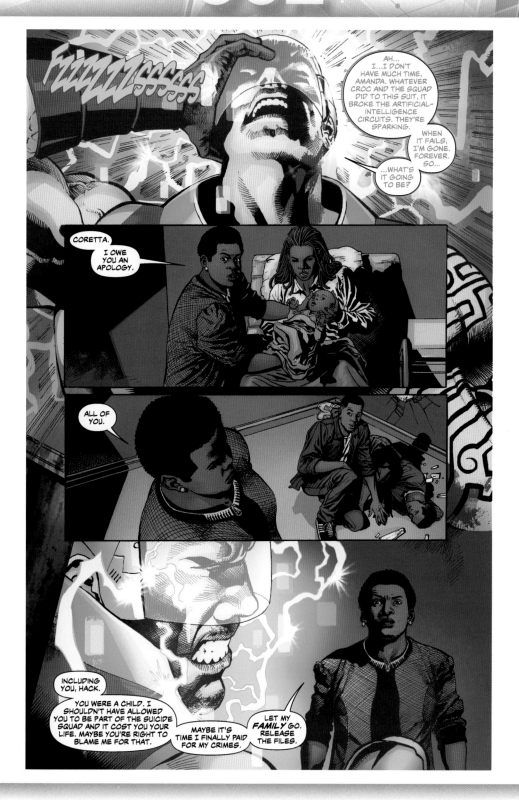

A merc named the Wall has gone to kill Waller's children and granddaughter—it is never wise to threaten her family, especially a new grandchild. And don't expect Grandma Waller to ever soften.

Suicide Squad #40, June 2018
Writer: Rob Williams *Artist:* Jack Herbert

Suicide Squad #40, June 2018
Writer: Rob Williams Artist: Jack Herbert

AMETHYST

AMY WINSTON LIVED IN HUDSON, NEW YORK (NEAR THE UNIVERSITY WHERE DICK GRAYSON briefly attended college), and on her thirteenth birthday, she learned the truth about her origins.

Her parents were the Lord and Lady Amethyst, and their only daughter was hidden on Earth by the witch-mother Citrina to protect her from the growing threat from Dark Opal. Amethyst was brought back to Gemworld (where she grew from tween to adult) when things were looking their bleakest, and across the twelve-issue maxiseries, she made allies and led the final battle against the conqueror.

3. IT'S ALL TRUE

Once Dark Opal was defeated and order restored in Gemworld, Amethyst realized she wanted to return to Earth and the Winstons. She wanted to be a teenager, go to school, make normal friends, and return to Gemworld someday. As she pierced the dimensional veil, Amethyst reverted to Amy, and she was still awake. It was all true, and those adventures were the stuff of legend, not dream.

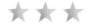

Amethyst was slowly folded into the DC Universe mythos once Gemworld became the object of attention by the Lords of Order and Chaos, and eventually circumstances prompted Amy to return as Amethyst sooner than expected.

The New 52 recast events so that she was now Princess Amaya of House Amethyst, brought to Earth by her mother Lady Graciel and raised as Amy once Aunt Mordiel usurped their home. She continued adventuring, briefly working with Justice League Dark.

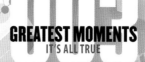

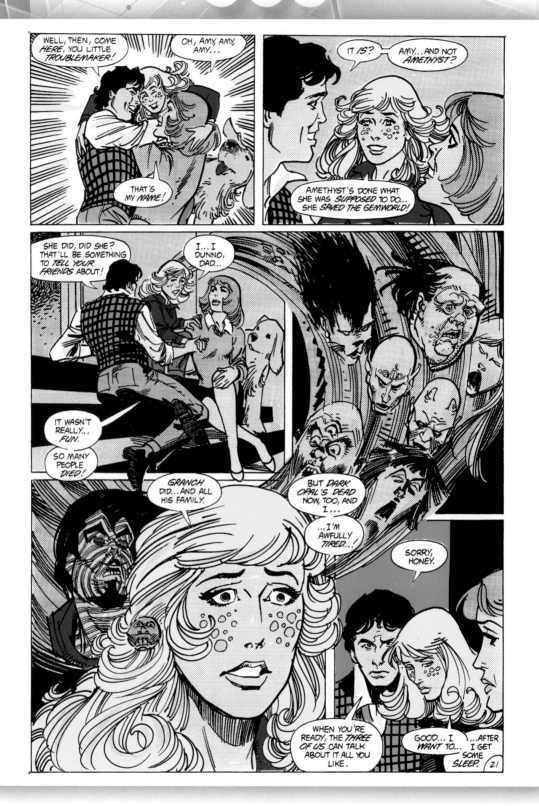

The adventure over, Amethyst returns home and discovers that everything that had happened was real. This transformative experience turned the young girl into a legendary hero.

Amethyst, Princess of Gemworld #12, April 1984
Writers: Dan Mishkin & Gary Cohn *Artist:* Ernie Colón

ARTEMIS

BANA-MIGHDALL WAS A CITY-STATE IN EGYPT INHABITED BY A FACTION OF AMAZONS, initially led by Queen Phthia. Powerful magic kept the city hidden from all, including the Amazons of Themyscira, until the latter part of the 20th Century. There came a time, though, when Queen Hippolyta had a vision of her daughter Diana's death. To forestall it, she ordered a new contest, initially excluding the Bana-Mighdall, until Diana insisted it be open to all.

4. ARTEMIS REPLACES DIANA AS WONDER WOMAN

The tall, muscular, redheaded Artemis prevailed and was given the uniform of Wonder Woman complete with the Gauntlet of Atlas, the Sandals of Hermes, and the golden lasso of truth. She journeyed to Man's World and began fighting for justice. Her methods lacked the training in the ways of peace and compassion, so she was seen as a coarser version of Diana, which grated Artemis.

Artemis struggled to fit into a violent world, making her an easily manipulated target, which also led to her conflict with the White Magician, who wound up killing her, bringing Hipppolyta's vision to reality. Artemis's soul traveled to Tartarus, where she served as a concubine to Dalkriig-Hath, one of the ruling Princes of Hell. Diana traveled there to rescue Artemis, but instead, the fierce warrior accepted her fate. When the demons tortured the Amazon Princess for coming to Artemis's aid, the redhead fought back, dragging Diana back to the world of the living. In the process, she won back her own life.

In the Rebirth reality, Artemis was never Wonder Woman, but instead was raised in the hopes of being the Shim'Tar, the champion of her people, the Bana-Mighdall. When the nation of Qurac attempted to expel the Bana-Mighdall, Artemis rose to their aid, only to lose the sacred Bow of Ra, which sent her on a quest to Gotham City, where the criminal Black Mask was believed to possess it. She worked with Red Hood and Bizarro, forming the Outlaws, to take down Black Mask and retrieve the bow.

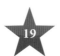

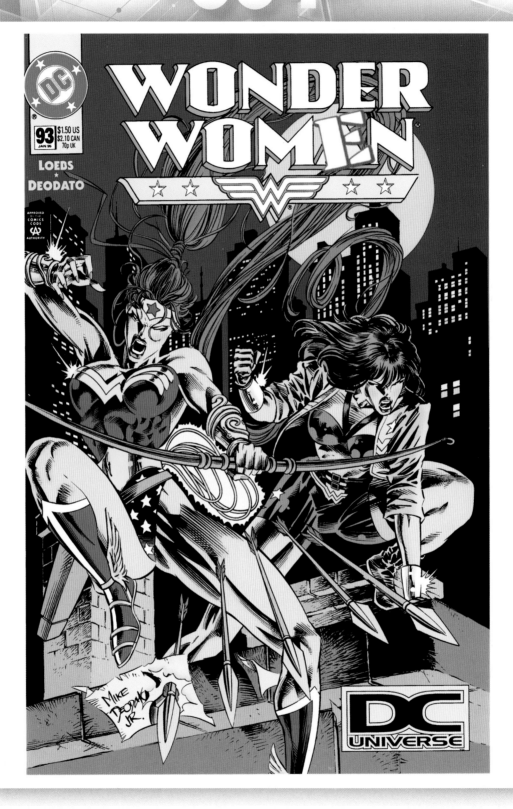

Artemis proved Diana's equal in matters of prowess, but when it came to spreading the Amazons' lessons about peace, she was not in the same league.

Wonder Woman #93, January 1995
Artist: Mike Deodato Jr.

BARBARA GORDON

DURING THE 1950S, EDITOR MORT WEISINGER WAS FINDING SUCCESS IN SLOWLY BUILDING up his Superman titles by adding elements to the mythos. Among the most popular was the arrival of Supergirl. It was inevitable that Batman editor Jack Schiff would follow suit.

5. BATGIRL DEBUTS

Comic fans were surprised in November 1966 when *Detective Comics* #359 hit newsstands, introducing one and all to Commissioner James Gordon's daughter Barbara. On her way to a masquerade ball dressed as a female version of Batman, Barbara intervened in a kidnapping attempt on Bruce Wayne by the villainous Killer Moth, attracting the attention of Batman and leading to a crime-fighting career. That story served as the inspiration for a short pilot film to show ABC that the character, played by dancer turned actor Yvonne Craig, was viable. They agreed, and Batgirl arrived for the abbreviated third season of *Batman* yet has remained a comics fixture ever since.

During the Silver Age, Batgirl is depicted as a spirited, if inexperienced, crime fighter. After a handful of guest appearances in Batman stories, she was given her own backup strip in *Detective Comics*. This allowed the character to be fleshed out considerably, with the shy, mousy, bookworm version of Barbara Gordon quickly giving way to a more modern, confident character (whom friends call Babs). Barbara eventually reveals her secret identity to her father (who had already discovered it on his own), and both run and win an election to the US House of Representatives. She moves to Washington, DC, and intends to give up her career as Batgirl forever.

6. BATGIRL KISSES ROBIN

Dick Grayson (Robin's alter ego) serves as Barbara's summer intern, building a friendship between the two as established in *Batman Family* #1. Nominally, Dick was attending Hudson University and dating Lori Elton, but Robin and Batgirl just worked well together. Astonished when the condescending Teen Wonder began to lecture her about the dangers of fighting crime for a woman, the redheaded heroine shut him down midsentence with a surprise kiss, leaving him swooning. Fans ate it up, so they continued to pair up in that title, learning each other's identity in the third issue. Although the older Batgirl saw Robin as a kid

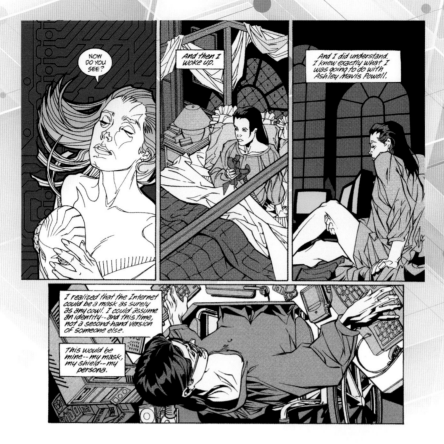

brother, the younger hero had an undeniable crush on his partner. During this period, Barbara was also dating Senator Tom Cleary, while Batgirl and Robin pursued a plethora of adversaries.

In the reality after the Crisis, Batman and Robin had a much more active role in training Barbara once she became Batgirl. Barbara and Dick Grayson had been lovers at some time in the past, and she had once been engaged to Jason Bard, who was no longer a Vietnam veteran but was still a private investigator (and former Gotham City police officer). Her biological history was also revised for a time, tweaked to establish her as the niece of Commissioner Gordon, who adopted Barbara after her parents died.

7. ORACLE REVEALED

Barbara's career came to a screeching halt one night when she answered a knock at her door. The Joker was on the other side and fired a pistol, knocking her to the ground, crippling her in the classic *Batman: The Killing Joke* (1988). After recovering at the hospital,

Barbara faced a new life in a wheelchair, her Batgirl career at an end. Still, she hungered to prevent such acts from happening again and sought some way to contribute.

Assessing her talents, she recognized that her skills at detecting remained intact, in addition to her superior abilities with computers. Bit by bit, she assembled hardware and software, perfecting her hacking skills and slowly building an online presence. She practiced by surreptitiously helping her uncle with a murder investigation. Finally, she contacted the Suicide Squad. She hid behind a green-hued avatar and called herself Oracle, first appearing in *Suicide Squad* #23 (January 1989), but readers weren't given confirmation that Oracle was Barbara Gordon until issue #38.

8. ORACLE AND NIGHTWING

In the late 1970s, *Batman Family* was canceled and its contents moved into *Detective Comics*. Apparently, the Babs/Dick infatuation didn't make the move,

and their relationship returned to the back burner. Instead, Dick Grayson met the alien Koriand'r, who joined his Teen Titans as Starfire, and they began their own torrid romance. Fans were either Team Babs or Team Kori throughout the 1980s.

In the 1990s, though, the two were seen as a couple in animated fare, something that writer Chuck Dixon liked. He slowly incorporated their romance as a thread, first in *Nightwing* and then *Birds of Prey*. Grayson was portrayed as a bit of a ladies' man, but his response to Babs being trapped in Gotham City during an earthquake made it clear where his heart truly lay.

Dick and Barbara remained close friends and occasional lovers. In *Birds of Prey* #8 (1999), the two met in their civilian guises for dinner, and he surprised her by taking her to Haly's Circus, where he'd worked as a child. After that evening's performance, he took her up to the trapeze, where they could fly free. At long last, Barbara and Dick Grayson (who was now the super hero Nightwing) reignited their love affair, and it was carried out in the pages of *Birds of Prey* and *Nightwing*. Barbara later ended the relationship when

she felt Dick was being overprotective of her. In truth, Dick was being attacked in all areas of his life by the Blockbuster. She and Dick still loved each other and remained in each other's lives. After the destruction of Blüdhaven by the Society, Dick proposed to her and Barbara accepted, only to later break it off. Lasting from 2000 to 2004, their mature romance left an indelible impression on readers.

9. BATGIRL OF BURNSIDE

Even with critical and commercial success, in 2014 it was decided to tweak Batgirl's new reality further. Under the new creative team of cowriters Brenden Fletcher and Cameron Stewart and artist Babs Tarr, the character was transformed into a graduate student, working on her PhD while living in the gentrified Gotham borough of Burnside.

The younger, hipper Batgirl has connected with audiences, and her efforts in school have been seen as a positive message for STEM education, while her daring exploits in costume thrill readers of all ages.

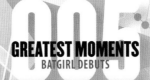

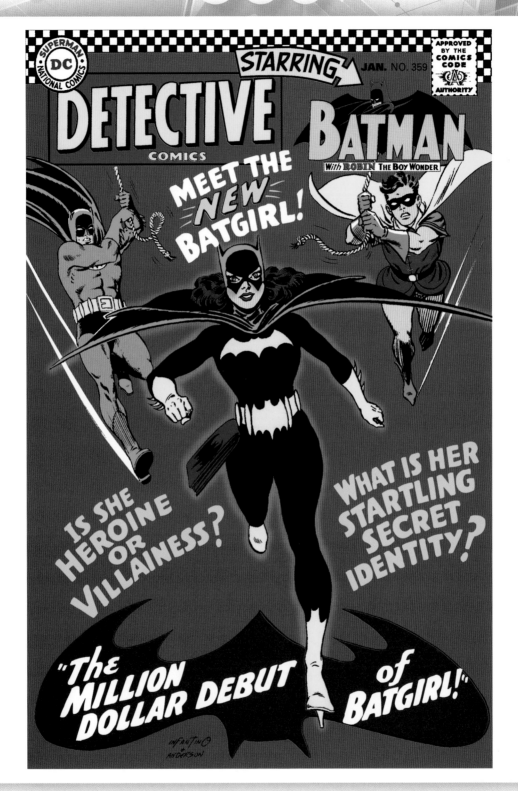

Barbara Gordon created quite a splash when she first arrived as Batgirl, charming the Dynamic Duo and readers alike, becoming a fixture ever since her million-dollar debut.

Detective Comics #359, January 1967
Artists: Carmine Infantino & Murphy Anderson

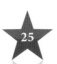

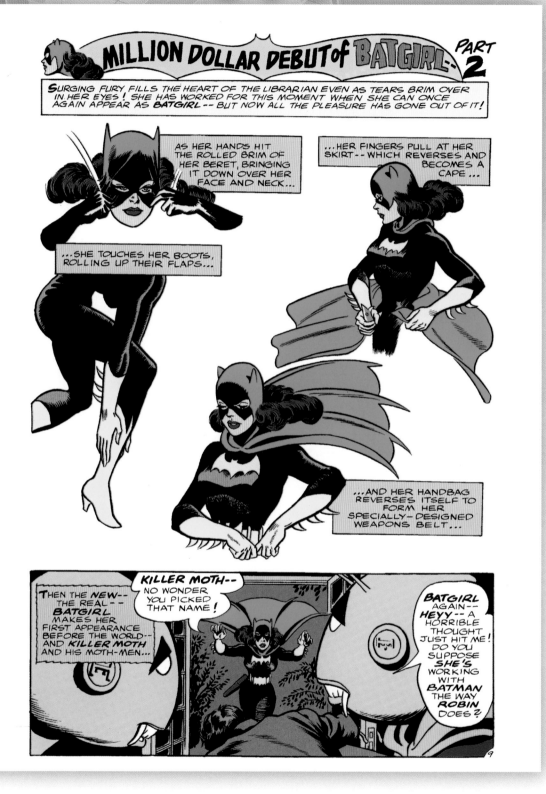

Detective Comics #359, January 1967
Writer: Gardner Fox Artists: Carmine Infantino & Sid Greene

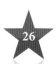

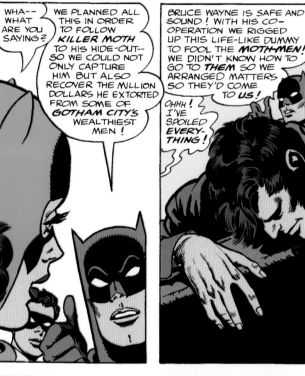

WHA-- WHAT ARE YOU SAYING?

WE PLANNED ALL THIS IN ORDER TO FOLLOW *KILLER MOTH* TO HIS HIDE-OUT-- SO WE COULD NOT ONLY CAPTURE HIM BUT ALSO RECOVER THE MILLION DOLLARS HE EXTORTED FROM SOME OF *GOTHAM CITY'S* WEALTHIEST MEN!

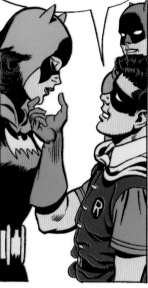

BRUCE WAYNE IS SAFE AND SOUND! WITH HIS CO-OPERATION WE RIGGED UP THIS LIFE-LIKE DUMMY TO FOOL THE *MOTH-MEN!* WE DIDN'T KNOW HOW TO GO TO *THEM* SO WE ARRANGED MATTERS SO THEY'D COME TO *US!*

OHHH! I'VE SPOILED *EVERY-THING!*

AWW, CHEER UP, *BATGIRL!* ALL ISN'T LOST YET! WE CAN STILL GO AFTER *KILLER MOTH!* YOU SEE -- I PLANTED A TRACKING DEVICE UNDER THE FENDER OF THE *MOTHMOBILE!*

I'M GOING ALONG WITH YOU--

NO, *BATGIRL!* THIS IS A CASE FOR *BATMAN* AND *ROBIN!* I'M SORRY--BUT YOU MUST UNDERSTAND THAT WE CAN'T WORRY OUR-SELVES ABOUT A GIRL...

AS THE *BATMOBILE* ROARS OFF, A RAGING YOUNG TIGRESS YANKS A SPECIAL MOTOR BIKE FROM THE TRUNK OF HER SPORTS CAR...

WORRY ABOUT A GIRL, eh? *HAH!* IF THEY THINK THEY CAN CUT ME OFF FROM WHERE THE ACTION IS, THEY'RE MISTAKEN! I RESTYLED THIS MOTOR BIKE FOR JUST SUCH AN EMERGENCY!

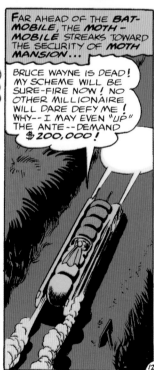

FAR AHEAD OF THE *BAT-MOBILE*, THE *MOTH-MOBILE* STREAKS TOWARD THE SECURITY OF *MOTH MANSION*...

BRUCE WAYNE IS DEAD! MY SCHEME WILL BE SURE-FIRE NOW! NO OTHER MILLIONAIRE WILL DARE DEFY ME! WHY-- I MAY EVEN "UP" THE ANTE--DEMAND $200,000!

Detective Comics #359, January 1967
Writer: Gardner Fox *Artists:* Carmine Infantino & Sid Greene

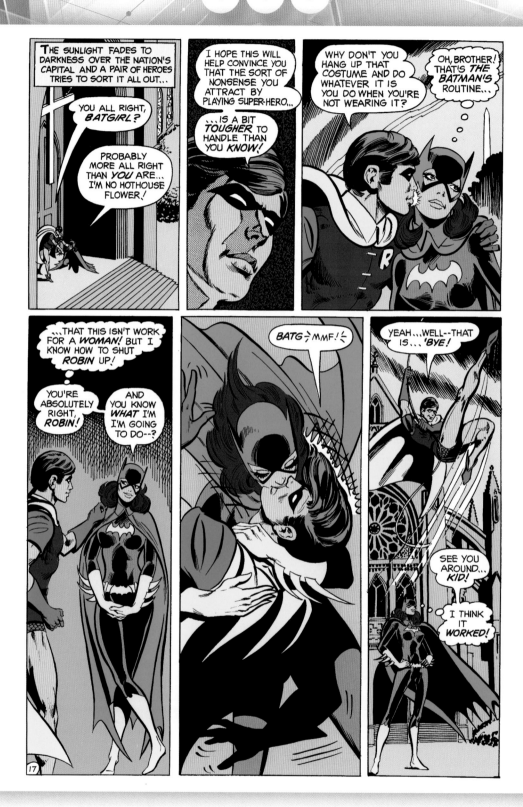

It looked like an impulsive moment, but the kiss electrified Robin, and one of comics' deepest, most enduring romances began after a routine case.

Batman Family #1, September/October 1975
Writer: Elliot S! Maggin *Artist:* Mike Grell

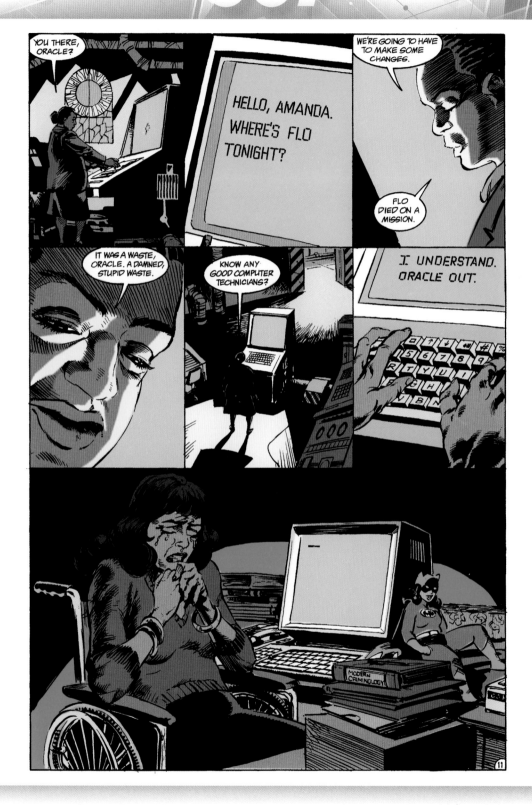

Barbara didn't let her handicap stop her, and soon Oracle was helping other champions, beginning with the Suicide Squad. It took more than a year before her identity was revealed to readers.

Suicide Squad #38, February 1990
Writers: John Ostrander & Robert Greenberger *Artists:* Luke McDonnell & Geoff Isherwood

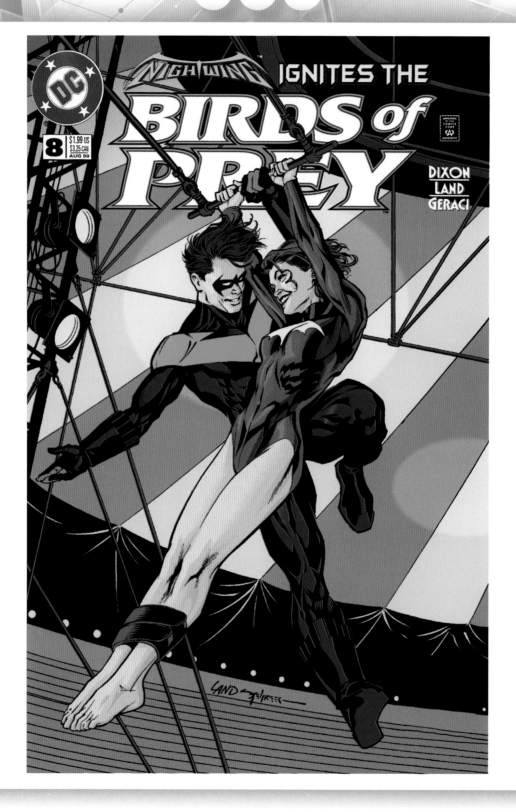

Dick Grayson and Barbara Gordon, Robin and Batgirl, Nightwing and Oracle. Regardless of the name, their friendship and deep-abiding love for each other has sustained them both through challenging times.

Birds of Prey #8, August 1990
Artists: Brian Stelfreeze & Greg Land

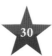

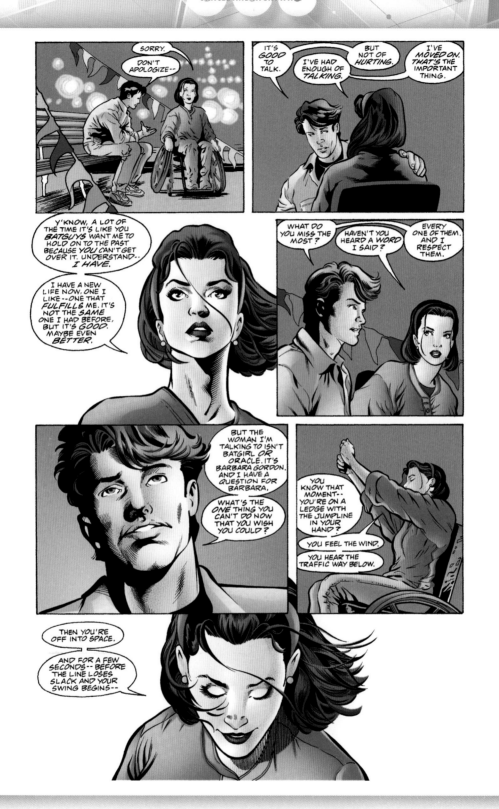

Birds of Prey #8, August 1990
Writer: Chuck Dixon Artists: Greg Land & Drew Geraci

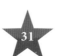

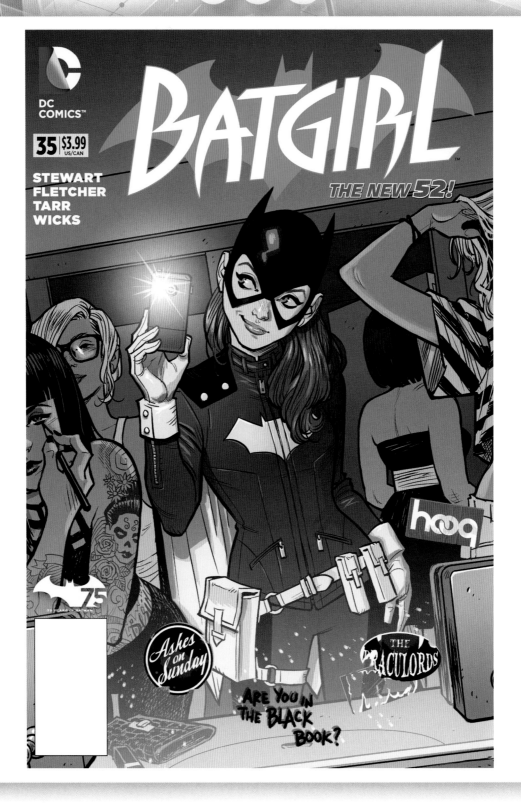

A fresh beginning meant a new locale, new friends, and a regression in age and experience, so Babs is now a grad student complete with a new attitude and uniform.

Batgirl #35, December 2014
Artist: Cameron Stewart

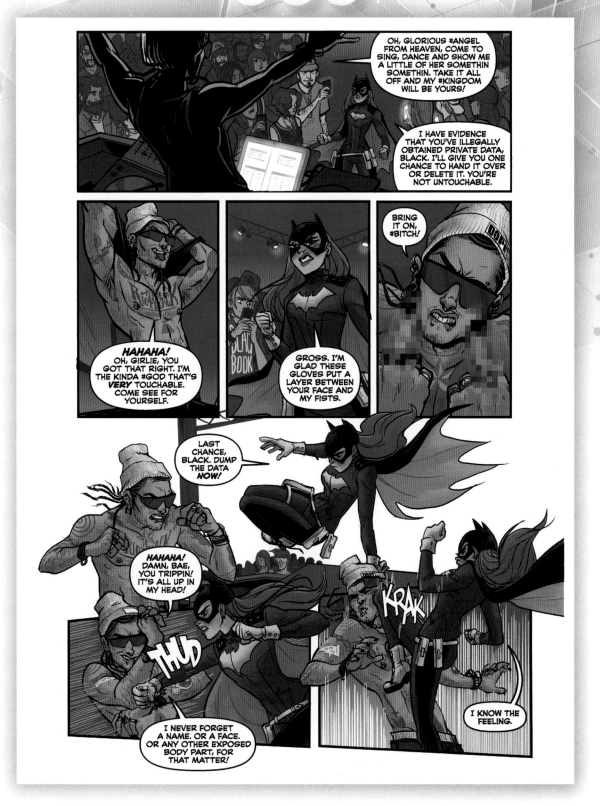

Batgirl #35, December 2014
Writers: Brenden Fletcher & Cameron Stewart Artist: Babs Tarr

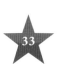

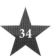

THERE HAVE BEEN SEVERAL WOMEN TO USE THE NAME BATGIRL. PRIOR TO BATMAN'S Silver Age, there was Betty Kane's Bat-Girl. Readers first met Betty Kane in 1961's *Batman* #139; she was the niece of Kathy Kane, who had already been introduced as Batwoman. The pair was created to be romantic interests for Batman and Robin as much as crime-fighting associates. Bat-Girl wore a red-and-green costume to "flatter" and match Robin's own attire. Bat-Girl appeared seven times between 1961 and 1964, but then disappeared in 1964 when new Batman editor Julie Schwartz decided these characters were too silly.

Under writer Bob Rozakis, Betty returned in the mid-1970s as a member of the Teen Titans West affiliate. A few years later, DC's continuity was rewritten so that Bat-Girl never existed. Mary Elizabeth "Bette" Kane, though, turned up in 1989 as a super heroine named Flamebird and wannabe Teen Titan. She was a tennis pro by day, crime fighter by night, elements retained in the wake of Rebirth. Bette Kane is now a relative of Kate Kane, the current Batwoman, living at West Point.

And then came Barbara Gordon. Once Barbara was crippled and became Oracle, the Batgirl mantle was used by others with and without her permission, starting with Helena Bertinelli before Cassandra Cain came to Gotham City.

The daughter of David Cain and Lady Shiva, Cassandra Cain was raised to be a living weapon until she rejected her training and sought her own destiny. David Cain was a member of Ra's al Ghul's League of Assassins, hoping to perfect a fighting style that would one day result in the flawless warrior who could serve as the nearly immortal leader's bodyguard. His research led him to Detroit and to Sandra and Carolyn Wu-San, sisters who studied martial arts from a young age and communicated in ways unique to the siblings. To win Sandra over and bring her to the emotional point he felt necessary, David killed Carolyn. Sandra wanted

revenge and sought the killer, which led her to the League and a trap laid by David, who offered to spare her life if she agreed to bear his child and let him raise it alone. Sandra agreed and resumed training, becoming the world's greatest living martial artist, Lady Shiva.

Cassandra was raised to be aware of the world around her, to understand what people meant by the way they moved. As a result, she never learned speech, but instead understood what was being conveyed and predicted the appropriate response. By age eight, Cassandra was deemed ready for her first assignment: to kill a randomly selected executive. She knew exactly the moment to strike and delivered the killing blow, but its aftermath shocked her. She concluded that what she had trained to do and what she was expected to become was wrong, so she ran away.

10. CASSANDRA CAIN BECOMES BATGIRL

Cassandra then spent the next decade surviving on her own, wracked with guilt over her crime. She entered Gotham City just as the federal government was withdrawing its support, cutting off the city from the rest of America. When Cassandra learned of Oracle's efforts—along with those of Batman, Robin, Nightwing, and others—to preserve order, she wanted to participate. Oracle, the original Batgirl, at first demurred, until Cassandra saved Commissioner James Gordon's life. Then she was allowed to work with the others and was given a Batgirl costume— covering her face and entire body in black—with the former Batgirl's blessing.

11. BATGIRL CONFRONTS HER FATHER IN JAIL

David Cain was never certain if Bruce Wayne was a good enough teacher for his daughter, so he accepted Lex Luthor's offer to frame Wayne for the death of Wayne's girlfriend, Vesper Fairchild. Cassandra and the rest of the team worked tirelessly to prove his innocence, with Wayne all the while abandoning that identity and operating just as Batman. In the end, Cassandra determined that David had killed Vesper

with a maneuver he taught her. With that, Batman confronted David, who determined he was worthy of his daughter and surrendered, clearing Wayne.

To tidy up loose ends, Luthor hired Deadshot to kill David, who felt guilt over his recent actions and nearly allowed the mercenary to make the fatal shot. Reminded of his daughter, he fought back, wounding his attacker but leaving him alive to prove a point. Not long after, Cassandra snuck into her father's jail cell, and they battled. She threatened to kill him should he take another life, making the father proud of the daughter. He finally revealed to her the date of her birth and once escaped custody to give her a gift.

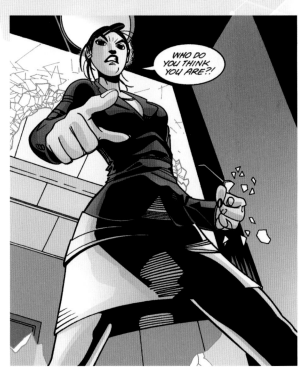

★ ★ ★

After reality was reordered in the wake of Flashpoint, Cassandra was trained by David Cain to be a gift to the villain Mother. She was dispatched to Gotham City to kill Miranda Row, mother to Harper, an ally of Batman's. He saved Miranda and found Cassandra an interesting teen, taking her under his care and assigning her to be trained by Batwoman along with other vigilantes. When she took the field, she continued to wear the all-black outfit but used the code name Orphan.

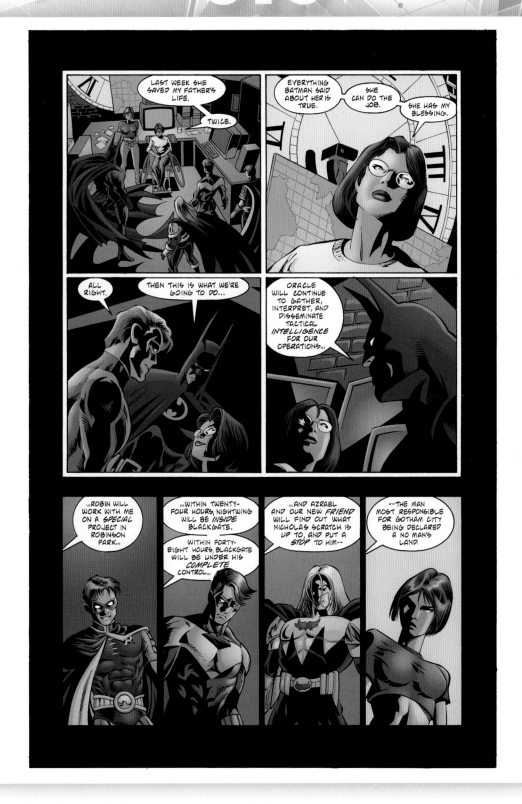

Cassandra Cain was trained to be the perfect child assassin but found murder distasteful and unworthy of her. Instead, she helped keep Gotham City safe before earning the mantle of Batgirl.

Legends of the Dark Knight #120, August 1999
Writer: Greg Rucka *Artists:* Mike Deodato Jr. & Sean Parsons

Legends of the Dark Knight #120, August 1999
Writer: Greg Rucka *Artists:* Mike Deodato Jr. & Sean Parsons

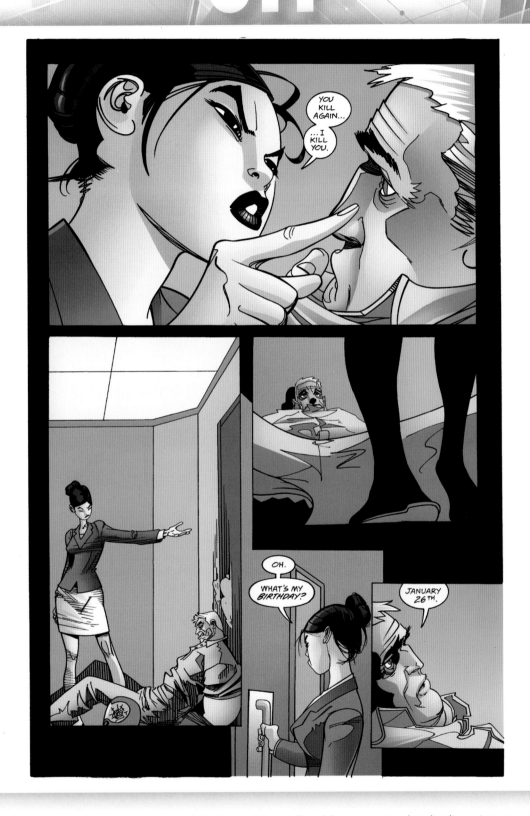

Cassandra Cain confronted her father in his Blackgate Prison cell to deliver a warning, but the discussion proved to be a far more subtle and emotional one.

Batgirl #33, December 2002
Writer: Kelly Puckett *Artists:* Damion Scott & Robert Campanella

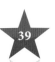

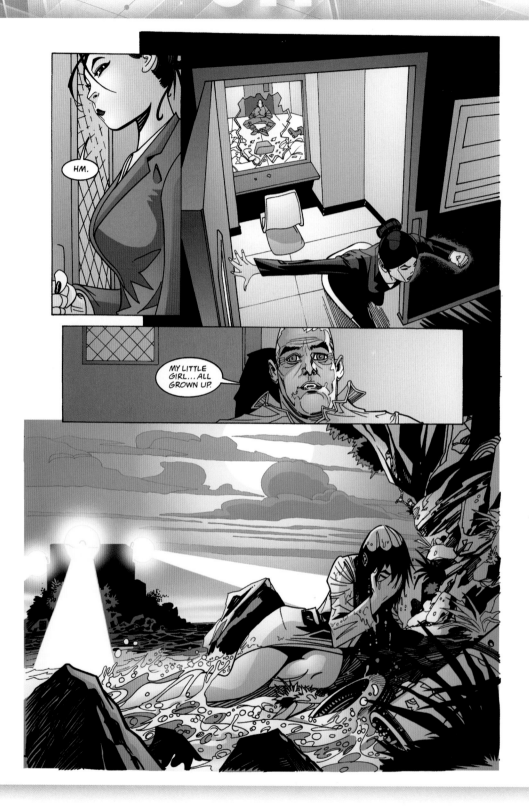

Batgirl #33, December 2002
Writer: Kelly Puckett Artists: Damion Scott & Robert Campanella

BATWOMAN

LIKE MANY CHARACTERS IN THE DC UNIVERSE, KATE KANE HAS GONE THROUGH MANY iterations. Her reality and backstory has changed ever so slightly to suit the needs of new writers. The first Kate Kane was a pre–Silver Age Batwoman, a Gotham socialite who saw that the Caped Crusader could use some help. She was briefly resurrected during the Bronze Age, only to fall victim in a war between the League of Assassins and Ra's al Ghul's operation.

In 2011, the *New York Times* broke the news that a new Batwoman was coming and would be a lesbian, a significant move for DC Comics. She arrived in *52 #11*, a weekly series that helped reshape the DC Universe. Between that series and subsequently taking over the lead feature in *Detective Comics*, her background was filled in.

12. BATWOMAN DEBUTS

Katherine "Kate" Kane and her twin, Elizabeth ("Beth"), are the daughters of Colonel Jacob Kane and Captain Gabi Kane, career military intelligence officers. While posted in Brussels, Gabi and the girls were kidnapped by members of the Religion of Crime. Jacob led the rescue operation, arriving too late; his wife and Elizabeth were dead.

In time, Kate grew up and enlisted in the Marines to win her father's approval. While at West Point, she entered into a romance with Cadet Captain Sophie "Gimme" Moore. When word leaked out, she admitted her sexual orientation, and under the rules of Don't Ask, Don't Tell, she was dishonorably discharged. Adrift and reckless, Kate enjoyed the newfound wealth that came when her father remarried, with weapons heir Catherine Hamilton as her new stepmother.

When pulled over in Gotham City for a suspected DUI, Kate flirted with the officer, Renee Montoya, resulting in a romance, only to break up when Montoya disapproved of Kate's wasted life and lack of direction. Not long after, Kate was saved from a mugger by

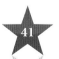

Batman, a transformative moment, and she spent the next two years training for her new career.

Donning her Batwoman gear for the first time, Kate trailed Montoya and her partner, the vigilante known as the Question. She subsequently made a public debut by rescuing them from Whisper A'Daire's shape-shifting minions. The investigation continued as Montoya found A'Daire's object: the sacred Book of Crime, which prophesied that the "twice-named daughter of Kane" would be murdered.

Nightwing gave her official sanction to operate in Batman's city by giving her a Batarang, and Kate renewed her romance with Renee.

When her father, Jacob, was kidnapped by the madwoman named Alice, Batwoman was on the case, beginning a new relationship with Lieutenant Maggie Sawyer. As they worked together, Alice was revealed as a twisted version of Kate's sister Beth, long thought dead, creating a rift between father and daughter. Alice was the new High Priestess of the Religion of Crime, prompting a rapprochement between Kate and her father, who became Kate's tactical adviser and weapons supplier in order to stop her sister.

13. DON'T ASK, DON'T TELL

Reality was soon after rewritten, and her backstory remained much the same, although Jacob was called Jake and Gabi went by Gabrielle. In the wake of Beth's death, Colonel Kane was incredibly supportive of Kate regardless of her life choices.

Again, a mugging in Gotham led her on the path to become Batwoman, although this time she trained for three years. Colonel Kane's final mission took her to Russia, but when she discovered that the mission's objective, a family, was already dead, she nearly killed the perpetrators. In the end, it proved to be a test, and she passed, ready to become a costumed crime fighter.

Batwoman's activities brought her close to Maggie Sawyer, and when the Department of Extranormal Operations' Cameron Chase hunted for Batwoman's identity (in an attempt to use it to learn Batman's alter ego), the women's friendship became something more.

14. BATWOMAN PROPOSES TO MAGGIE SAWYER

Not long after, a being known as Ceto was ripping the fabric of reality, and even with Wonder Woman's help, Batwoman seemed powerless to stop it. The ancient Medusa was also involved in the complicated case, and Batwoman managed to use a reflection to turn the creature to stone, which also seemed to end Ceto's threat.

In the wake of the mission, Kate sought out Maggie Sawyer, who was despondent over her inability to locate a group of missing children. Batwoman solved the case and brought the children to the detective. It was then that Batwoman revealed her identity and proposed. In the end, the wedding fell through, but the engagement, brief as it was, was yet another milestone for the character.

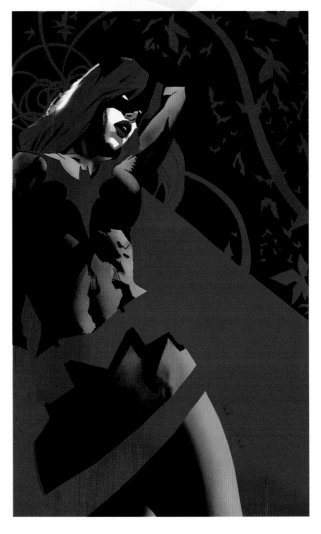

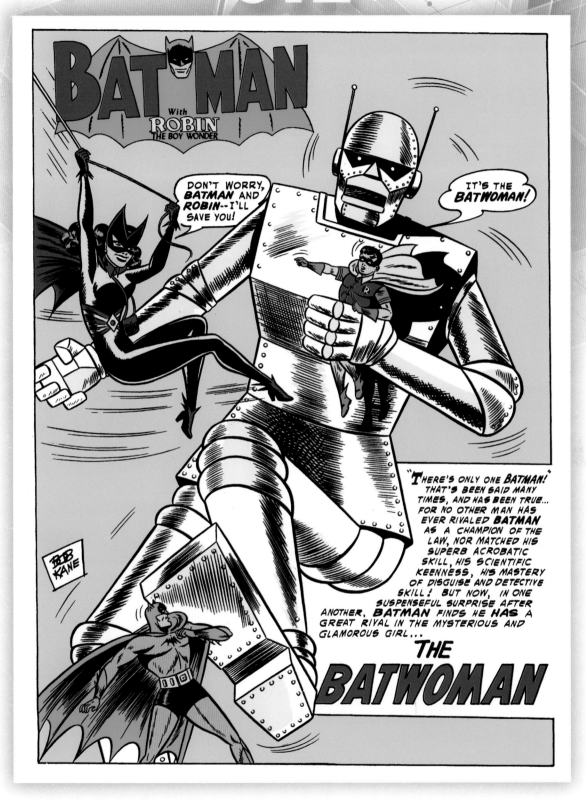

Kathy Kane had spent years training to become a costumed vigilante, inspired by Batman, so of course she styled herself as a Batwoman.

Detective Comics #233, July 1956
Writers: Edmond Hamilton *Artists:* Sheldon Moldoff & Stan Kaye

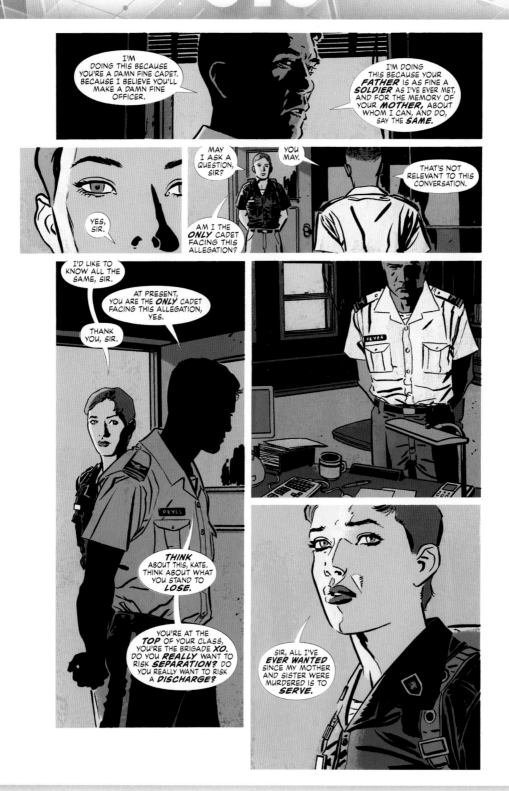

Dating back to President Bill Clinton's 1993 policy, the military turned a blind eye on gay service members; they acted only when sexual orientation came to light, as it did for Kate Kane.

Detective Comics #859, January 2010
Writer: Greg Rucka *Artist:* J. H. Williams III

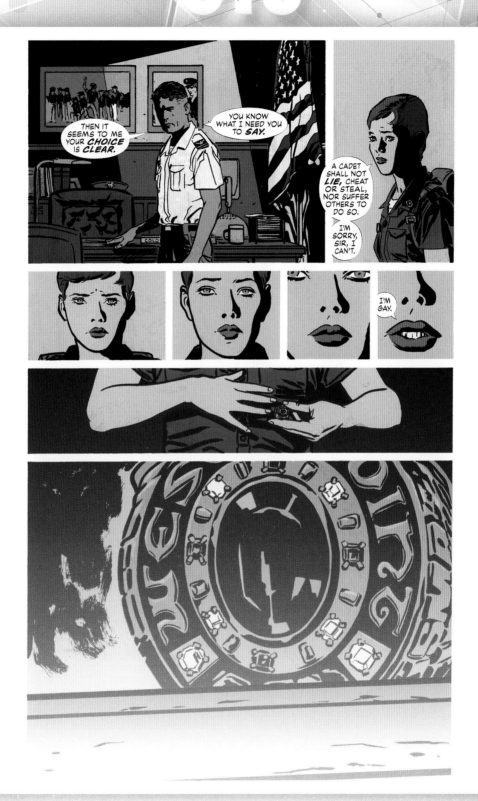

Detective Comics #859, January 2010
Writer: Greg Rucka Artist: J. H. Williams III

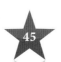

At the end of a harrowing case, Batwoman does a fairly mundane thing: find lost children. But it's enough to prompt her to propose to Detective Maggie Sawyer, who says yes.

Batwoman #17, April 2013
Writers: J. H. Williams III & W. Haden Blackman *Artist:* J. H. Williams III

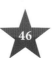

BIG BARDA

AFTER THE OLD GODS DIED, A NEW RACE OF GODS AROSE, SOME LIVING IN HARMONY on New Genesis while others toiled under the lash on fiery Apokolips. Some 250 years ago, the woman known as Barda was born to Big Breeda on that dangerous latter world. She was consigned to be raised in Granny Goodness's Home for Orphaned Youth. Barda showed tremendous spirit, so Granny chose to groom her to eventually lead her Female Fury Battalion.

At some point after reaching adulthood, Barda encountered Scott Free, the son of New Genesis's Highfather, being raised on Apokolips to maintain a fragile peace between the worlds. There was something different about the young man, an inner peace she found fascinating, and it wasn't long before their friendship blossomed into love. Unable to stand life on Apokolips any longer, Scott was planning an escape to Earth, a plan that Barda helped make a reality. Among her reasons was the recent murder of her friend Auralie, who died for the sin of dancing. She worked with the New God Himon and Metron to get Scott to Earth. His adoptive father, Darkseid, allowed this to happen, since it would shatter the pact with Highfather, reigniting the war with New Genesis.

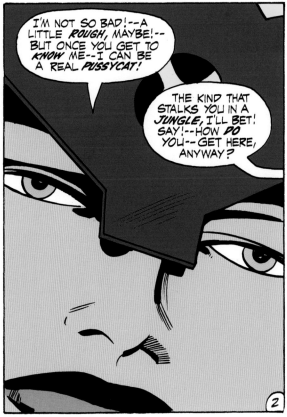

In the Rebirth reality, Scott Free and Big Barda still hail from Apokolips, but in the hands of Tom King and Mitch Gerads, their story is as much about their relationship than action-packed adventures. Their love is one for the ages.

15. BIG BARDA ESCAPES GRANNY GOODNESS

Barda had long since realized she was not at all interested in becoming leader of the Female Furies. When Granny was otherwise occupied, Barda escaped Apokolips for Earth. Whereas Darkseid didn't act overtly to retrieve Scott, Granny wanted Barda back and unleashed the Furies, among other dangers, after them. Armed with her Mega Rod, Barda held them at bay. Time and again, Scott and Barda beat back the threats and continued to yearn for a simple life on Earth.

16. BIG BARDA KNOCKS OUT QUEEN BEE

There was a time when Highfather was dead and New Genesis was ruled by Takion. Knowing the coming of the entity Mageddon, he asked Darkseid's son Orion and Barda to return to Earth and serve as members of the Justice League.

The coming of Mageddon across the galaxies upended activities on countless worlds but also presented opportunities. One, Zazzala, the Queen Bee, brought a space armada to Earth in the hopes of conquering it before Mageddon. She landed in New York and established a hive, taking out the Air Force in the process and possessing members of the JLA. In the end, though, Steel revealed he had been faking submission and signaled an attack. During the battle, Barda landed the decisive blow, ending Queen Bee's threat and letting her focus on the true threat as it neared Earth.

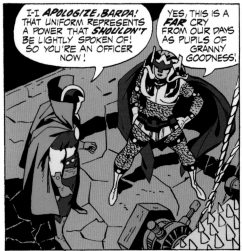

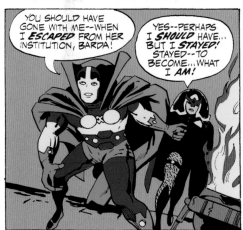

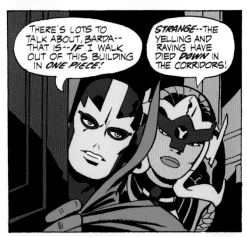

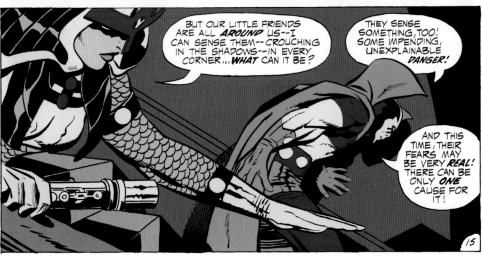

Big Barda escaped from Apokolips and Granny Goodness to find her true love, Scott Free. What neither could anticipate were the lengths Granny would go to retrieve her prized pupil.

Mister Miracle #4, September/October 1971
Writer/Penciller: Jack Kirby *Inker:* Mike Royer

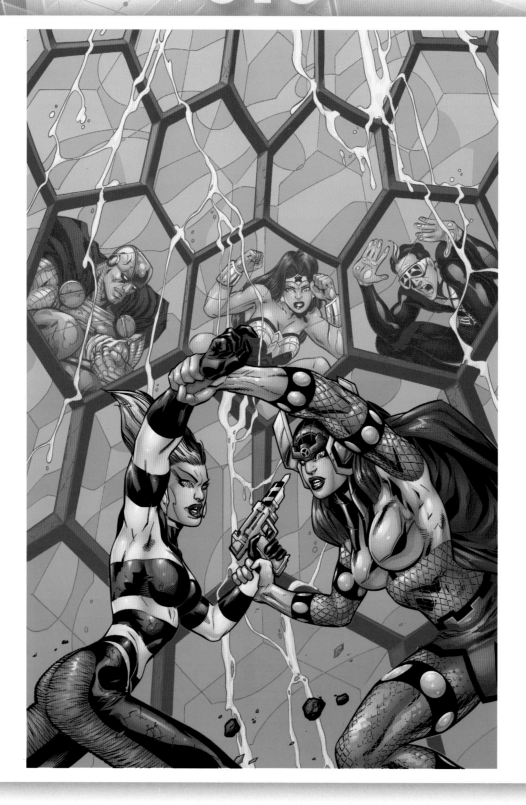

The focus is on making certain the Justice League is ready for the coming of Mageddon, but a warrior like Barda can't help but land a few blows whenever possible, and Queen Bee is just one victim.

JLA #39, March 2000
Artists: Howard Porter, John Dell & David Smith

BIRDS OF PREY

17. ORACLE FORMS THE BIRDS OF PREY

For a brief time, Oracle was a full-fledged member of the Justice League of America, all without leaving her clock tower headquarters in Gotham City. The development followed Oracle's realization that other heroes could do the legwork she could not. Her first attempt at working with another hero, Power Girl, ended badly, and she was hesitant to do so again, fearing more mistakes. She scoured other potential heroes around America and selected Black Canary, who had previously worked on several teams and was at that point without an anchor or focus.

Oracle got in touch with Black Canary, who responded enthusiastically. For a while, the two worked well together without even meeting. At times, Black Canary was paired with other operatives, most notably the Huntress. After trying out the concept in several one-shots and a miniseries, *Birds of Prey* earned its own title, even spawning a one-season television series on the WB network.

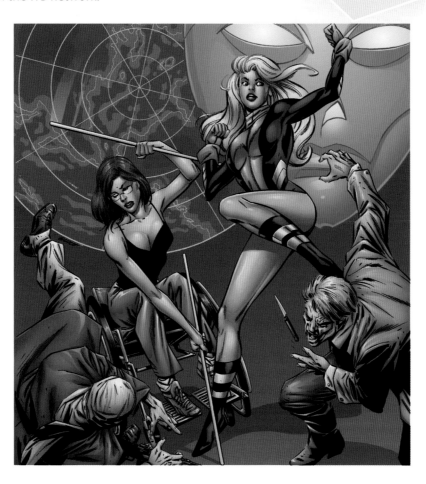

As a leader, Oracle displayed a compassionate nature, offering support and funds, as well as whatever else her friends and fellow agents needed.

The Birds of Prey continued their operations around the world using a variety of costumed adventurers as their skills were required. Oracle granted personal access to a precious few at that time, including Black Canary, Huntress, and Lady Blackhawk.

As DC reordered their reality after the events of Flashpoint, novelist Duane Swierczynski and artist Jesus Saiz brought out a new interpretation of the team, which continued to feature Barbara Gordon and rock star turned hero Black Canary along with less obvious members including Catwoman, Poison Ivy, and Starling. Here, Barbara regained the use of her legs, having only been crippled for a few years, and refused membership, suggesting that Katana replace her.

Rebirth blended the best of previous realities, with the new, younger Batgirl working with Black Canary and Huntress, among other heroes. Despite fan complaints about no longer having her as a role model for disabled people, the creative executives felt that a larger audience wanted her back as Batgirl. As a result, her injury was three years in her past, but she was still contending with PTSD caused by the trauma. Despite this alteration, she founded the Birds of Prey and was now a more active participant.

18. ORACLE AND BLACK CANARY FINALLY MEET

In *The Supergirls: Fashion, Feminism, Fantasy, and the History of Comic Book Heroines*, Mike Madrid notes that Oracle and Black Canary's relationship is comparable to the friendship depicted in the film *Thelma & Louise*. Interestingly, the pair knew little about each other, with Oracle acting as the mother/life coach to the Canary, who seemed at loose ends when they first worked together. Over the issues, writer Chuck Dixon deepened the friendship as Black Canary gained confidence as an independent operative, beholden to no man (her romance with Green Arrow on the rocks at this point). They didn't meet until circumstances forced Barbara out of her clock tower headquarters and they wound up drenched on a boat together, in *Birds of Prey* #21. When the time came, she sacrificed her freedom to protect Barbara. The Canary poses as Oracle, saving Barbara's life in *Birds of Prey* #24, December 2000.

In the most recent incarnation, *Batgirl and the Birds of Prey*, the two are on more equal footing. The series was written by sisters Julie and Shawna Benson, and the latter told the press, "She and Barbara have a good, solid relationship with each other. They are friends. In fact, they are more like sisters. So we draw upon our relationship with each other, as sisters, to inform their relationship, which means they're not always going to see eye to eye. They're not always going to get along. But at the end of the day, they're going to have each other's backs."

19. TO SAVE GOTHAM'S MEN

When the Daughters of Gotham unleash a genetically engineered influenza virus to attack Gotham's men, intended to rid the city of corrupt males, Amanda Waller quarantines the city and it falls to the Birds, aided by Batwoman, Catwoman, Gotham Girl, Harley Quinn, Lois Lane, Orphan, Poison Ivy, Spoiler, and Wonder Woman to stop the cabal and find a cure before Batman, Robin, Commissioner Gordon, and the other men die.

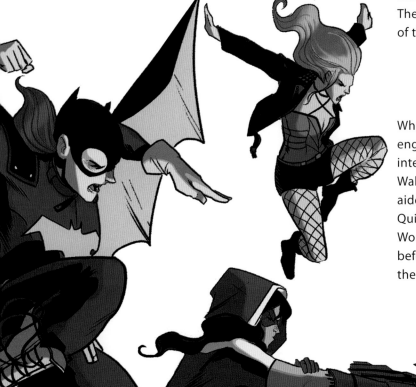

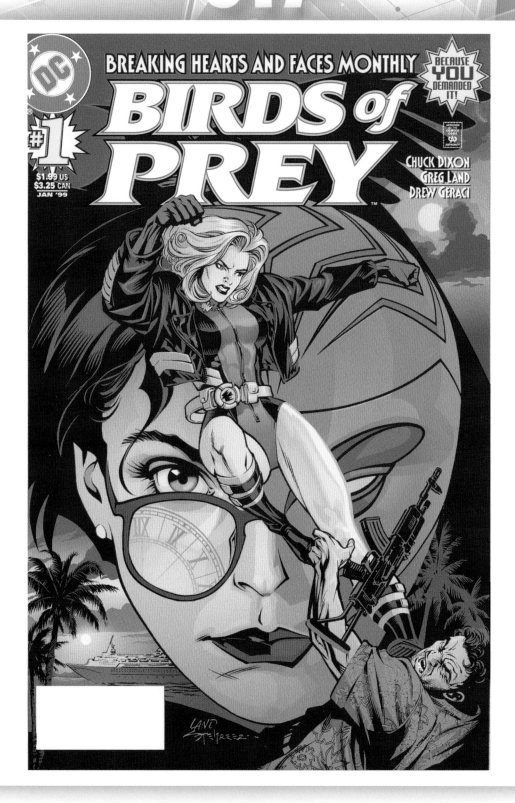

Oracle came to realize she needed operatives to do what she could not and selected Black Canary to be her partner. Thus began an unusual friendship where the pair only spoke via comm systems.

Birds of Prey #1, January 1999
Artists: Brian Stelfreeze & Greg Land

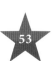

Birds of Prey #1, January 1999
Writer: Chuck Dixon *Artists:* Greg Land & Drew Geraci

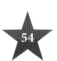

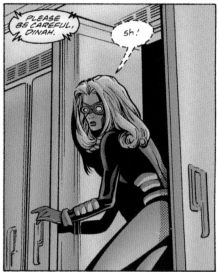

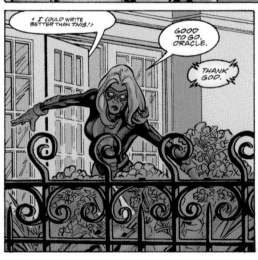

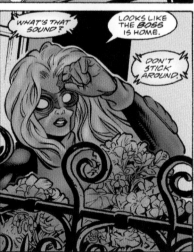

Birds of Prey #1, January 1999
Writer: Chuck Dixon *Artists:* Greg Land & Drew Geraci

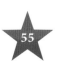

Oracle and Black Canary finally meet, as their war with Blockbuster gets nastier and ever more dangerous. They could barely do more than say hello before getting back to work.

Birds of Prey #21, September 2000
Writer: Chuck Dixon *Artist:* Butch Guice

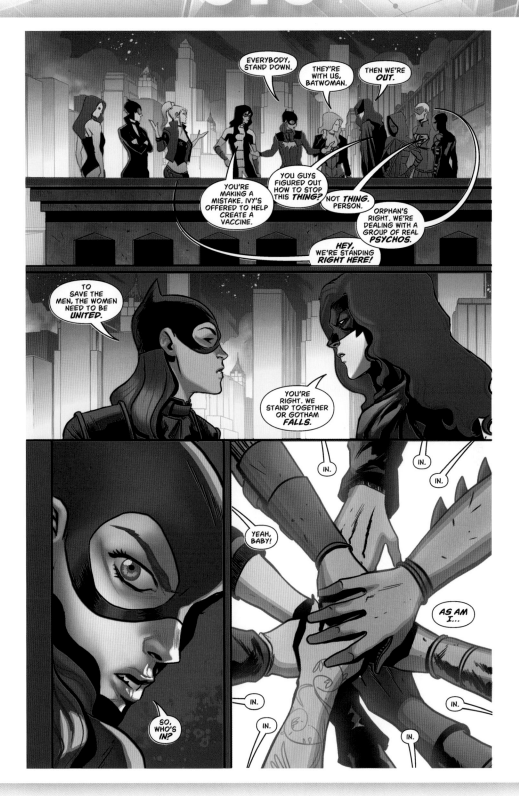

When things look bleak for Gotham's infected men, the Birds swing into action, and bring along some much-needed tactical support.

Batgirl and the Birds of Prey #15, December 2017
Writers: Julie Benson & Shawna Benson *Artist:* Roger Antonio

Batgirl and the Birds of Prey #15, December 2017
Writers: Julie Benson & Shawna Benson *Artist:* Roger Antonio

BLACK CANARY

BLACK CANARY IS THE CODE NAME FOR TWO WOMEN, A MOTHER AND DAUGHTER, WHO have been costumed crime fighters in different eras. On Earth-2, Dinah Lance was the daughter of a cop and trained to become a fighter and detective. She donned a wig, fishnets, and a short jacket to fight crime as Black Canary, encountering Johnny Thunder in the pages of *Flash Comics*. The new character proved popular, and she soon displaced him and was the last hero invited to join the legendary Justice Society of America in the late 1940s. She operated out of Gotham City, also home to Batman and Green Lantern, running a florist's shop and in love with private eye Larry Lance.

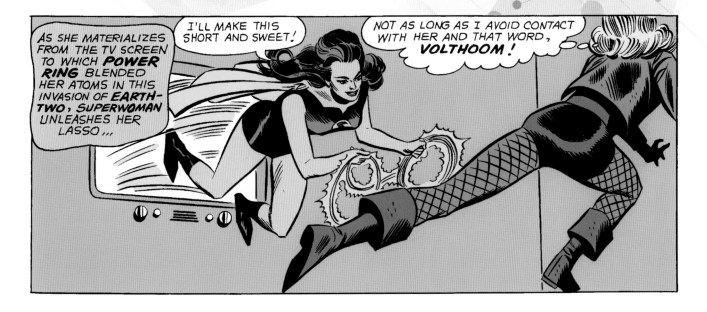

20. BLACK CANARY MOVES TO EARTH-1

On her sixth mission with the combined forces of the JLA and JSA, they were up against a cosmic entity called Aquarius. When things looked bleakest, Larry Lance sacrificed himself to prevent a ball of energy from taking out many lives. After Larry's funeral, Black Canary asked to relocate to Earth-1, home to the Justice League.

A funny thing happened as she crossed the dimensional plane: she developed sonic powers that were dubbed her Canary Cry. She at first had trouble mastering it, but with time, practice, and guidance from the Emerald Archer, she learned to control this power. As a result of their time together, a romance began to blossom, helping her move on.

21. BLACK CANARY HEALS ROY HARPER

Not long after Black Canary moved to Earth-1, Green Arrow lost his fortune, stolen out from under him by an unscrupulous employee. He grew a goatee, adopted a new uniform, and changed his worldview. Realizing there were so many ills in the world that super powers could not solve, he challenged his fellow Leaguer Green Lantern to see America's real problems.

Accompanying them on their road trip was a Guardian of the Universe and Black Canary. These hard-traveling heroes saw many dangers, from pollution to poverty. In time, they realized there were problems on other worlds, too.

Still, the biggest shock was the one closest to home. While they were away, Oliver Queen's ward Roy Harper had felt neglected. Adrift as Speedy after the Teen Titans had one of their periodic breakups and feeling abandoned, he turned to drugs for comfort. Addicted to heroin, Roy was silently screaming for help from a man too self-absorbed to notice.

Black Canary let the Emerald Crusaders pursue the drug dealers while she remained with Roy, refusing to lose another person. They didn't have much in the way of a relationship, and Dinah had never evinced much of a maternal instinct, but she stood by as Roy endured the withdrawal. Both were heroic acts, leaving each a better person.

22. BLACK CANARY BECOMES JLA CHAIRPERSON

The JLA reformed after the events of the Infinite Crisis, and Black Canary became the new team's first chair, asked to take the role by Superman, Batman, and Wonder Woman.

In time, she began to question if she were truly free to run the team, with the founding trinity observing from their interdimensional space, called the Lounge. Finally, she had enough and resigned. She was then furious to learn that Green Arrow and Green Lantern formed their own Justice League.

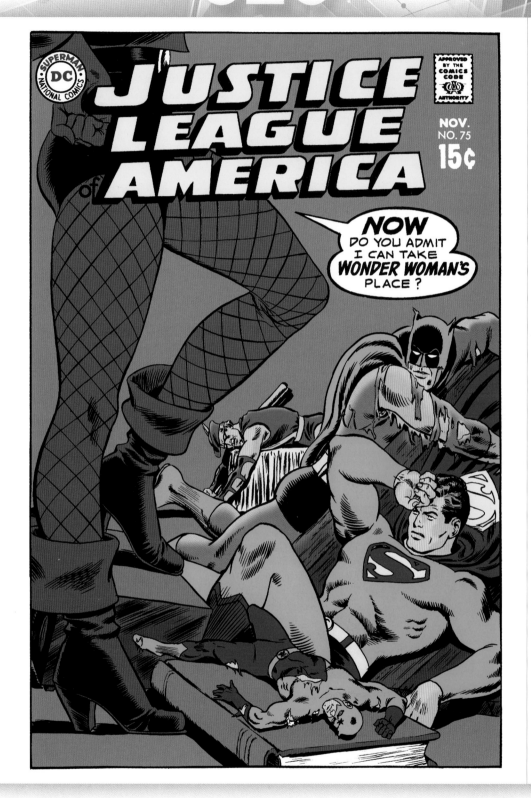

In a first for the DC Universe, Black Canary chose to permanently relocate from Earth-2 to Earth-1 in the wake of her husband's heroic death. Along the way, she gained sonic powers, making her a perfect fit for the Justice League.

Justice League of America #75, November 1969
Artists: Carmine Infantino & Murphy Anderson

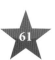

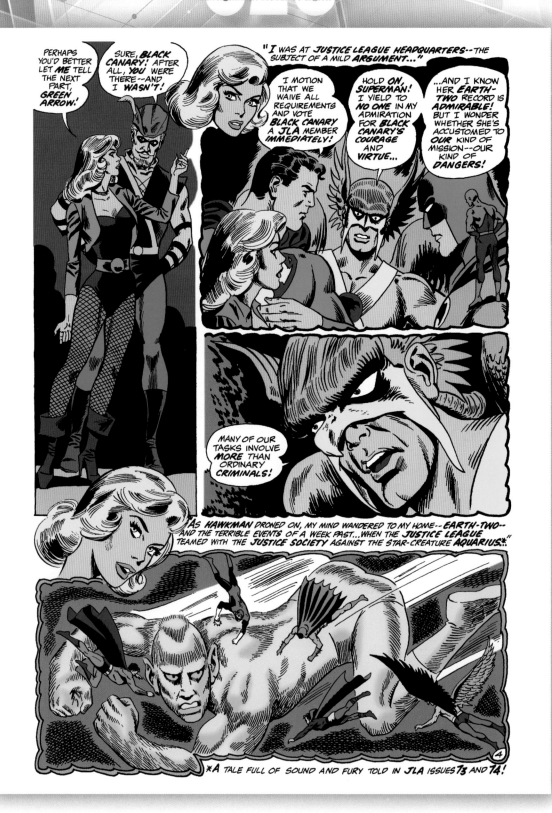

Justice League of America #75, November 1969
Writer: Dennis O'Neil *Artists:* Dick Dillin & Joe Giella

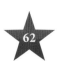

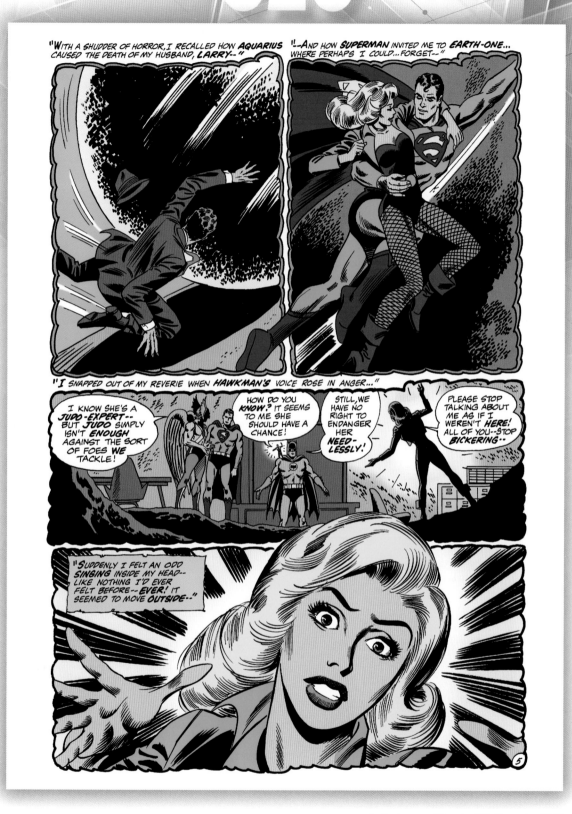

Justice League of America #75, November 1969
Writer: Dennis O'Neil Artists: Dick Dillin & Joe Giella

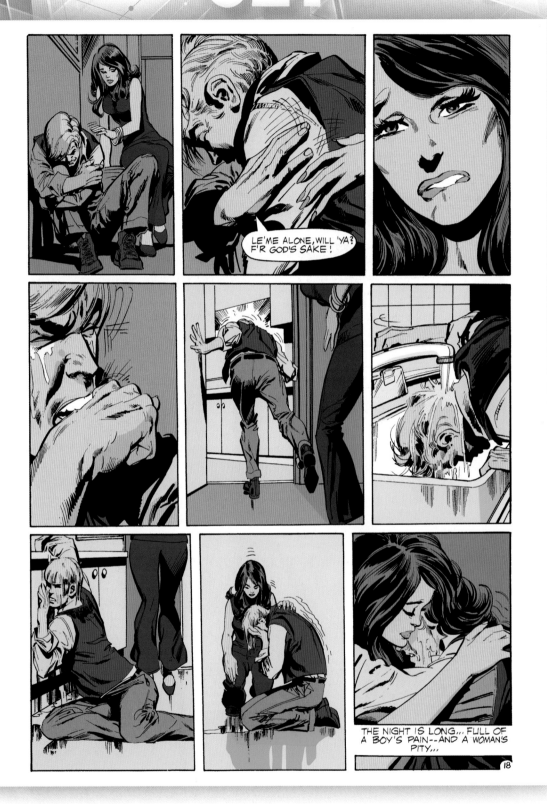

In the classic two-part story about drug abuse, Green Arrow's ward Speedy is trying to kick his heroin addiction. It falls to Black Canary to be there for him, an unusual maternal moment for the hero.

Green Lantern #86, October/November 1971
Writer: Dennis O'Neil *Artists:* Neal Adams & Dick Giordano

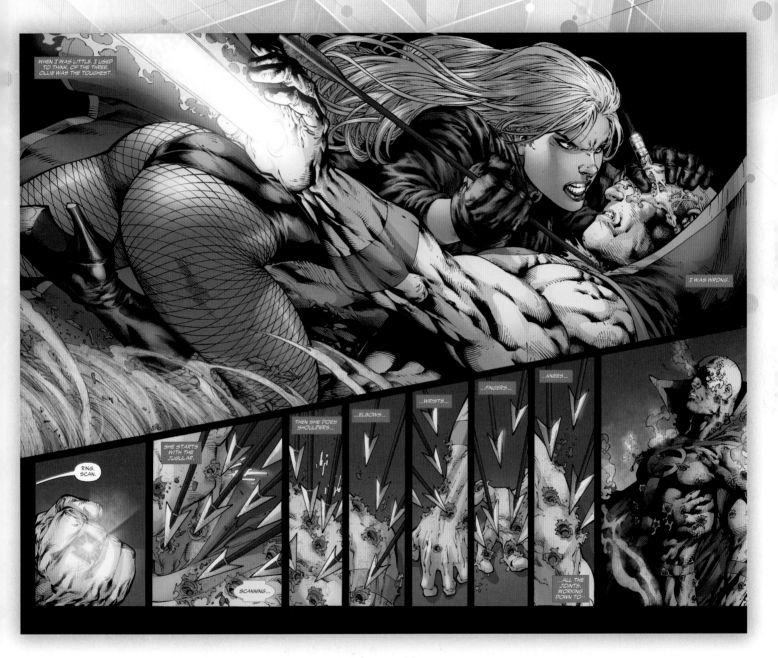

According to writer Brad Meltzer's notes, this sequence helped convince him once and for all that Black Canary deserved her spot as chair of the newly formed Justice League of America.

Justice League of America #3, December 2006
Writer: Brad Meltzer *Artists:* Ed Benes, Mariah Benes & Sandra Hope

BUMBLEBEE

KAREN BEECHER WAS A NEW YORK LIBRARIAN BY DAY AND A BUDDING SCIENCE COLLEGE student at night when she met Mal Duncan. They began dating, and he revealed that he had been a member of the just-disbanded Teen Titans. He was distraught over feelings of inadequacy compared with the more powerful members and was at loose ends. As their friendship evolved into something deeper and more meaningful, she used her genius to create a sonic weapon known as Gabriel's Horn. When Doctor Light lured him and other Titans back to their headquarters, he dubbed himself Herald and used the Horn to open a spatial distortion that rid them of Light's threat.

23. FROM GIRLFRIEND TO HERO

In the pre-Crisis account, the Gabriel's Horn was a celestial artifact that Mal acquired after the reformation of the Titans. Frustrated that even this object failed to earn her boyfriend the respect that he deserved, Karen designed and constructed a super-suit of her own, inspired by bees, so it came with both wings and stinger-like weaponry. She intended to attack the team and let Mal be the hero, but things backfired when the Titans rallied around their friend.

She revealed herself to Mal and then apologized to the team, which warmly welcomed her. As a result, Bumblebee was on hand as the Titans opened the Gabriel's Horn nightclub as a front for its Farmingdale, Long Island, headquarters. When the Titans opened a West Coast branch, it was inevitable that she would become Bumblebee on a regular basis.

During the events of the Infinite Crisis, Bumblebee was irradiated with an unusual energy that reduced her to six inches in height, requiring medicine to maintain her heart. Thanks to the efforts of the man called Chief, Mal and Karen shifted allegiances to the Doom Patrol.

After reality was rewritten by Flashpoint, Karen continued to adventure as Bumblebee but apparently was never trapped at a small size. She and Mal continued their marriage without conflict and often worked with the Titans while doting on their young daughter.

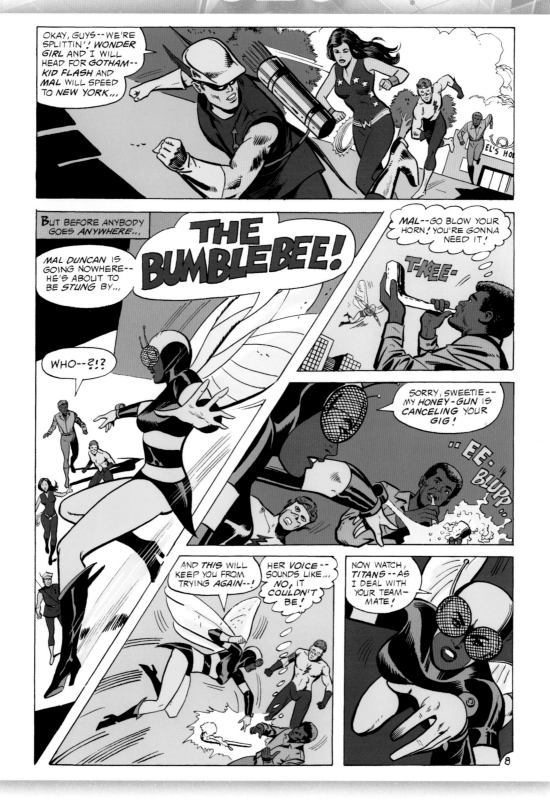

Donning her Bumblebee outfit to support her lover, Mal Duncan, Karen came to enjoy being a hero and continued adventuring alongside the Teen Titans.

Teen Titans #48, June 1977
Writer: Bob Rozakis *Artists:* Jose Delbo & Vince Colletta

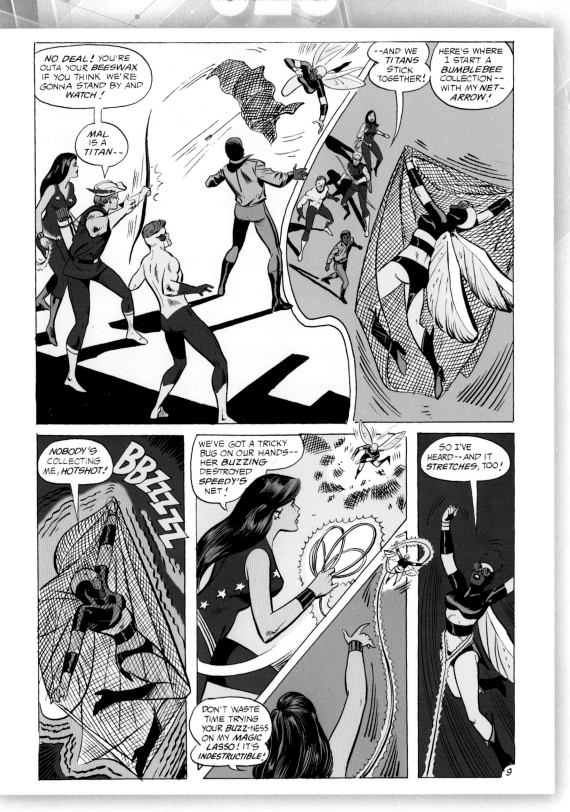

Teen Titans #48, June 1977
Writer: Bob Rozakis *Artists:* Jose Delbo & Vince Colletta

CATWOMAN

SELINA KYLE HAS MORE LIVES THAN A CAT AND EVEN MORE PERSONAS. REGARDLESS OF which reality is visited, the attraction between the Bat and the Cat waxes and wanes but is never far from sight. As a result, the criminal is sometimes the hero and at other times succumbs to fickle emotions.

When she first confronted Batman, on Earth-2 in 1940, she was the Cat, a jewel thief who commanded attention from the masked detective. She soon returned, initially wearing a gown and cat's-head mask and assuming the new alias of the Catwoman. Repeatedly, she and the Batman opposed each other; both acknowledging that there was romantic tension underlying each meeting.

Finally, in the 1950s, they slowly withdrew from their battle and gave in to their romantic feelings. Bruce Wayne and Selina Kyle were married in a lavish ceremony that was attended by a large gathering. Some years later, Selina gave birth to a daughter, Helena, and the three settled into a happy family situation. This idyll was shattered when Selina was blackmailed into committing a crime, which resulted in her death.

24. CATWOMAN GOES STRAIGHT

On Earth-1, Selina Kyle became Catwoman and enjoyed many successes as a cat burglar and frequent opponent of Batman and Robin.

As Catwoman's life of crime continued, she went so far as to murder to accomplish her tasks. Eventually, Selina Kyle worked on reforming her wicked ways and even engaged in a romance with Bruce Wayne. Batman's alter ego encouraged the relationship in the hopes that it would reform her, which worked until Earth-1 was erased.

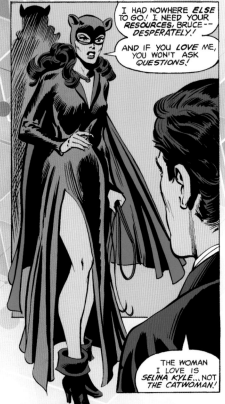

In the wake of parallel worlds being melded into one during the Crisis on Infinite Earths, Selina's life changed dramatically. This Selina was a prostitute and dominatrix, performing in a catsuit with a whip and a jaundiced view toward society. When news reports first told of a man dressed as a bat, she was intrigued. She modified one of her catsuits and entered Batman's life for the first time.

Her adventures over the next couple of years paralleled those of her Earth-1 counterpart, complete with a variety of costumes. The key distinction was that this Selina was defeated but never apprehended. After the Justice League discovered her tenuous link to the Secret Society of Super-Villains, Zatanna altered Catwoman's memories. She retired her costumed identity and, as Selina, started up an affair with Bruce Wayne, only to have it collapse when his trust in her wavered due to Batman's mistaken belief that she'd returned to crime. Resuming her Catwoman persona, Selina remained a hero, deducing that Bruce was Batman and gradually rekindling their romance.

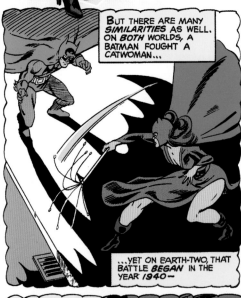

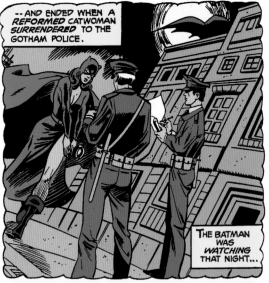

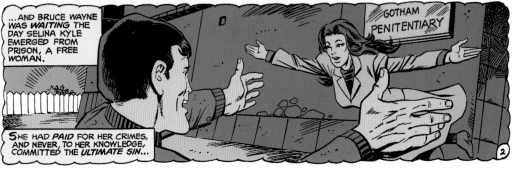

decided this was her refuge. She would become its defender, and woe to any cop, cape, or villain who tried to cross her there.

Catwoman continued her burglaries, as much for the thrill as for the money. She found herself fighting against the Dark Knight as often as she did with him. As a result, they began their long-anticipated romance, leading Batman to actually unmask, ready to share everything with her.

25. CATWOMAN TAKES DOWN PROMETHEUS

Along the way, she appeared to revise her moral code based on the situation in which she found herself. On the one hand, she had a tender spot in her heart for orphans, such as the young teen runaway Arizona whom she adopted, but also thought nothing of working alongside killers such as Bane. In one instance, she disguised herself and accompanied the first public tour of the JLA's Watchtower headquarters on the moon. She intended to see the sights and steal a souvenir but wound up being in the right place at the right time to thwart Prometheus's plan to destroy the team. It was her first heroic action in some time, which may have changed her attitude.

Selina wound up fighting alongside Batman as he opposed Lex Luthor's attempts to gain control of real estate during Gotham's reconstruction. Still, she was arrested by Commissioner Gordon for older crimes, but she easily broke out of jail.

26. CATWOMAN PROTECTS EAST END

Slam Bradley, a private investigator, tracked down Selina, who had settled in the East End and had

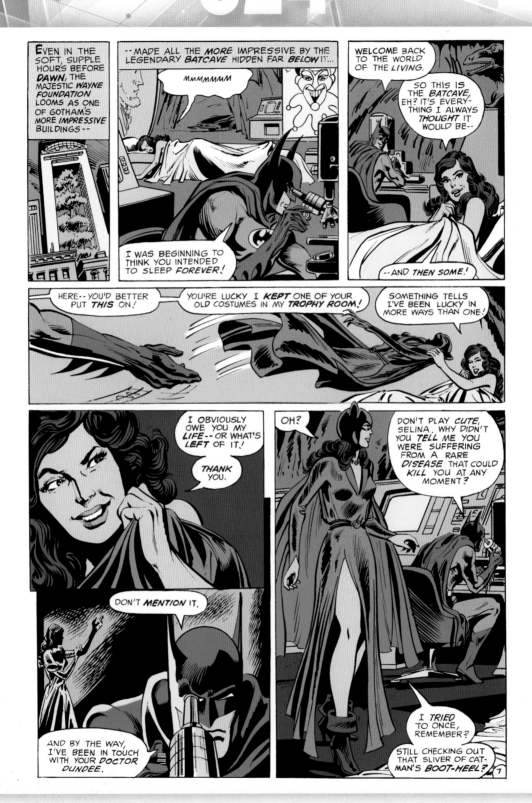

Selina Kyle sought out Bruce Wayne, as she wanted to make amends for her criminal past, never realizing the man she wanted help from was also Batman. Still, their romance should have been a clue.

Batman #324, June 1980
Writer: Len Wein *Artists:* Irv Novick & Bob Smith

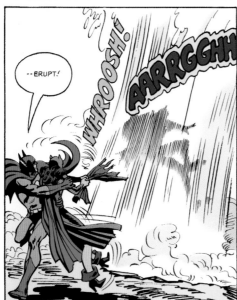

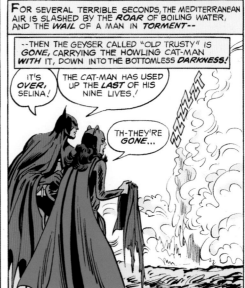

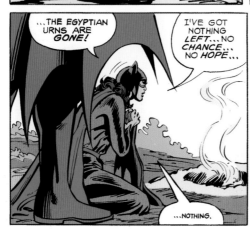

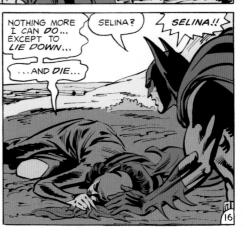

Batman #324, June 1980
Writer: Len Wein *Artists:* Irv Novick & Bob Smith

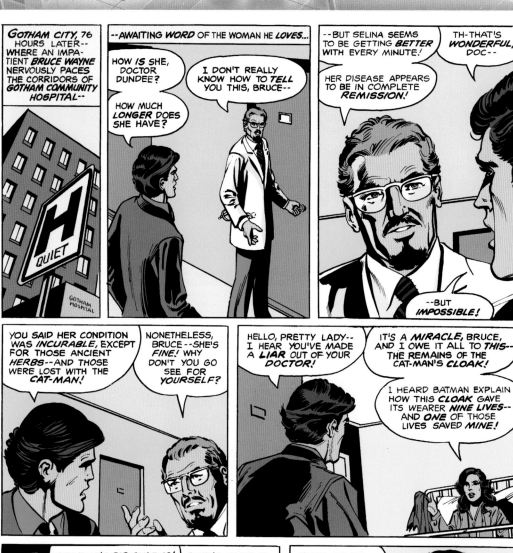

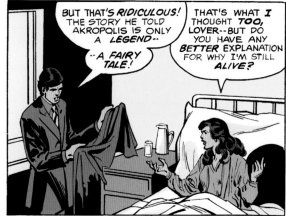

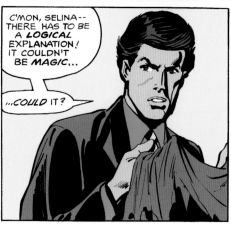

Batman #324, June 1980
Writer: Len Wein *Artists:* Irv Novick & Bob Smith

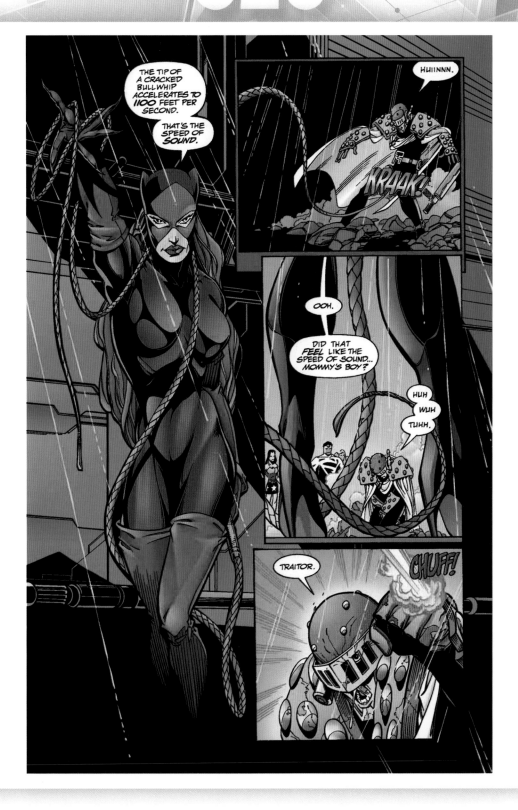

Stealing something from under the JLA's noses was too tempting for Catwoman, who disguised herself and visited the moon. She happened to be the X factor Prometheus could never have anticipated when he attacked.

JLA #17, April 1998

Writer: Grant Morrison *Artists:* Arnie Jorgensen & Mark Pennington

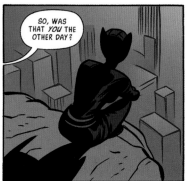

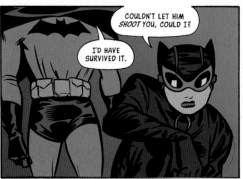

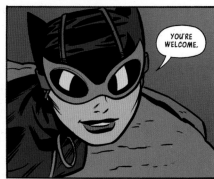

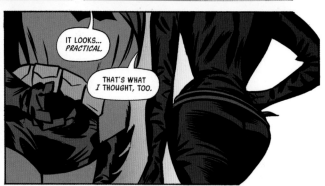

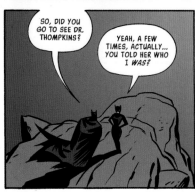

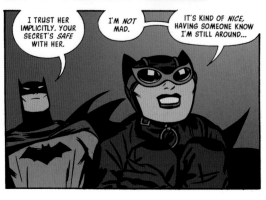

Her beloved Gotham City had seen enough, so Selina Kyle determined to become the protector of the East End, ensuring its inhabitants could live without fear. Of course, she still stole for the thrill of it.

Catwoman #1, January 2002
Writer: Ed Brubaker *Artists:* Darwyn Cooke & Mike Allred

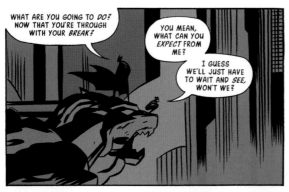

WHAT ARE YOU GOING TO *DO?* NOW THAT YOU'RE THROUGH WITH YOUR *BREAK?*

YOU MEAN, WHAT CAN YOU *EXPECT* FROM ME?

I GUESS WE'LL JUST HAVE TO WAIT AND *SEE,* WON'T WE?

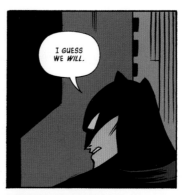

I GUESS WE *WILL.*

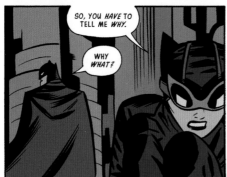

SO, YOU *HAVE* TO TELL ME *WHY.*

WHY *WHAT?*

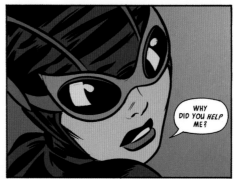

WHY DID YOU *HELP* ME?

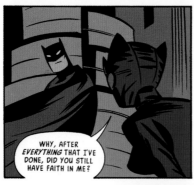

WHY, AFTER *EVERYTHING* THAT I'VE DONE, DID YOU STILL HAVE FAITH IN ME?

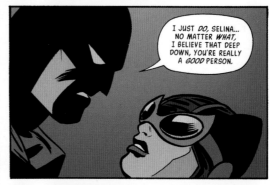

I JUST *DO,* SELINA... NO MATTER *WHAT,* I BELIEVE THAT DEEP DOWN, YOU'RE REALLY A *GOOD* PERSON.

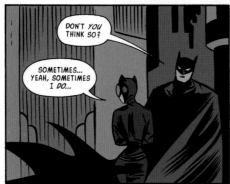

DON'T *YOU* THINK SO?

SOMETIMES... YEAH, SOMETIMES I *DO...*

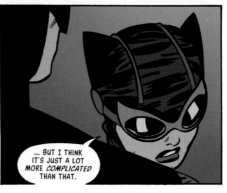

... BUT I THINK IT'S JUST A LOT MORE *COMPLICATED* THAN THAT.

Catwoman #1, January 2002
Writer: Ed Brubaker *Artists:* Darwyn Cooke & Mike Allred

DOCTOR LIGHT

KIMIYO HOSHI NEVER IMAGINED HERSELF DOING ANYTHING BUT STUDYING THE STARS. AN accomplished astronomer in Japan, and mother of two, she was fascinated by the unknown. As she examined a theretofore unknown phenomenon, the men she supervised grew nervous, so she ordered them away. Shortly thereafter, a beam of energy struck the facility, enveloping Hoshi. Rather than kill her, she was transformed, now able to manipulate light.

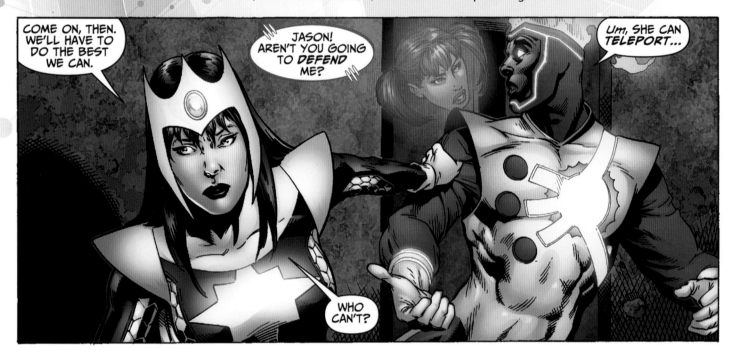

Later, she learned that this was a deliberate bolt of power sent from the Vegan star system by the Monitor, who needed a champion in his battle with the Anti-Monitor. However, at that moment, she had no idea what had happened to her. She did, though, recognize that the cosmos was in danger and Earth needed defending. She put on a protective costume and took the name Doctor Light, despite its being in use by an American criminal.

Assigned by the Monitor to guard one of the vibrational tuning forks to protect Earth, she found herself in conflict with Starfire and Halo, who thought the machine should be destroyed. The language barrier kept them unable to communicate until Superman arrived and provided translation. When the misunderstandings cleared up and she acquired English, Doctor Light was welcomed to the ranks of Earth's defenders. She accompanied its most powerful members to the anti-matter universe to stop the Anti-Monitor. When Superman was knocked unconscious in his battle, Doctor Light rescued him, while Supergirl gave her life to ensure her cousin survived.

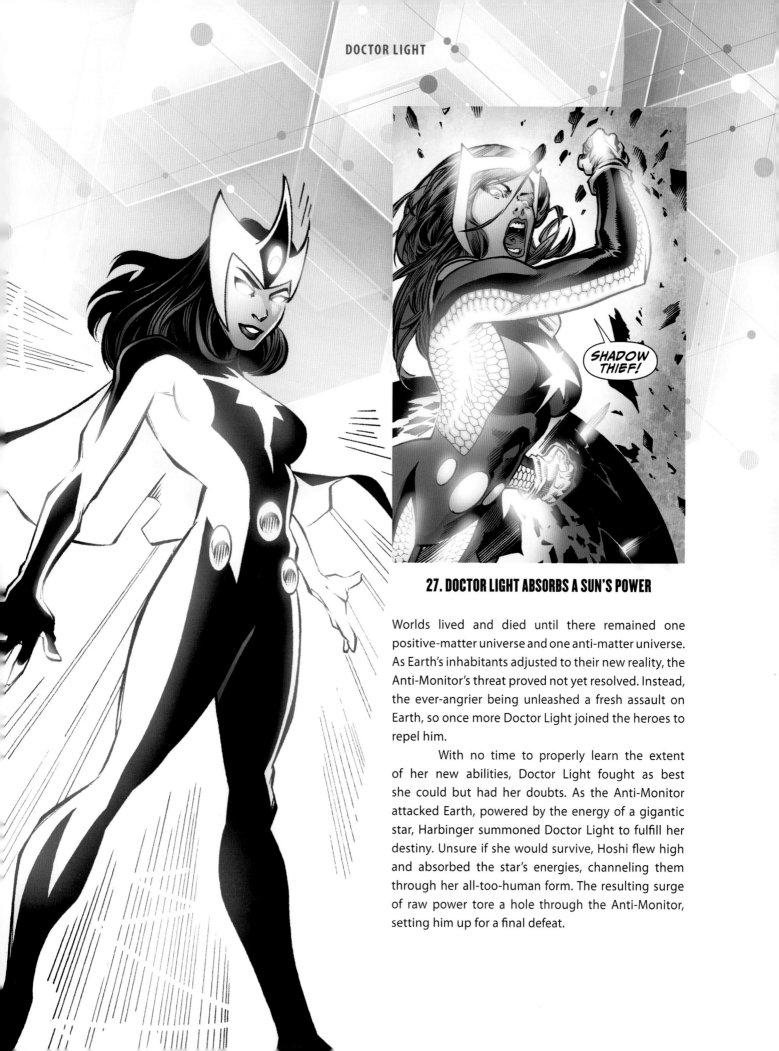

SHADOW THIEF!

27. DOCTOR LIGHT ABSORBS A SUN'S POWER

Worlds lived and died until there remained one positive-matter universe and one anti-matter universe. As Earth's inhabitants adjusted to their new reality, the Anti-Monitor's threat proved not yet resolved. Instead, the ever-angrier being unleashed a fresh assault on Earth, so once more Doctor Light joined the heroes to repel him.

With no time to properly learn the extent of her new abilities, Doctor Light fought as best she could but had her doubts. As the Anti-Monitor attacked Earth, powered by the energy of a gigantic star, Harbinger summoned Doctor Light to fulfill her destiny. Unsure if she would survive, Hoshi flew high and absorbed the star's energies, channeling them through her all-too-human form. The resulting surge of raw power tore a hole through the Anti-Monitor, setting him up for a final defeat.

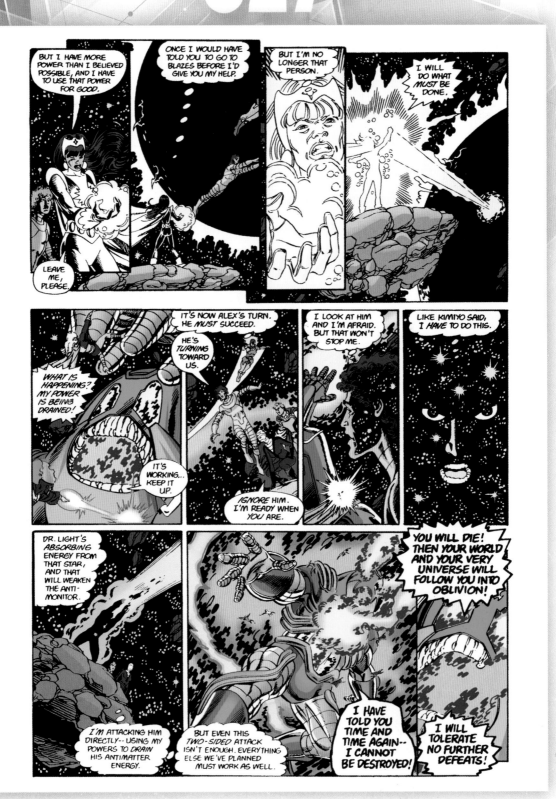

Unsure if she could survive absorbing so much stellar power, Doctor Light channels a star's energy to interrupt the Anti-Monitor's assault on Earth.

Crisis on Infinite Earths #12, March 1986
Writer: Marv Wolfman *Artists:* George Pérez & Jerry Ordway

DONNA TROY

SHE WAS THE GIRL WHO SHOULDN'T BE. ORIGINALLY, WONDER GIRL WAS PRINCESS DIANA of Paradise Island, in stories writer Robert Kanigher told about her teen years. Apparently, Bob Haney didn't realize this when he was asked to write a story featuring teen heroes under the title *Teen Titans*. Readers were delighted and confused, and editor George Kashdan shrugged it all off as long as the title sold and the stories were good.

Fan turned professional writer Marv Wolfman, though, was irritated and felt this character needed an origin. With artist Gil Kane, he told a 1968 story that explained that a young girl was rescued by Wonder Woman in a fire and, with no family found, she took her home. There, she had Paula von Gunther use the Purple Healing Ray to give the teen powers of her own. Donning a red unitard, the teen adopted the name Donna Troy, and ventured forth.

28. WHO IS DONNA TROY?

Wonder Girl remained with the Teen Titans through various incarnations, forging close friendships with the team, notably with Dick Grayson.

Wolfman decided to revisit the origin he provided the character and, with artist George Pérez, added a new chapter to her past. Robin investigated the fire where Donna was rescued and found clues, which led him to Dorothy Hinckley, who'd given birth to Donna while still a teen herself. Donna was adopted by Carl and Fay Stacey, although Carl died in an accident at work. Being a single mother was more than Fay could handle, so she put the child up for adoption, only to have the toddler caught up in a child-selling ring. It was with these criminals that the child found herself trapped in the fire. Further detective work by Robin led him to Fay, who had happily remarried, this time to Hank Evans. They had two children of their own, Cindy and Jerry—suddenly giving Donna a family.

Flashpoint cleaned the slate of subsequent rewrites of her history and let the story be told anew. Now she was created by a sorceress, Derinoe, intending this life-form to destroy Diana. When the Amazons discovered the plot, they defeated Derinoe and took the child, raising her on Themyscira and implanting memories of the fire and rescue by Wonder Woman. She left for Man's World, took the name Wonder Girl, and adventured with the Teen Titans. In time, she learned of these planted memories and was horrified to realize she was created to be a weapon. Her friends on the Titans stood beside her as she forged her own destiny.

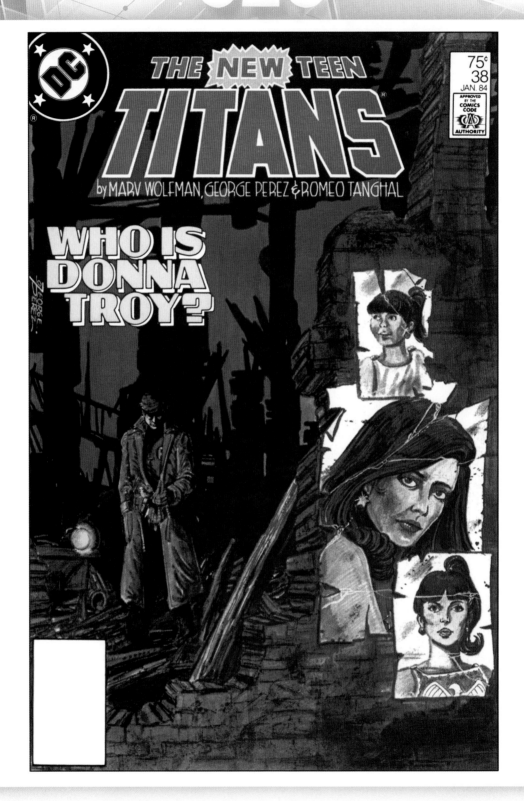

A long-running comic book conundrum is just the kind of mystery Dick Grayson is suited to solve, the perfect wedding present for his close friend Donna Troy.

New Teen Titans #38, January 1984
Artist: George Pérez

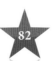

New Teen Titans #38, January 1984
Writer: Marv Wolfman *Artists:* George Pérez & Romeo Tanghal

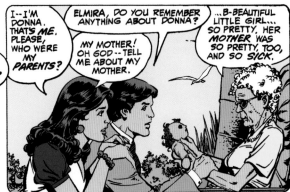

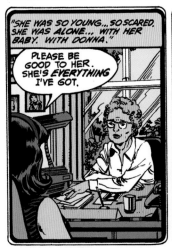

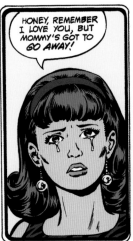

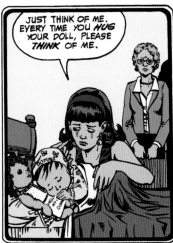

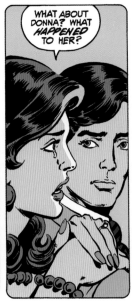

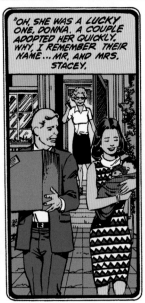

New Teen Titans #38, January 1984
Writer: Marv Wolfman *Artists:* George Pérez & Romeo Tanghal

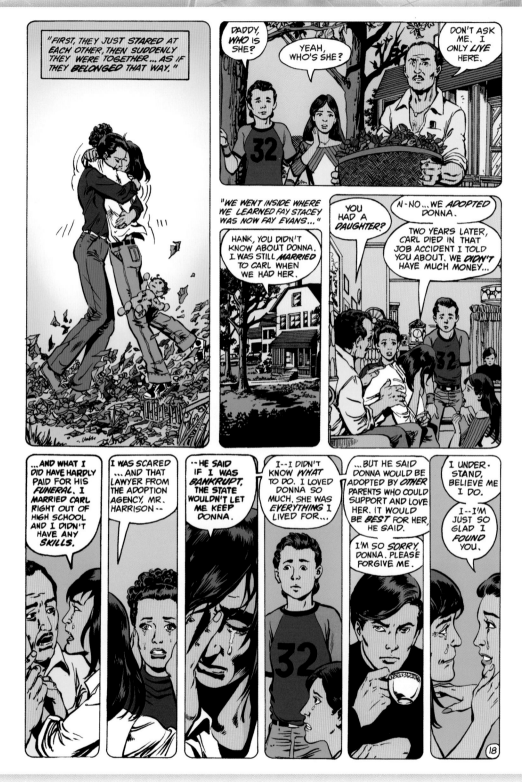

New Teen Titans #38, January 1984
Writer: Marv Wolfman *Artists:* George Pérez & Romeo Tanghal

DOVE

29. DAWN GRANGER INHERITS THE POWER OF DOVE

The law of conservation of energy states that one form of energy can be changed to another form of energy without any loss. During the Crisis on Infinite Earths, there was chaos around the globe. In London, Marie Granger was held hostage by terrorists at the United States embassy. Her daughter Dawn felt powerless, when a voice offered her the ability to handle the matter on her own. She agreed, said, "Dove," and was transformed into a hero. After rescuing her mother, she learned that the first Dove had just died in New York. Guilt wracked her; she felt she had taken his power, causing his death.

Traveling to America, Dawn attended the memorial service for the costumed champion and spotted Hawk, Dove's partner. She followed Hawk (Hank Hall) to Georgetown University, and learned that Dove had been Hank's brother, Don Hall, and that Hank was growing increasingly erratic without his brother's presence. She revealed herself to Hank, but he rejected her help, until they needed each other to stop the threat of Kestrel, an agent for the Lords of Chaos. At this point, she learned that she was given the power only because Don had died and the energy was free to relocate.

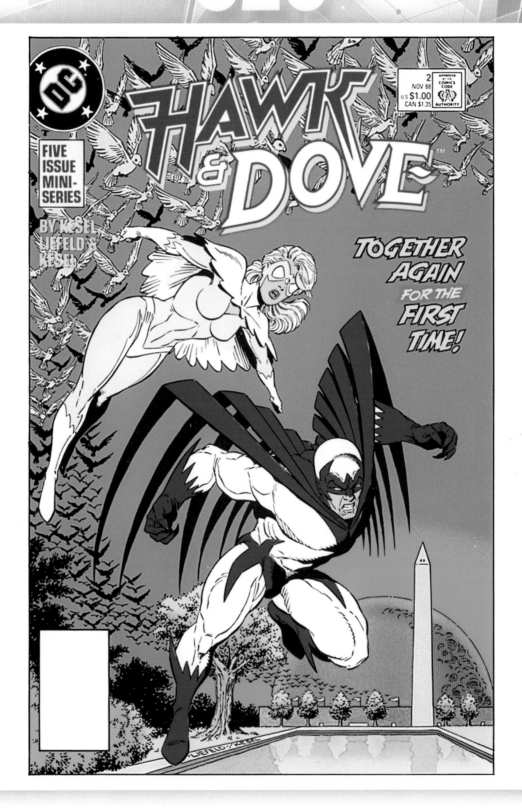

Dawn recounts the events that led to her gaining powers from a mysterious voice, the true nature of which remain hidden from her for some time.

Hawk & Dove #2, November 1988
Artists: Rob Liefeld & Karl Kesel

ELASTI-GIRL

THERE WERE FEW ACTORS MORE POPULAR THAN RITA FARR, WHO WORKED ON A WIDE range of films, including a series of chillers that were a favorite of the Martian Manhunter. While on location in Africa, she was exposed to odd volcanic gases and passed out. When she awoke, Rita realized her body had changed and could now expand or contract at will. While her limits were not known, she was seen at hundreds of feet tall and at microscopic size.

Shunned by Hollywood for now being a "freak," Rita was despondent until approached by Niles Caulder, known as the Chief. He offered her a place with other freaks, to form the Doom Patrol. Under his tutelage, she managed to gain greater control over her powers, so she could retain her normal size while enlarging or extending a single limb. She worked well with Robotman and Negative Man, the latter of whom had feelings for her.

30. SAVING THE STATUE OF LIBERTY

Early in the Doom Patrol's existence, a series of scientific thefts tipped the team off to the plans of the Brotherhood of Evil, led by the Brain, and operating in Europe. The thefts were committed by Morden, operating a giant robot. They were done as an audition to join the Brain, Monsieur Mallah, and Madame Rouge. Once Morden was admitted, the Brain sent him and Mallah back to the United States to steal the Statue of Liberty in order to ransom it to fund their future plans.

Only Elasti-Girl was able to fight the oversize robot and protect the statue, allowing her teammates to tackle the human operator and his gorilla compatriot. From that moment on, the Doom Patrol and the Brotherhood were mortal enemies, until the day came when a small New England village was threatened. The Doom Patrol sacrificed their lives to protect the innocent.

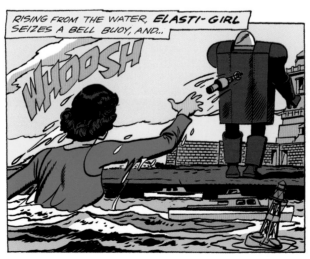

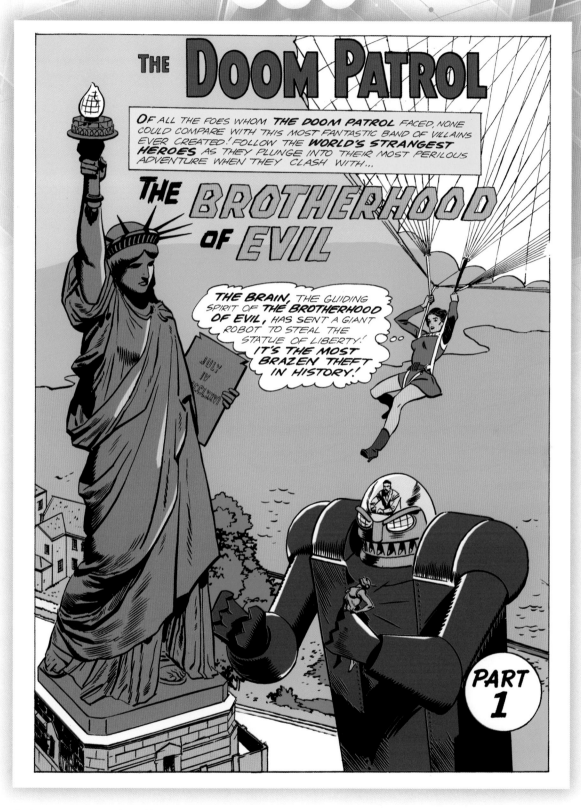

On her own, against the odds, Rita Farr, Elasti-Girl, attempts to preserve the Statue of Liberty, which has become a pawn in the Brotherhood of Evil's plans.

Doom Patrol #86, March 1964
Writer: Arnold Drake *Artist:* Bruno Premiani

ENCHANTRESS

FREELANCE ARTIST JUNE MOONE ATTENDED A COSTUME PARTY HELD AT AN OLD CASTLE, where she was overcome by a demon called Dzamor. As she said the words "the Enchantress," she transformed into a powerful raven-haired sorcerer. She struggled with her newfound powers and split persona, fighting villains, creatures, and even Supergirl. Succumbing to the Enchantress's side, she even operated as a member of the Forgotten Villains, challenging Superman.

Once reality was altered by the Crisis on Infinite Earths, June sought help in managing her Enchantress half and was recruited to work with Amanda Waller's Task Force X in exchange for aid. She proved her worth on their first mission, dispatching Brimstone, a creature created by Darkseid. Despite surrounding herself with a team, June struggled more and more to control her occult twin. Waller tasked Deadshot with taking her out should she prove uncontrollable. In time, though, Madame Xanadu diagnosed the issue—June had begun using her power before learning how to control it, causing an imbalance.

31. JUNE VERSUS DZAMOR

On a mission to the Nightshade dimension, June discovers the truth: she is not a split personality, but her body is now shared with the demonic entity Dzamor. Worse, Dzamor's brother is the Incubus, who has taken over the body of Nightshade's brother. During the conflict, the Incubus tears Dzamor from June, leaving the woman powerless. Once they return to Earth, June Moone leaves the team.

In the post-Flashpoint reality, June Moone was the human host to a magical entity known as the Enchantress. Here, she was less in control, so when the Enchantress created hundreds of mindless duplicates, the world was imperiled. This prompted the formation of Justice League Dark by Madame Xanadu, and in the end, John Constantine bound the Enchantress to June, sacrificing one life to save the world.

Since then, she has resumed work with the Suicide Squad but proved susceptible to Maxwell Lord's powerful telepathy. While with the Squad, she began a relationship with Killer Croc.

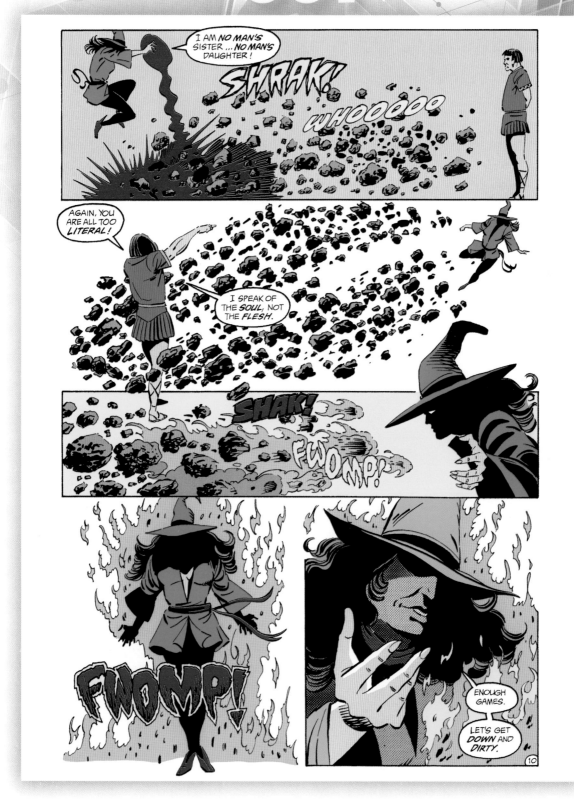

June Moone thought she was a split personality but was horrified to discover she had been sharing her body with an extradimensional demon, Dzamor.

Suicide Squad #15, July 1988
Writer: John Ostrander *Artists:* Luke McDonnell & Bob Lewis

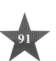

FIRE & ICE

BEATRIZ DA COSTA, PRESIDENT OF THE BRAZILIAN BRANCH OF WAYNE ENTERPRISES, WAS given her power over fire as a result of Brazilian mysticism. Well known in her homeland, the Green Fury also shared several adventures abroad with the Justice League. Soon after, she was recruited to the Global Guardians, where she met Icemaiden, and a close friendship formed. In the wake of reality being altered during the Crisis on Infinite Earths, she was now Beatriz Bonilla da Costa, a flirtatious top model who became a secret agent for her native Abin (Agência Brasileira de Inteligência, the Brazilian Intelligence Agency). While on a mission, she was exposed to a pyroplasmic explosion, which activated her metagene and gave her the green fire powers. She adopted the hero name Green Flame and joined the Guardians.

Tora Olafsdotter, with her natural ability to create and manipulate ice, was born a princess among an isolated tribe of Norsemen known as the Romanifolket. She was raised and trained in secret, keeping her from a powerful grandfather who wished to use her for his own wicked goals. Unfortunately, he found his family, and Tora let loose to defend them, unintentionally killing her grandfather, father, and other members of her clan. The psychological trauma caused her to contain the violence within her, and Tora developed a shy persona.

In time, the teen was introduced to the enigmatic Doctor Mist, who recruited her to join his Global Guardians, taking the code name Icemaiden. When she met Beatriz, a close bond was formed despite their oppositional abilities.

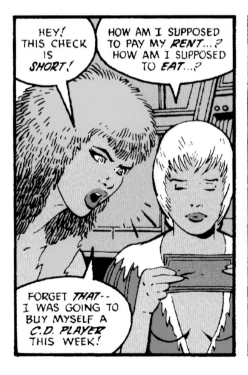

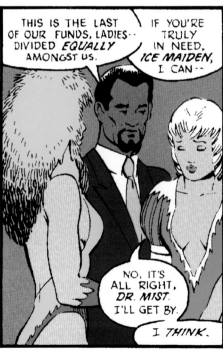

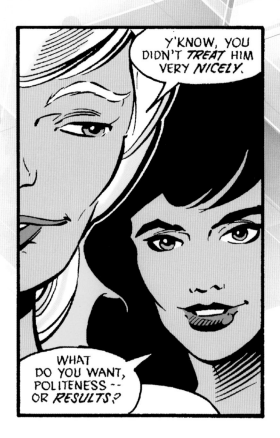

33. ICE VERSUS STARRO

Starro, the intergalactic conqueror, repeatedly attempted to add Earth to its list of worlds, but the Justice League was always in the way. In one gambit, the creature told the team it was dying and wished to return home. Once launched aboard a spacecraft, Starro reached the vacuum of space, where it detonated the ship, shattering its body and forming spore versions of itself that fell across Europe. This led Starro to amass an army of telepathically controlled humans, including powerful members of the League. With dwindling allies, Ice finally stopped the threat to all life on Earth by locating and freezing the original Starro body, severing the telepathic link.

32. JOINING THE JUSTICE LEAGUE

There came a time when the United Nations withdrew their support in favor of Justice League International, and the Guardians disbanded. The team was their life, and they felt adrift until Beatriz suggested they just change teams.

The pair traveled to New York and showed up at the Justice League's main embassy, knocked on the door, and asked to join. Oberon, acting as the team's majordomo, didn't quite know what to do with them, so they were kept around, just waiting. As it happened, Black Canary had just resigned from the team and other members had been abducted, leaving the squad underpowered. As a result, the two were brought along on a provisional basis but quickly proved their worth. To acknowledge their status, Green Flame changed her name to Fire, and Tora dropped the "maiden" from her code name.

Not long after joining the JLI, a metagene bomb was detonated during an alien invasion of Earth and Fire's powers increased but proved maddeningly erratic.

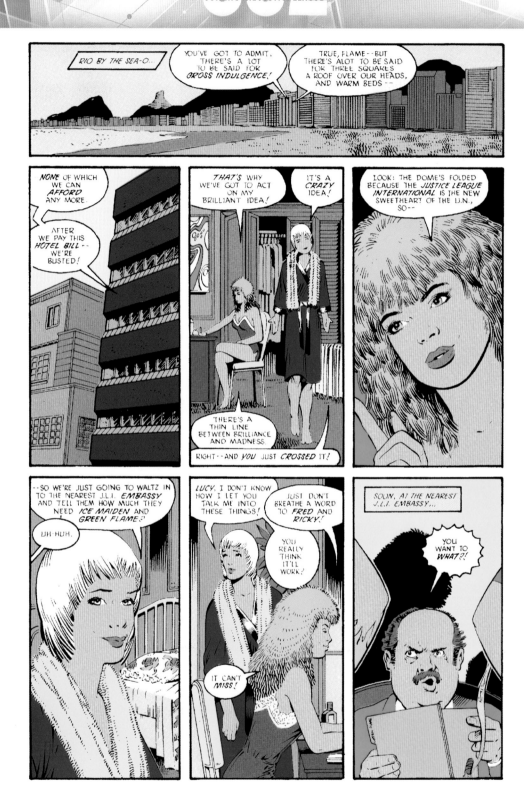

Soon after receiving United Nations sanction, the Justice League received unexpected applicants, never imagining that the pair would prove to be two of their staunchest members.

Justice League International #12, April 1988

Writers: Keith Giffen & J. M. DeMatteis *Artists:* Kevin Maguire & Al Gordon

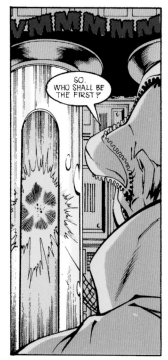
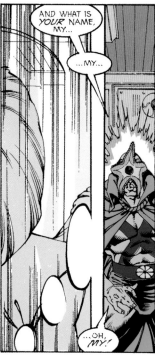
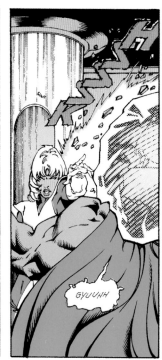
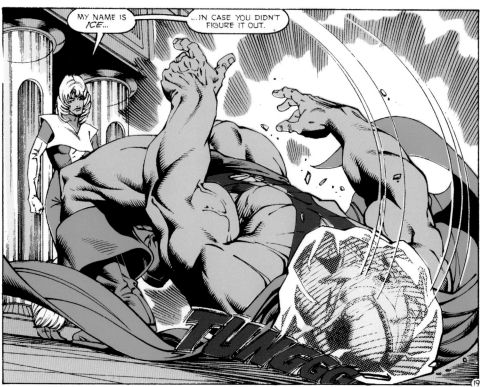

Most of the European branch of the Justice League has been in Starro's thrall, and the alien creature threatens to kill everyone unless the team submits. Ice, though, is not going to let that happen.

Justice League Europe #28, July 1991

Writers: Keith Giffen & Gerard Jones *Artists:* Bart Sears & Randy Elliott

GOTHAM CITY SIRENS

IN THE WAKE OF CATWOMAN'S BODY BEING RAVAGED BY HUSH, WHO WENT SO FAR AS to cut out her heart only to have her healed by Zatanna's magic, the feline criminal realized there were limitations to what she could do. During a confrontation with Boneblaster, she was nearly killed, only to be rescued by Poison Ivy. When Poison Ivy took her back to the Riddler's lair, which she had commandeered, Catwoman was surprised to see Harley Quinn also present. They formed a pact, agreeing to watch one another's back.

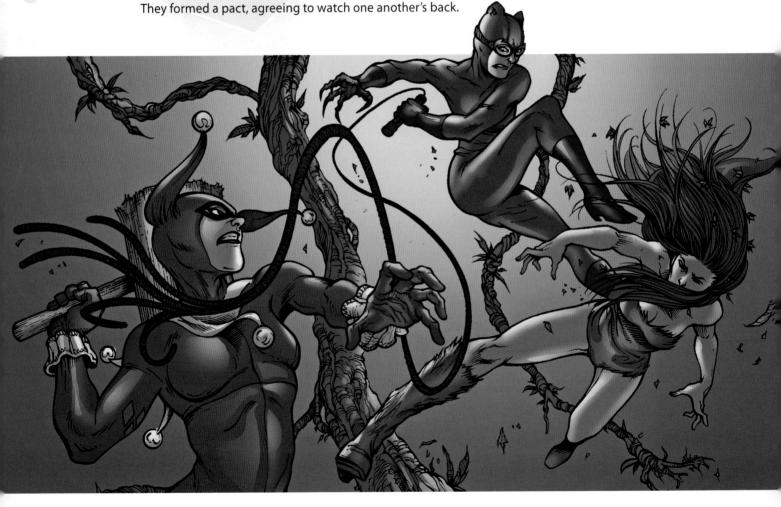

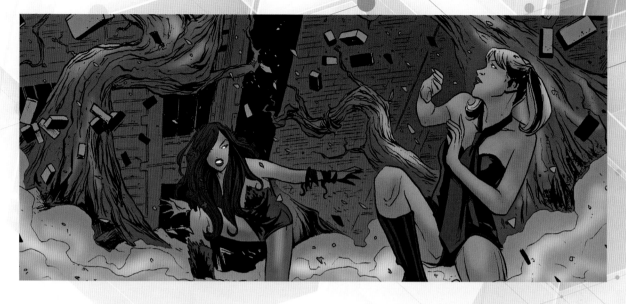

34. TO SAVE CATWOMAN

Senpai abducts Catwoman in the hopes of learning Batman's alter ego, causing Harley and Ivy to collaborate with Ra's al Ghul's daughter Talia and Zatanna to rescue her. In the aftermath, Talia tries to convince the Maid of Magic to erase the crucial information from Catwoman's memory, but Zatanna balks when she realizes it had more to do with Talia's jealousy that a romantic rival knew the secret.

35. PROTECTING HER PARTNERS

At one point, Harley decides to exact vengeance from the Joker for his treatment of her, and it results in both her and Ivy being locked in Arkham Asylum. They both run on Catwoman for letting this happen when it is 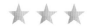 revealed that since the Sirens formed, she had been working with Batman to truly protect them, steering them from breaking the law and instead coaxing their better selves to the surface.

Just as Batman is ready to apprehend the three, Catwoman helps the women escape, and they go their own ways.

★ ★ ★

In the Rebirth reality, none of these events happened despite the trio's paths constantly crisscrossing.

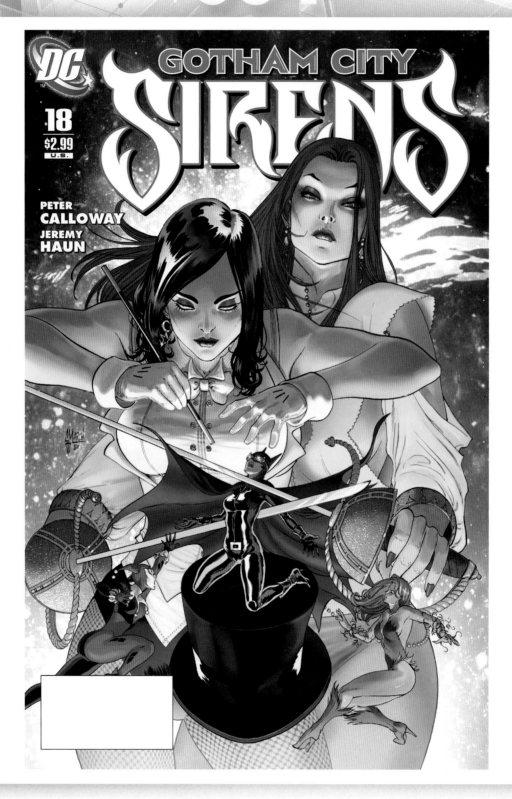

Zatanna and Talia come to Catwoman's aid and then argue over tampering with her memories of Batman's secret identity.

Gotham City Sirens #18, February 2011
Artist: Guillem March

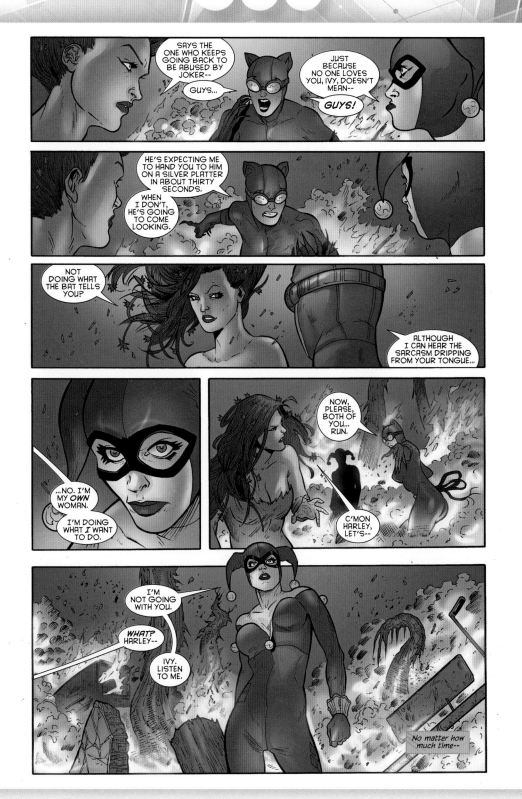

Despite the fragile bonds that had been formed during their alliance, each member of the Sirens had her own agenda that seemingly took precedence over the collective's needs.

Gotham City Sirens #26, October 2011

Writer: Peter Calloway *Artists:* Andres Guinaldo, Lorenzo Ruggiero & Raul Fernandez

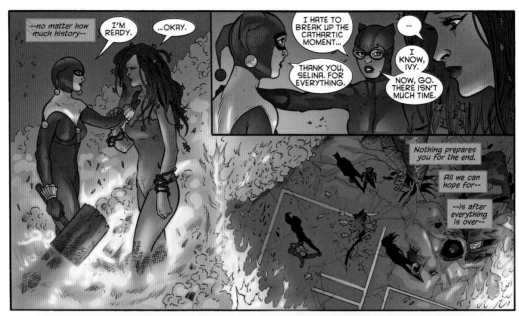

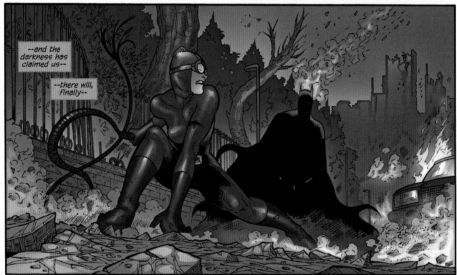

the end

Gotham City Sirens #26, October 2011
Writer: Peter Calloway *Artists:* Andres Guinaldo, Lorenzo Ruggiero & Raul Fernandez

GREEN LANTERN

AGORAPHOBIC JESSICA CRUZ REMAINED IN HER BEDROOM FOR FOUR YEARS AFTER accidentally encountering mobsters burying a body while on a hunting trip. They executed Jessica's friends as she fled for safety. There she remained until the magical Ring of Volthoom chose her to be its next bearer, after the previous host, a member of Earth-3's Crime Syndicate, was killed in battle with Sinestro. Jessica proved a most unwilling host, and the powerful Volthoom possessed her body, sending her on a rampage that was only stopped thanks to the combined efforts of the Justice League and Doom Patrol. Batman got Jessica to calm down long enough to exhort some will over the ring, while the Flash summoned Hal Jordan to teach her how to control the weapon.

Uneasily, Jessica gathered some control, unable to form the elegant constructs that other Green Lanterns managed. She continued to have trouble concentrating away from the safety of her own room, her mind under constant assault from Volthoom.

36. JESSICA CRUZ DEFEATS VOLTHOOM

When Darkseid's daughter Grail arrived on Earth, she attacked Jessica and used the ring to bring the Anti-Monitor from Earth-3 to Prime Earth to combat Darkseid. Caught up in the war between cosmic forces, Jessica approached the Crime Syndicate, which allowed Volthoom to resume control over her body, her mind trapped elsewhere. She may have lingered there forever, except Grail ordered the Black Racer, the New God of Death, to collect the Flash. Jessica exerted her will just enough to put her body in the Racer's path. Rather than be killed, Volthoom was seemingly banished from her body, the power ring crumbling, giving Jessica full control once more. To her surprise, a different power ring found her, rewarding her for conquering her fear by making her a member of the Green Lantern Corps.

Hal Jordan, the Corps's leader, assigned Jessica to remain on Earth, training with fellow Lantern Simon Baz, and serving with the Justice League. In time, she had to prove herself all over again when Prime Earth's Volthoom, that universe's first Green Lantern, escaped confinement and wanted to rebuild his original ring, which had been taken apart to forge the Corps's rings. Jessica's ring had a trace and he went after her with a vengeance, but this time, she was better prepared, and prevailed.

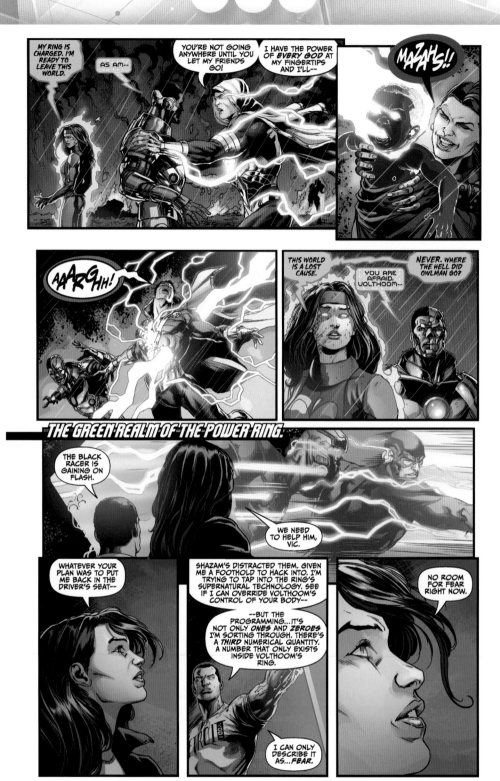

Jessica Cruz didn't intend to become a hero and had many obstacles to overcome, but when she proved herself worthy, she was welcomed to something greater: the Green Lantern Corps.

Justice League #50, July 2016
Writer: Geoff Johns *Artist:* Jason Fabok

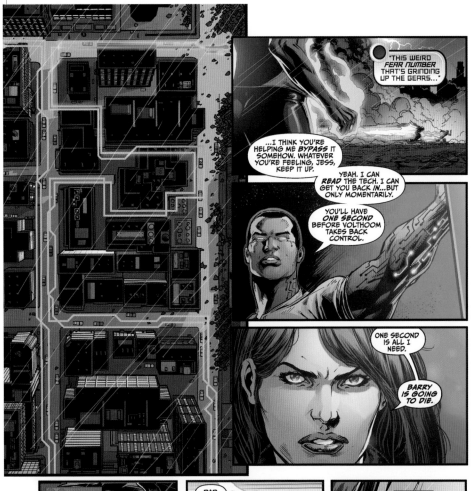

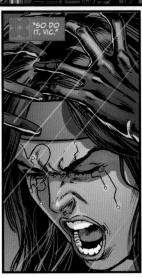

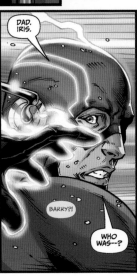

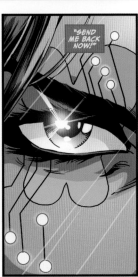

Justice League #50, July 2016
Writer: Geoff Johns *Artist:* Jason Fabok

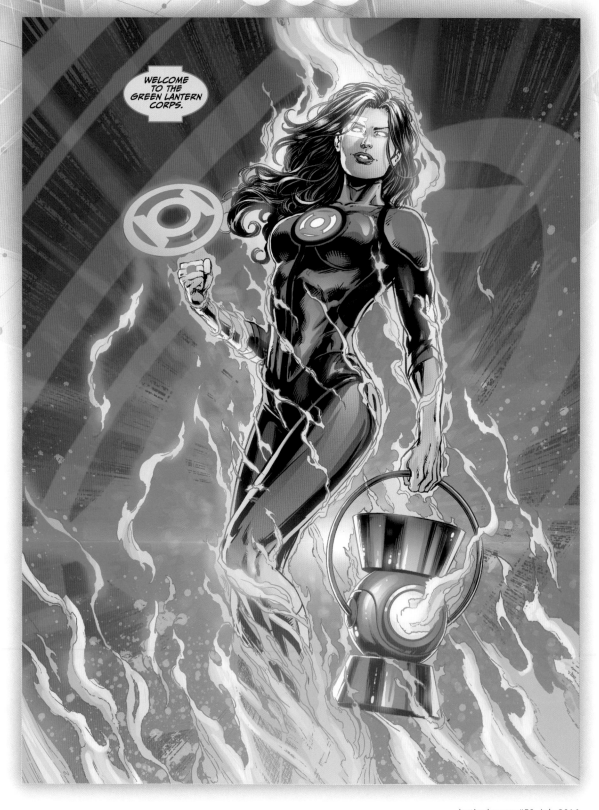

Justice League #50, July 2016
Writer: Geoff Johns *Artist:* Jason Fabok

GYPSY

CYNTHIA "CINDY" REYNOLDS WAS FOURTEEN WHEN HER WORLD WAS TURNED UPSIDE down. She was a normal teen, but things began to alter after her younger brother was born and her parents' marriage deteriorated. Then she realized she had illusion powers and used them to make herself disappear from her broken home. She bought a bus ticket, left for Detroit, and lived by her wits for the next several years.

When a new incarnation of the Justice League of America relocated to Detroit and operated out of the Bunker, she tested its security measures and managed to enter the headquarters. She then followed the new team when they battled the Overmaster's Cadre, finally joining the fray. Her heroism was recognized, and she was welcomed to the team.

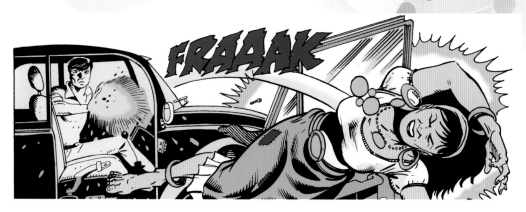

37. AGAINST PROFESSOR IVO

Not long after this, longtime opponent Professor Ivo returned to systematically take down and destroy the JLA. Gypsy was attacked by an android, and from a distance, Ivo watched his creation kill the team's youngest member. At least that's what he thought he saw. Gypsy used her powers to make Ivo see her attacked but had used her wits to talk the machine into not killing her. Instead, they created the illusion of her death, freeing her from its wrath. The android then escorted Gypsy back to her parents, who had reconciled, keeping her away when Ivo killed Vibe.

Soon after, Despero returned to Earth and attacked Gypsy, killing her parents. The JLA intervened, rescuing their teammate, but in the emotional aftermath, she accepted Booster Gold's offer to join his rival team, the Conglomerate. The fit proved less than ideal, and in time she accepted the Martian Manhunter's offer to work with his new Task Force, a splinter JLA operation. They formed a familial bond as he trained her to be a better illusionist and fighter.

Professor Ivo built his android killer too well and gave it enough artificial intelligence to allow Gypsy to talk some sense into it, sparing her life, allowing her to stop the murderous scientist.

Justice League of America #259, February 1987
Writer: J. M. DeMatteis *Artists:* Luke McDonnell & Bill Wray

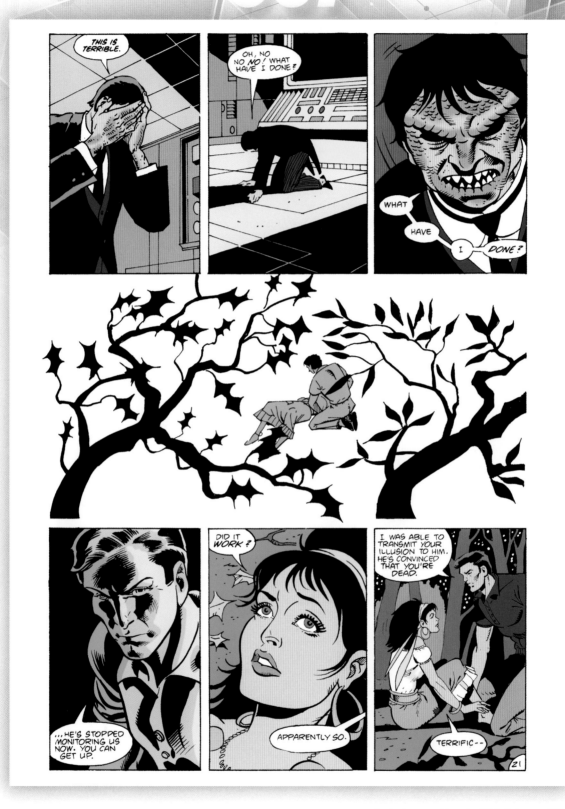

Justice League of America #259, February 1987
Writer: J. M. DeMatteis *Artists:* Luke McDonnell & Bill Wray

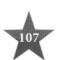

HARLEY QUINN

FIRST APPEARING ON *BATMAN: THE ANIMATED SERIES* EPISODE "JOKER'S FAVOR," HARLEY Quinn has become a global fan favorite, migrating from animation to comic books and live-action film, maintaining a careful balance between pathos and slapstick. Dr. Harleen Quinzel was a new psychiatrist at Arkham Asylum and saw the Joker as too tempting a subject not to study. Over time, he seduced her and she became an unwitting accomplice in helping him escape. The former gymnast donned a harlequin costume and white face paint to become his sidekick and lover.

His abuse and neglect drove them apart, and she charted her own path as a criminal, benefactor, landlord, teammate, and friend to all. Harley has worked with a variety of teams, either as a part-timer or full-fledged member, mixing it up with heroes and villains as circumstances demanded. Harley even briefly partnered with Power Girl for a series of escapades. She embarked on several romances, beginning with Poison Ivy and later Task Force X commander Rick Flag Jr.

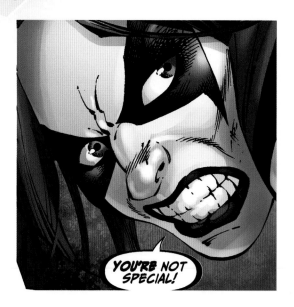

38. TEACHING MR. J A LESSON

The Joker may love Harley Quinn…but then again, no one can know what he's thinking. Over the years, he has used her, abandoned her, beaten her, and belittled her, rarely returning her affection. On several occasions, she claimed to have had enough and sought him out to deliver justice, usually to be thwarted by circumstance. There came a moment, though, when she worked her way into his cell for a final confrontation that seemed to sever their relationship for the last time.

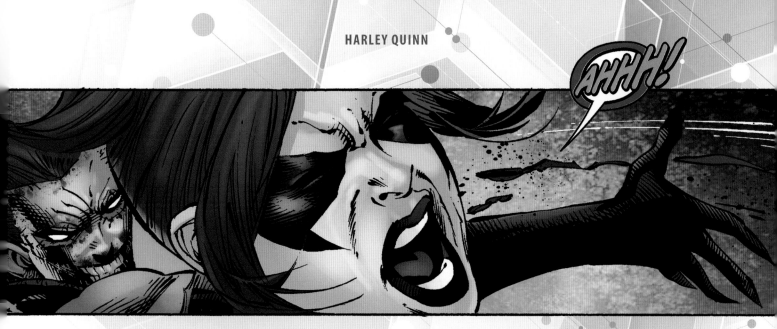

39. HARLEY & IVY

Fans adored Harley and Poison Ivy as a team, which led to a comic miniseries and frequent pairings in comic books. Their affection for each other has evolved into romance, along with many adventures. There came a time when Coney Island, where Harley was based, was threatened by zombies. Harley nearly succumbed until Poison Ivy arrived and together, they found not only a cure, but also a way to administer it to everyone in Brooklyn. From this experience, it became clear to Ivy that she could use her powers for good.

40. AGAINST THE JOKER'S DAUGHTER

When Harley was recruited, against her will, to join Amanda Waller's Suicide Squad, she found herself working with the deranged woman claiming to be the Joker's Daughter. Their enmity was immediate and repeatedly threatened the missions. On a rescue mission in Russia, the Joker's Daughter delivered one taunt too many, and Black Manta was no longer able to keep the women apart. Harley delivered so brutal a beating, warning the woman to be nothing like the Clown Prince of Crime, that the Joker's Daughter had to be left behind and was soon removed from the roster. Harley remained, eventually leading the team for a time.

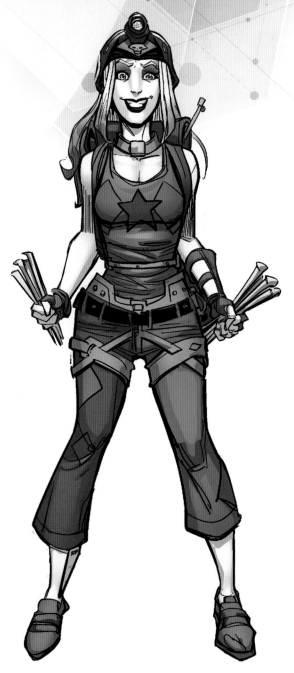

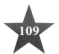

Breaking into Arkham Asylum sounds insane, but that's what Harley does to have a final confrontation with her "Mr. J," warning him she was done taking his abuse.

Harley Quinn #25, April 2016
Writers: Amanda Conner & Jimmy Palmiotti *Artist:* Chad Hardin

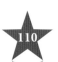

Harley Quinn #25, April 2016
Writers: Amanda Conner & Jimmy Palmiotti Artist: Chad Hardin

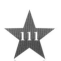

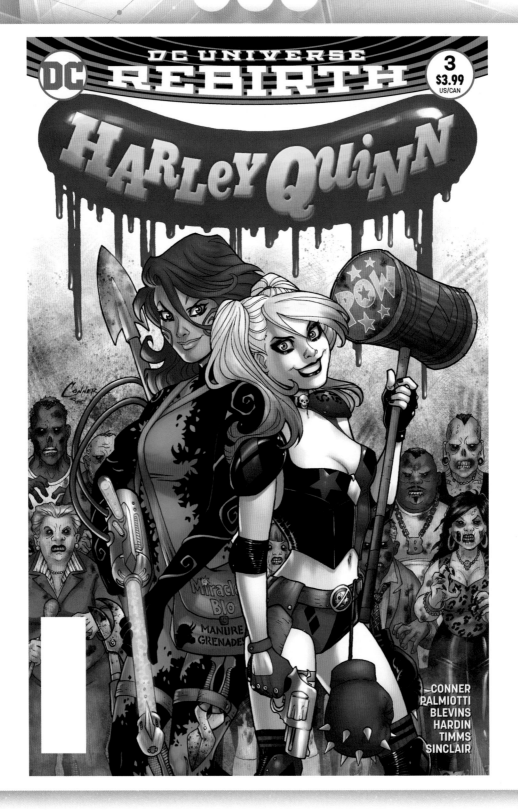

Zombies to the left, zombies to the right—it all comes down to Harley Quinn and Poison Ivy, normally seen as villains, to save the residents of Brooklyn.

Harley Quinn #3, November 2016
Artists: Amanda Conner & Alex Sinclair

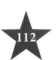

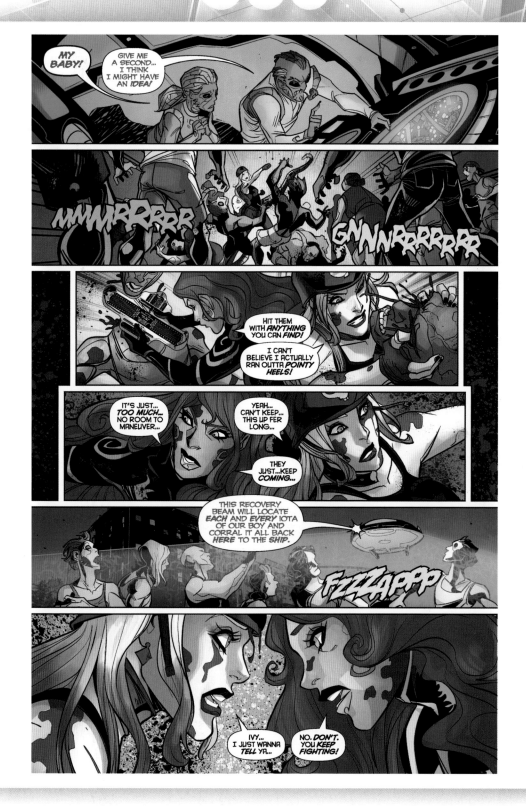

Harley Quinn #3, November 2016
Writers: Amanda Conner & Jimmy Palmiotti *Artists:* Bret Blevins & John Timms

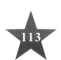

It is certainly debatable which of the two combatants is less emotionally stable: Harley Quinn or the modern-day incarnation of the Joker's Daughter.

New Suicide Squad #3, December 2014
Artist: Jeremy Roberts

HAWKWOMAN

OF ALL THE CHARACTERS THAT HAVE BEEN REINTRODUCED, RETCONNED, RELAUNCHED, and revived, Hawkman and Hawkgirl may possess the most convoluted backstory. During the Golden Age, Carter Hall was an archeologist who discovered a special sarcophagus and became the reincarnation of Prince Khufu. Using the magical Nth metal to power his wings, he took to fighting injustice as Hawkman. His girlfriend, Shiera Sanders, eventually learned his secret, and after two years donned her own pair of wings, adventuring by his side as Hawkgirl.

Editor Julie Schwartz reinvented the pair as married police officers Katar Hol and Shayera Hol, from the distant world of Thanagar, who chased the criminal Byth to Earth and decided to stay and observe police methods in America. They adopted human guises as museum directors in Midway City and favored ancient weapons to fight crime.

In time, we learned that Shayera was still a teen when she joined the planetary police force, assigned to Katar, the force's most decorated officer. He initially resisted working with her, until she acquitted herself by capturing the Rainbow Robbers. That's when he looked at her with new eyes and they fell in love. He proposed at the same spot where they captured the Rainbow Robbers and enjoyed a decade of bliss before coming to Earth.

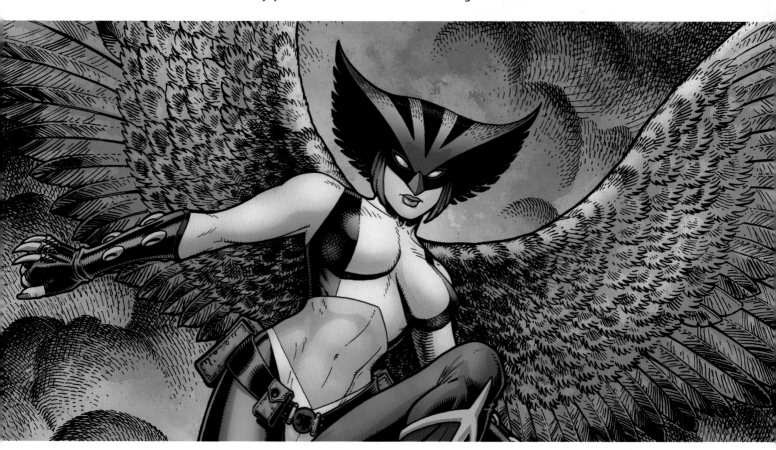

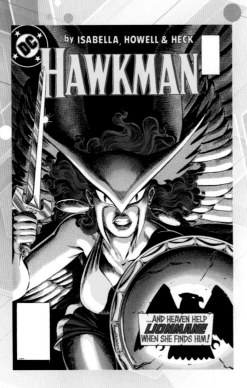

41. HAWKGIRL DEFEATS COUNT CRYSTAL

When Count Crystal made a deal with the demon Azgore to obtain the power needed to defeat the League and sacrifice them to the netherworld, he invaded the satellite headquarters. Killing Superman, he was on his way to success when the Phantom Stranger intervened. He summoned Batman, Wonder Woman, Green Arrow, Black Canary, Hawkman, and Hawkgirl to hold a séance intended to revive the Man of Steel. Events led them to Rutland, Vermont, home of the annual super-hero Halloween parade, and from there to the extradimensional realm known as the Carnival of Souls. During their conflict, it appears the Stranger was killed and Crystal made off with Hawkgirl, intending to keep her as his consort. She turned the tables on him, freeing herself and rescuing her allies. The Stranger's spirit helped Superman defeat Azgore and return to the mortal plane.

It took only the following issue, *Justice League of America* #146, to finally admit her as a member. A few years later, in 1981, she finally insisted on being called Hawkwoman.

42. HAWKWOMAN DEFEATS LION-MANE

Carter Hall and fellow archeologist Ed Dawson were in Iran and learned of a "meteor god" who could turn lions into domesticated animals. A glance at Mithra, though, would break the spell, reverting the lion to its savage nature and transforming the man into a beast. Dawson dared break the taboo and was cursed to live as Lion-Mane. He frequently opposed Hawkman and Hawkwoman over the years.

In one instance, Lion-Mane telepathically took control of the Midway City Zoo's inhabitants. Hawkwoman took up her weapons and flew into action. The battle was a fierce one, as the two appeared evenly matched, but she used her wings to carry them both high into the sky. As the atmosphere thinned and the cold chill of outer space crept over him, Lion-Mane's will was snapped and he reverted to his normal form, ending the threat.

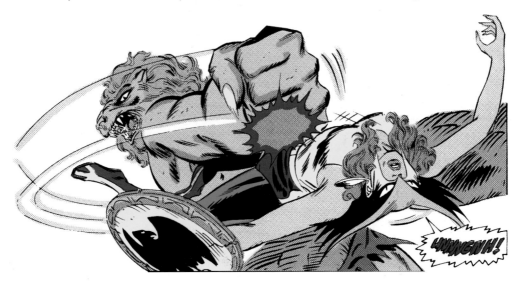

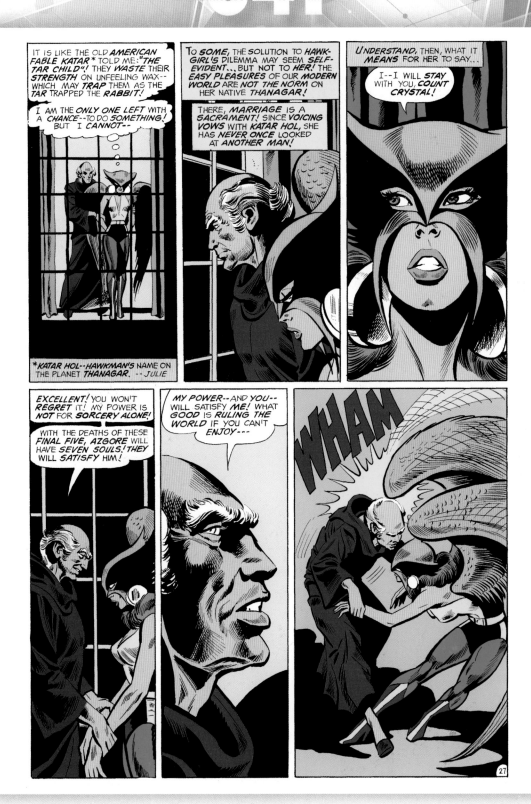

It takes daring and ingenuity to thwart Count Crystal's plans to destroy the Justice League, but Hawkgirl manages to outwit him and save the team, earning her a place on the team.

Justice League of America #145, August 1977
Writer: Steve Englehart *Artists:* Dick Dillin & Frank McLaughlin

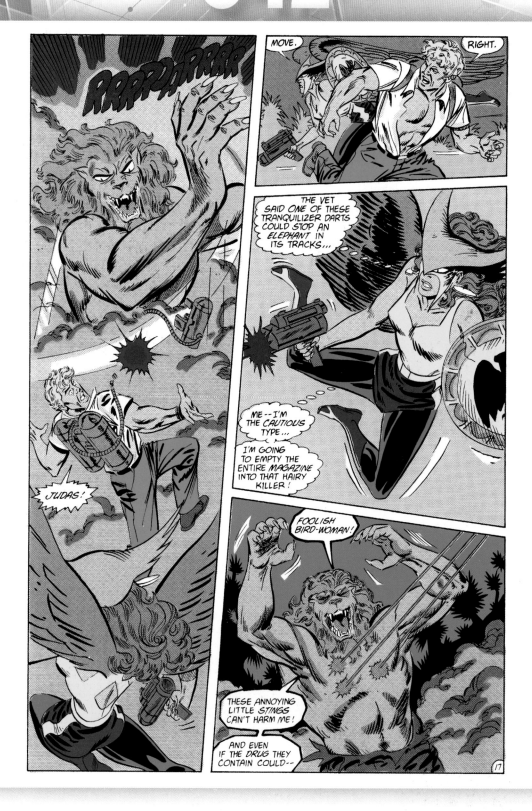

While they've battled before, this rare one-on-one confrontation with Lion-Mane comes while Hawkwoman is distracted by her husband's hospitalization. She does not have time for this, and neatly neutralizes the problem.

Hawkman #6, January 1987
Writer: Tony Isabella *Artists:* Richard Howell & Don Heck

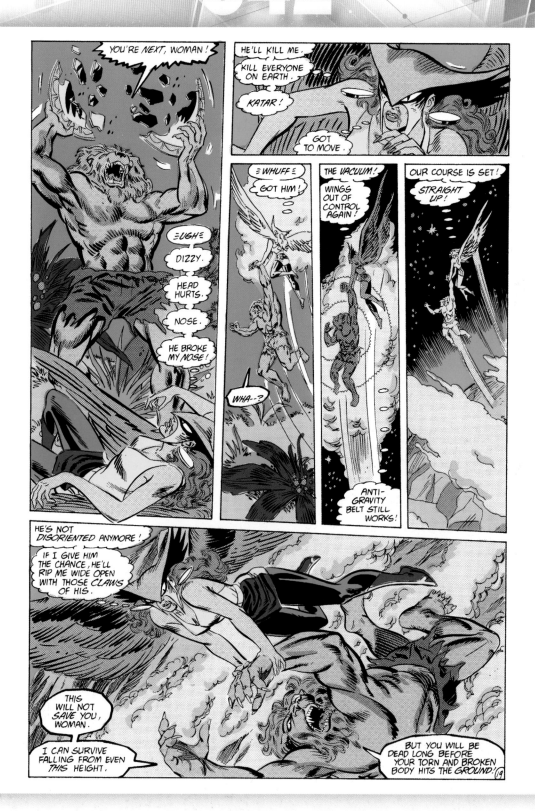

Hawkman #6, January 1987
Writer: Tony Isabella *Artists:* Richard Howell & Don Heck

HIPPOLYTA

THE GREEK MYTHS AND LEGENDS HAVE BEEN TOLD AND RETOLD SO OFTEN, IT IS HARD TO distinguish fact from fiction, myth from reality. What is a given, though, is that Hippolyta is queen of the Amazons living on Themyscira and wanted a child so much that she fashioned it from clay, and the gods granted the statue life and powers. The child grew up to become Diana, who journeyed to Man's World to spread the message of peace but was trained to protect and defend it as Wonder Woman.

On Earth-2, during comics' Golden Age, she was called Hippolyte, one of the Amazons who were targeted by Hercules. He was tasked as one of his twelve labors to capture Hippolyte's golden girdle. She bested him in battle but succumbed to his charms, and after their lovemaking, he stole the girdle and placed the Amazons in bondage. Aphrodite intervened and helped her worshippers escape, but forever after they had to wear metal bracelets as a reminder of their folly that was submitting to a man. She had them relocate to the hidden Paradise Island, and so they remained through the millennia. Hippolyte ruled as queen but longed for a child, and in time her wish was granted.

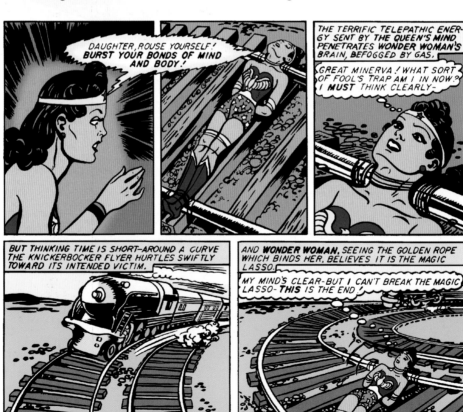

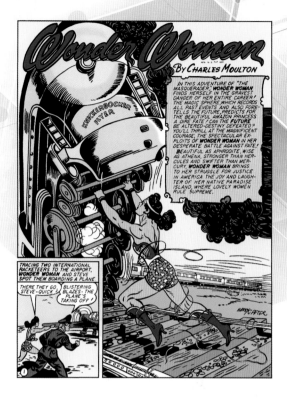

across countless galaxies, it came to Earth, seeing it as the perfect staging ground for the final assault.

Such was the nature of the threat that Darkseid chose to ally himself with Earth's champions to preserve the order of things. As it was, it took the magical strength of Tempest plus the faith of the entire Amazon population to help power the Entropy Aegis armor worn by Steel to finally bring down Imperiex. Lex Luthor used a time-displacement device to send Imperiex back to the Big Bang, which finally destroyed it.

However, Hippolyta, despite her gods-blessed battle armor, fought valiantly to protect Greek citizens and all other Earth residents, and perished in the battle. It was believed that her spirit, along with that of Antiope and Steve Trevor's mother Diana, watched over Themyscira. Circe, though, brought the queen back to life during a conflict between the Amazons and America.

⭐ ⭐ ⭐

43. HIPPOLYTE BECOMES WONDER WOMAN

At one point, Hippolyte used the amazing Magic Sphere and saw that her daughter was going to be captured by a gang of racketeers. Fairly normal for Wonder Woman, but for some reason, this alarmed her so much that she sought the gods' permission to leave Paradise Island, which was granted for seventy-two hours, along with the proviso that she not reveal her true identity. Unaccustomed to operating in Man's World, she struggled but managed to masquerade as Diana Prince and then Wonder Woman. This caused all manner of confusion for Steve Trevor, Etta Candy, Diana, and the racketeers, but all worked out in the end. Hippployte was comforted in helping her daughter feel closer to her than ever before.

44. HIPPOLYTA SAVES THE UNIVERSE

There came a day when Earth was threatened by the embodiment of entropy in the form of Imperiex. It sought to repair the "imperfections" it saw in the universe's fabric and wished to destroy it all and start fresh with a perfect universe. After smashing its way

In the Rebirth reality, the Golden Age origin has been restored to Hippolyta, where she continues to rule over the Amazons on Themyscira and is proud of her daughter, Wonder Woman.

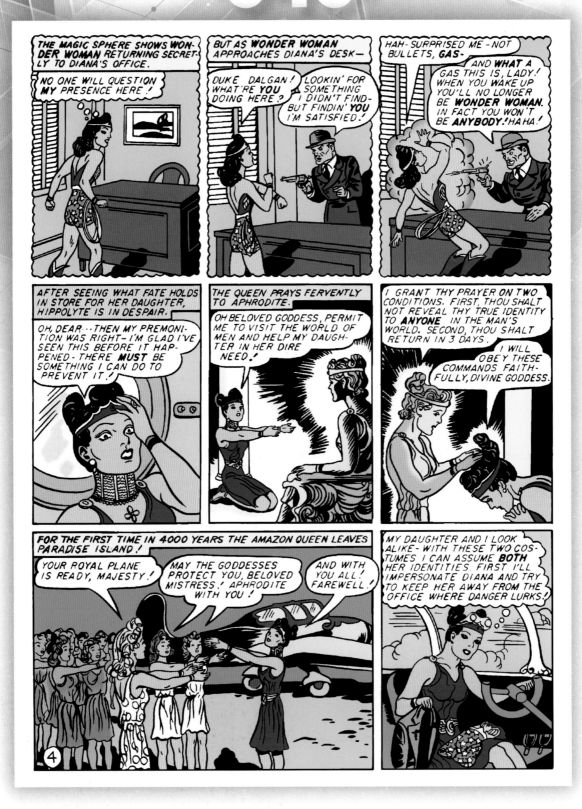

The story may be played with a lighter than usual touch, but the danger to Diana is real, and her mother does whatever she can to ensure Wonder Woman's safety, even if it means making herself a target.

Sensation Comics #26, February 1944
Writer: Charles Moulton *Artist:* Harry G. Peter

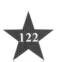

Sensation Comics #26, February 1944
Writer: Charles Moulton *Artist:* Harry G. Peter

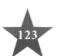

In what had to be her greatest battle, Hippolyta proves herself worthy of the gods' love and trust as she fights for all life beside the World's Greatest Super Heroes, making the ultimate sacrifice.

Wonder Woman #172, September 2001
Writer/Penciller: Phil Jimenez *Inker:* Andy Lanning

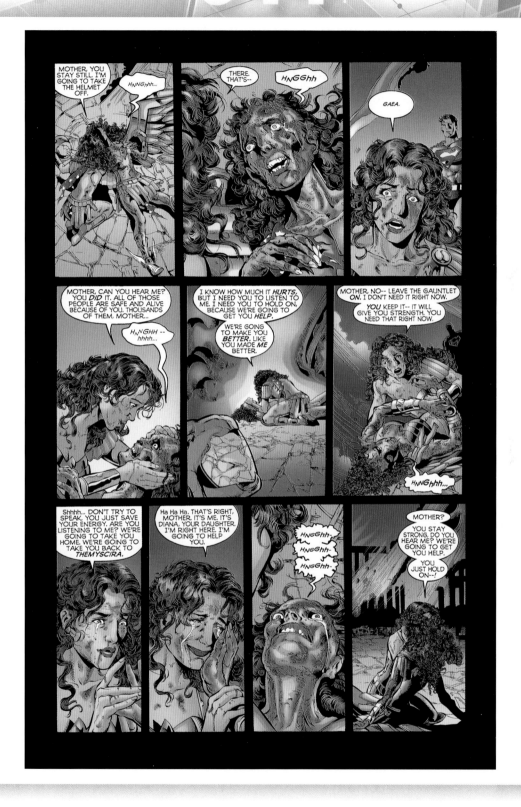

Wonder Woman #172, September 2001
Writer/Penciller: Phil Jimenez *Inker:* Andy Lanning

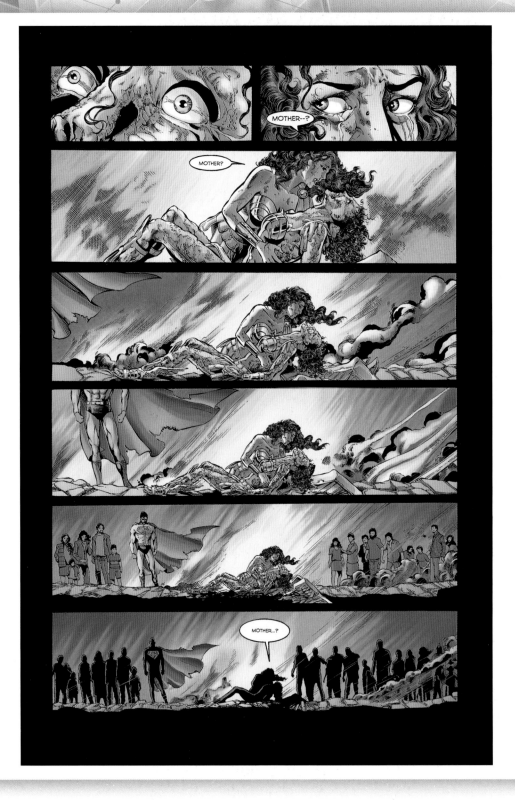

Wonder Woman #172, September 2001
Writer/Penciller: Phil Jimenez *Inker:* Andy Lanning

HUNTRESS

THE HUNTRESS CHARACTER EXISTS IN VARIOUS INCARNATIONS.

45. HUNTRESS AVENGES HER MOM'S DEATH

On Earth-2, Batman finally married Catwoman and they had a single child, a daughter, Helena. She was raised with her father Bruce's sense of civic responsibility and her mother's instincts. Both trained her to be an excellent athlete, able to defend herself. She was close to Wayne's ward Dick Grayson and followed his path to law school.

When Helena was nineteen, her mother was blackmailed into resuming her Catwoman persona by "Silky" Cernak. He possessed a photo showing Catwoman murdering a police officer and offered it to her for assistance on a crime. Things went badly and Selina Kyle died.

Helena crafted her own costume and pursued her mother's killer, debuting as Gotham City's latest protector, the Huntress. After tracking Cernak down, she proved the photo was doctored, preserving her mother's reputation.

46. HUNTRESS FACES THE JOKER

Helena remained a super hero, joining the fabled Justice Society of America and becoming close friends with Power Girl, eventually helping found Infinity, Inc., but remaining with the JSA. Helena was therefore present when her father died on a case, leaving her the heir to twin legacies.

On her own, she battled new foes such as Karnage and the Earthworm, in addition to the seemingly unkillable Joker. When her boyfriend was infected with Joker Venom, Huntress sought out her father's arch foe. Her investigation brought her to Commissioner O'Hara's office, but he was also shot with a Joker dart before he could give her information. She studied the dart in the Batcave and determined that the active ingredient was "dimethylsilicate" and sought its supplier. At the same time, the Joker was feeling directionless, even for him, with Batman dead. When word was out that a new Batman was in Gotham, he sought him out, only to find the Huntress instead. They fought and she prevailed, despite his taunts at her inexperience, and he was imprisoned.

47. HUNTRESS AVENGES HER FAMILY

On the newly formed singular Earth, Helena Janice Bertinelli, daughter of a Mafia don, grew up to become the heroic Huntress. Her anger and take-no-prisoners approach to fighting

crime kept her at odds with Batman, but she seemed to find her place as a field leader for Oracle's Birds of Prey. For reasons unknown, that background was tweaked so that Helena Rosa Bertinelli survived the brutal gangland slaughter of her family to grow up and become the vigilante known as the Huntress.

In another version of Helena Bertinelli's story, she continued taking on the Gotham mob, but was forced to stop and reexamine her life when she uncovered new information about her past. The new information revealed that she was actually sired by rival don Santo Cassamento. When Cassamento's capo, Mandragora, ordered the Bertinelli family eliminated, he passed on the order and instructed that Helena's mother, Maria, be spared. A misunderstanding left eight-year-old Helena alive instead.

Helena was then said to have been shipped off to live with her cousins, the Asaro family, in Sicily, Italy. Sal, her older cousin, taught her how to fight using a variety of weapons, and also helped her turn

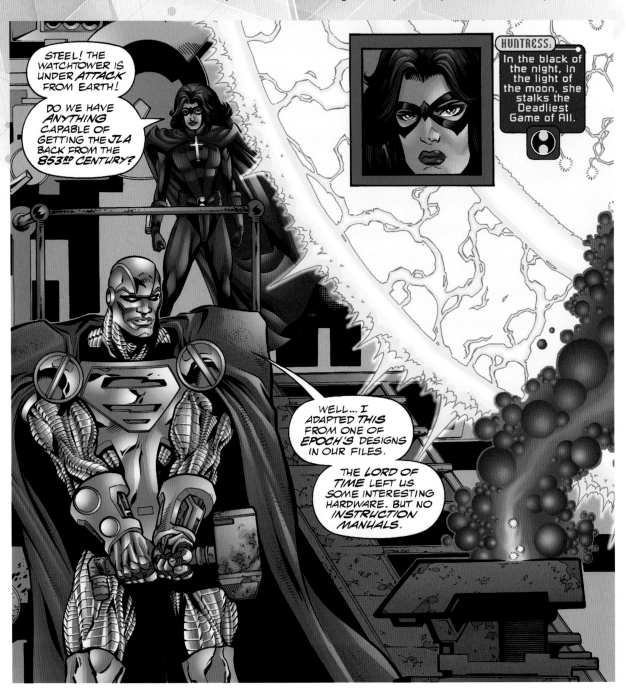

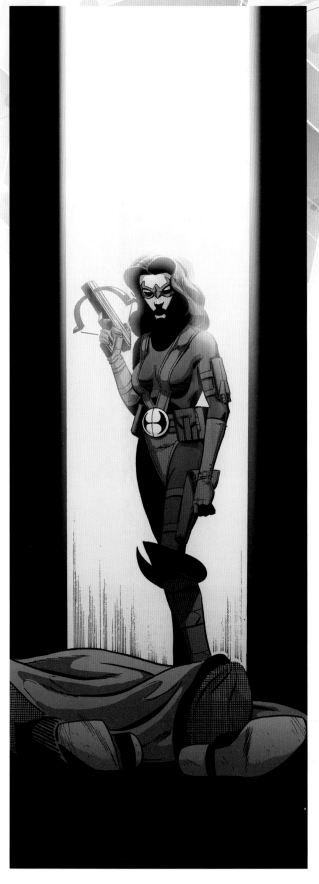

her body into a weapon. Sometime later, Sal and his father were arrested and the truth finally hit home: Helena was born into a Mafia family from which there was little hope of escape. She continued to grow a hard shell around her, keeping others at arm's length.

When Helena was sixteen, she made a brief return to her home city of Gotham, where she first saw Batman in action. Upon completion of her lessons, Helena attended a university in Palermo to be closer to her family. With a degree in education in hand, Helena eventually returned to Gotham City and became both a schoolteacher and the Huntress.

Shortly after learning of her true heritage, Helena tracked down her father, Cassamento, who had already figured out that his daughter was the Huntress. She told her uncle that Cassamento was the man who ordered the Bertinelli killings, and he was subsequently executed.

48. HUNTRESS SAVES THE FUTURE

In an effort to "smooth her edges," Batman acted as the Huntress's sponsor to join the Justice League. She worked hard to be accepted by the whole team, although she never really grew close to any of her costumed colleagues. Her tenure was cut short when the Huntress tried to kill Prometheus after the mercenary attempted to destroy the League.

Still, there came one bizarre case where they had to help save the 853rd Century. A sentient sun, Solaris, was threatening both past and future, until Batman figured out that creating Solaris in the 21st Century would help them defeat it in the future. It would mean generations of heroes would have to contend with Solaris, but this was deemed a price worth paying. That left the combined forces of the Justice League and Justice Legion A to solve a future dilemma. Of all people, the Huntress hits on the idea to bury the weapon they need in the past so it's in place when needed. In one version of the future, Solaris has used a kryptonite bullet, long hidden on Mars, to kill Superman, emerging from isolation within Sol. The Huntress's idea was to swap out the bullet for Green Lantern Corps's power ring, which does the trick, saving Superman and preserving the future.

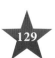

A devastated nineteen-year-old Helena Wayne follows in her father's footsteps and dons a costume to strike fear in a criminal's heart and bring the guilty to justice as the Huntress.

DC Super-Stars #17, November/December 1977
Writer: Paul Levitz *Artists:* Joe Staton & Bob Layton

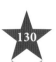

DC Super-Stars #17, November/December 1977
Writer: Paul Levitz *Artists:* Joe Staton & Bob Layton

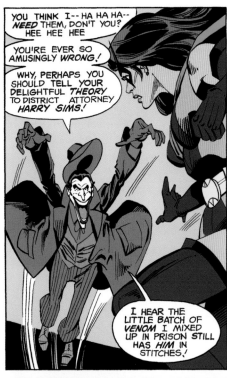

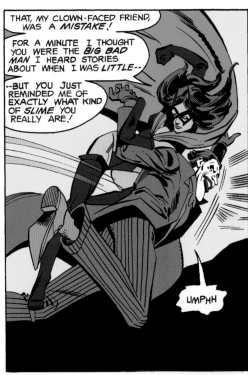

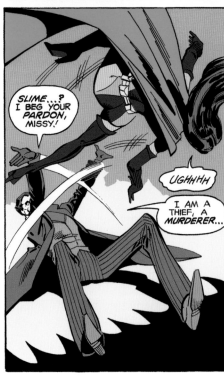

The Joker is aimless without Batman to torment, but despite that and his advanced age, he gives the Huntress a run for her money during one spree in Gotham City.

Wonder Woman #283, September 1981
Writer: Paul Levitz *Artists:* Joe Staton & Steve Mitchell

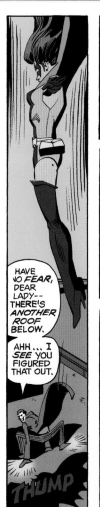

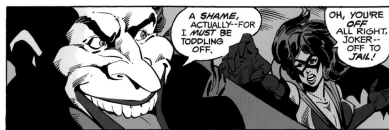

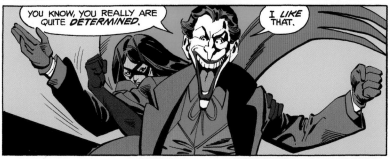

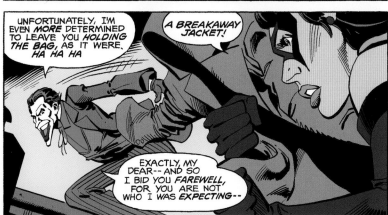

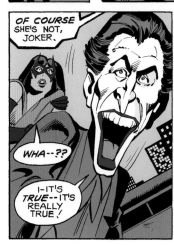

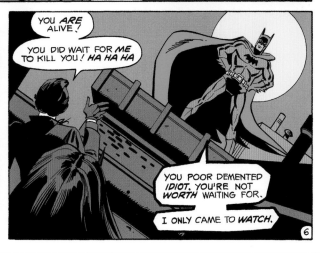

Wonder Woman #283, September 1981
Writer: Paul Levitz *Artists:* Joe Staton & Steve Mitchell

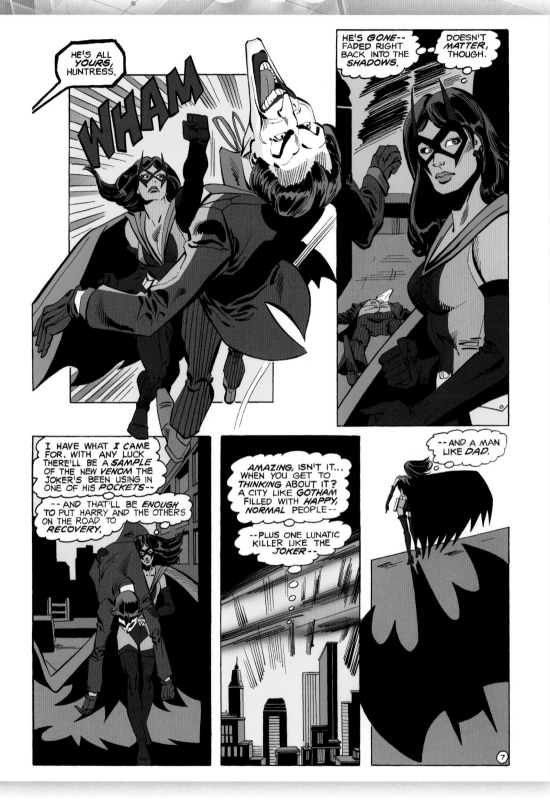

Wonder Woman #283, September 1981
Writer: Paul Levitz *Artists:* Joe Staton & Steve Mitchell

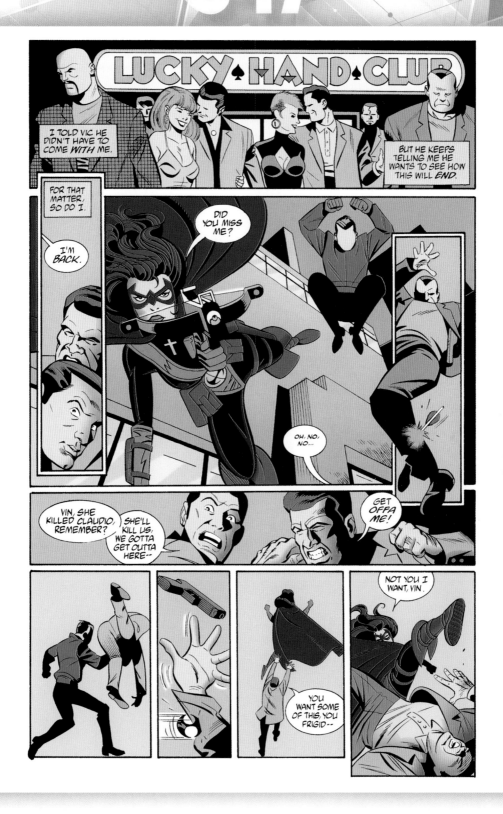

Despite learning of a family past soaked in crime and bloodshed, Helena Bertinelli has become the Huntress and confronts the man behind so much of her pain.

Batman/Huntress: Cry for Justice #6, November 2000
Writer: Greg Rucka Artist: Rich Burchett

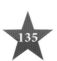

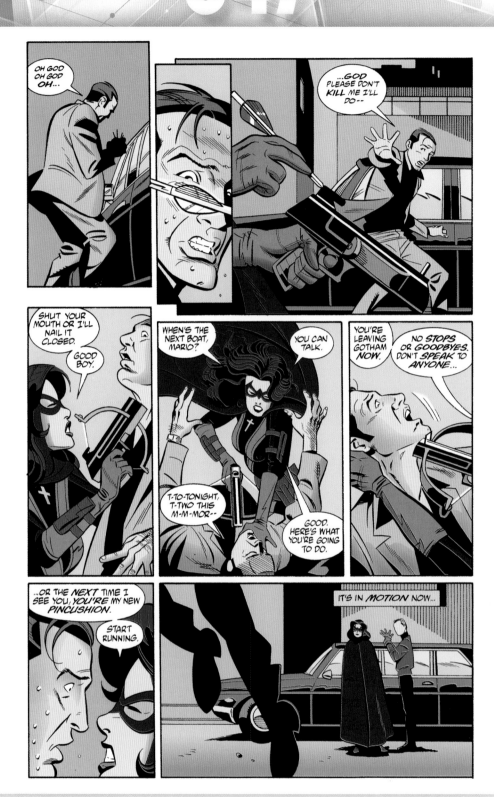

Batman/Huntress: Cry for Justice #6, November 2000
Writer: Greg Rucka Artist: Rich Burchett

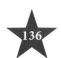

Not usually credited for being a tactician, the Huntress winds up providing the very gambit the JLA needs to preserve Justice Legion A's future.

JLA #1,000,000, November 1998
Writer: Grant Morrison *Artists:* Howard Porter & John Dell

JADE

IT MUST HAVE BEEN CONFUSING GROWING UP THE DAUGHTER OF A HERO AND A VILLAIN. Jennie-Lynn Hayden and her twin brother, Todd James Rice, were the children of Earth-2's Alan Scott, the Green Lantern, and his one-time nemesis Thorn, aka Rose Canton. Thanks to the magical properties of the Starheart from which Scott crafted his power battery and ring, the children were born with amazing powers. Jennie-Lynn's green skin contained chlorophyll, which allowed her to photosynthesize energy, while Todd had control over shadows.

As teenagers, they took the names Jade and Obsidian and joined Infinity, Inc., where they adventured until the Crisis on Infinite Earths rewrote reality. On the new Earth, they seemed unchanged but had different adventures; Jade's saw her join a variety of teams, from Bloodpack to the Outsiders to the Justice League to the Justice Society of America and finally the Green Lantern Corps.

49. BECOMING GREEN LANTERN

In time, she met up with Kyle Rayner, then the Green Lantern of Earth. They were at first roommates before becoming romantically involved and then learning of each other's heroic identities. When the Starheart gained malevolent sentience, Jade went off to battle it, but the magical entity triumphed, stripping her of her metahuman power.

Rayner recognized her valor with her own power ring and battery, making her Earth's first female Green Lantern. For a time, they left Earth to travel the stars, where she proved adept with the ring.

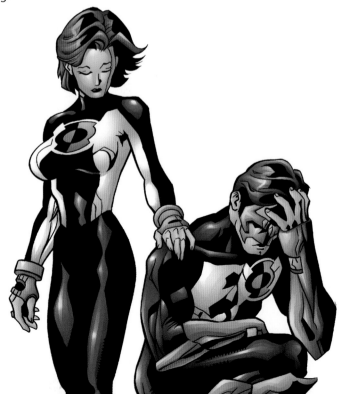

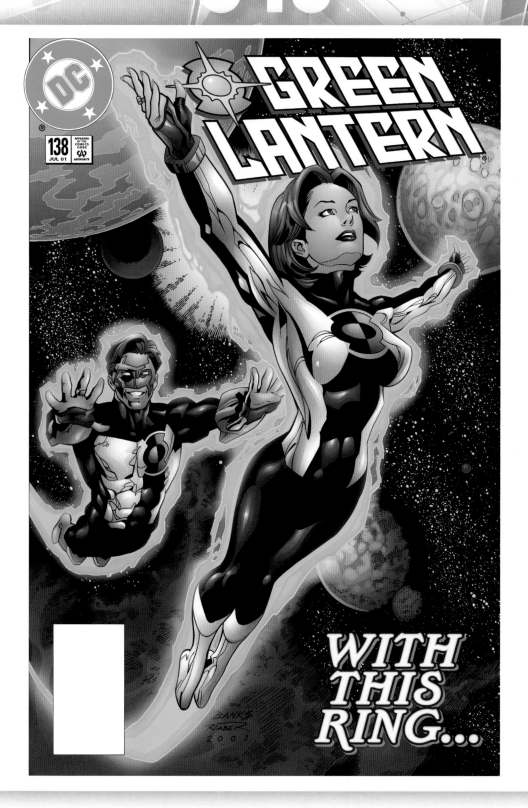

A daughter of the first Green Lantern on Earth, she operated as Jade for most of her career, but for one brief stretch, she earned her own power ring and became a member of the Green Lantern Corps.

Green Lantern #138, July 2001
Artists: Darryl Banks, Rich Faber, Richard Horie & Tanya Horie

JESSE QUICK

JOHNNY CHAMBERS WAS A JOURNALIST WHO TAPPED INTO THE SPEED FORCE WHEN HE said a special formula, granting him temporary super-speed, which he used to fight crime as Johnny Quick. He adventured on Earth-2 until the Crisis on Infinite Earths, at which point his past was rewritten. In the new reality, at some point he married Libby Lawrence, the fellow adventurer Liberty Belle, and they had a daughter, Jesse. Seeking an heir to the speed, he taught her the formula at an early age. Although she trained with him to master the speed, she preferred to attend Gotham University, avoiding heroism. However, she did write her thesis on "The Impact of Superheroes on Society."

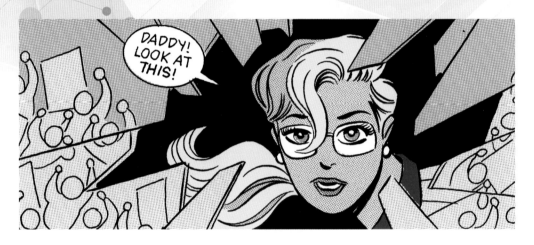

50. FATHER VERSUS DAUGHTER

Not long after, Johnny asked her to bring some papers to the Justice Society of America, who had recently returned from a period trapped in limbo. The close encounter was providential, as she began working with them in her new costumed identity as Jesse Quick. Johnny was prouder than ever. He even resumed his costumed identity to work on cases with the team, but not before the pair had a footrace, each thrilling in competition and comradeship.

From there, she met other speedsters, befriending the third Flash, Wally West, who helped her heal from a leg injury. Later, she lost her speed and blamed him, but it was learned that Savitar had severed everyone's connection to the Speed Force.

She moved away from the JSA, joining people her own age in the Titans before reconnecting with the JSA and igniting a romance with Rick Tyler, who was a new Hourman. Jesse tried something new, giving up Jesse Quick and becoming the second Liberty Belle in honor of her mother, Libby Lawrence. Her romance with Rick led to marriage and many happy days. However, Nekron reanimated her father's corpse during the Blackest Night, and she had to battle it through the tears. After the threat was ended, she resumed her Jesse Quick identity.

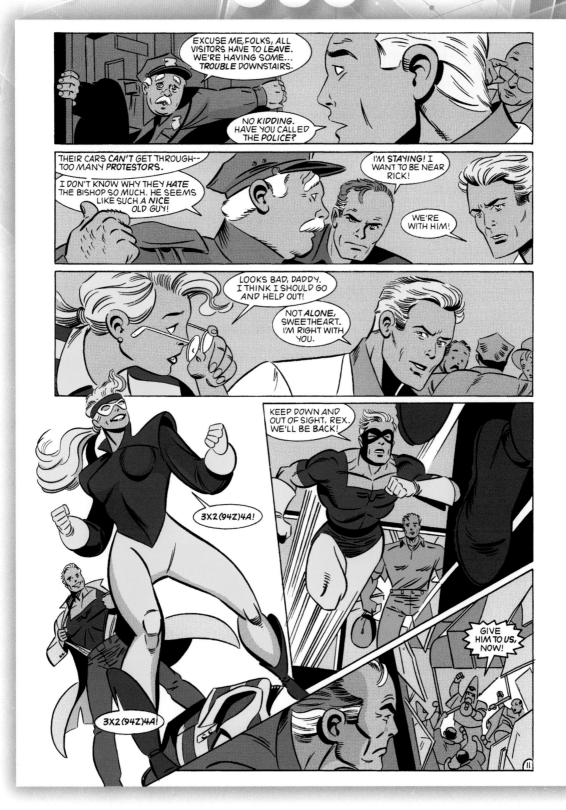

Johnny Chambers must have been the proudest parent in the Justice Society when his daughter Jesse proved to be a speedster off the old block, ready to challenge Dad to see who was faster.

Justice Society of America #8, March 1993
Artist: Mike Parobeck

JUSTICE SOCIETY OF AMERICA

THE JUSTICE SOCIETY OF AMERICA WAS FORMED AT THE REQUEST OF PRESIDENT FRANKLIN Delano Roosevelt, intending for them to keep America safe while its soldiers fought against the Axis threat around the world. They met out of a brownstone in Gotham City, and their roster altered through the years as members retired or arrived on the scene.

51. WOMEN TO THE RESCUE

There came a time, early in their existence, when the roster—Atom, Doctor Fate, Doctor Mid-Nite, Hawkman, Johnny Thunder, Sandman, Spectre, and Starman—failed to arrive for their regularly scheduled meeting. Team secretary Wonder Woman received letters from each apologizing for not being able to make the event, as they were busy with cases of their own. In reading the missives, the Amazon Princess deduced there was one man behind all eight cases and sought to find him.

Deciding she needed help, she reached out to the member's significant others—Clarice Winston, Dian Belmont, Doris Lee, Hawkgirl, Inza Cramer, Mary James, Myra Mason, and Peachy Pet—and had them wear their partners' costumes to wade into action. In this imaginative twist, each member began to realize that Henry King was behind their difficulties.

In the final chapter, King revealed his backstory, how his psychic powers, able to create three-dimensional images, made him an outcast. Taking the name Brain Wave, he set out to become a criminal, preying on criminals to work for him. As he waited for the JSA to fall into his clutches, Wonder Woman and the female heroes arrived but were fooled by images of their partners. Brain Wave gassed the women, all save the Amazon Princess, who freed herself. Startled, Brain Wave fell from his tower, apparently to his death, but being the JSA's first super-criminal, he returned and is still active.

When James Robinson retold this fanciful tale in his *Starman* run during the 1990s, he modernized it by having the women free themselves and actually win the day.

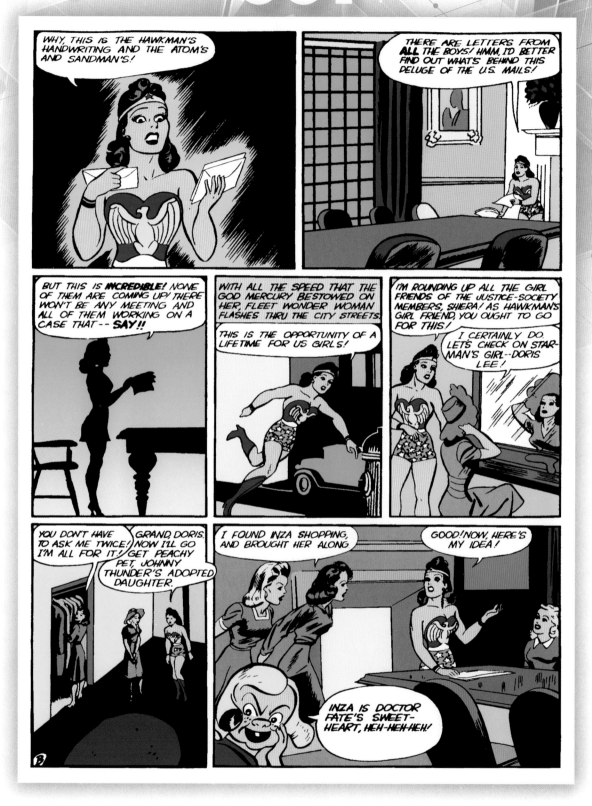

The Justice Society's girlfriends thankfully know the alter egos of their partners, making it easier for Wonder Woman to recruit them to assist her in tracking down Brain Wave.

All-Star Comics #15, February 1943
Writer: Gardner Fox *Artists:* Joe Gallagher, Sheldon Moldoff, Stan Aschmeier,
Joe Simon, Jack Kirby, Ed Dobrotka, Bernard Baily & Howard Sherman

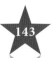

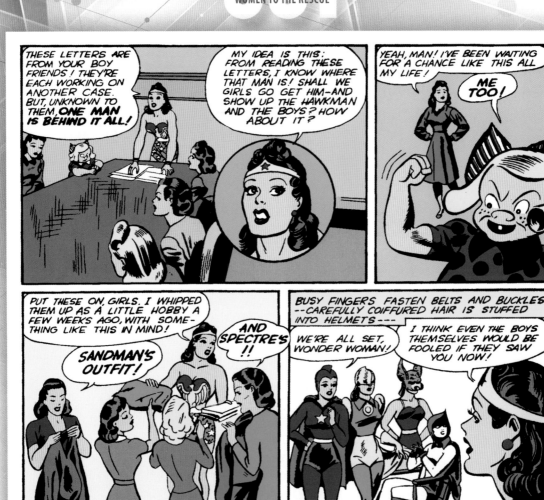

All-Star Comics #15, February 1943
Writer: Gardner Fox *Artists:* Joe Gallagher, Sheldon Moldoff, Stan Aschmeier,
Joe Simon, Jack Kirby, Ed Dobrotka, Bernard Baily & Howard Sherman

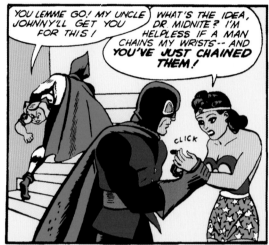

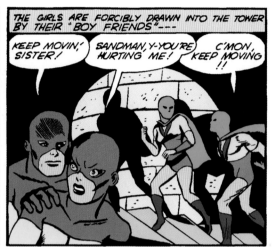

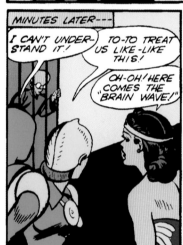

All-Star Comics #15, February 1943
Writer: Gardner Fox *Artists:* Joe Gallagher, Sheldon Moldoff, Stan Aschmeier,
Joe Simon, Jack Kirby, Ed Dobrotka, Bernard Baily & Howard Sherman

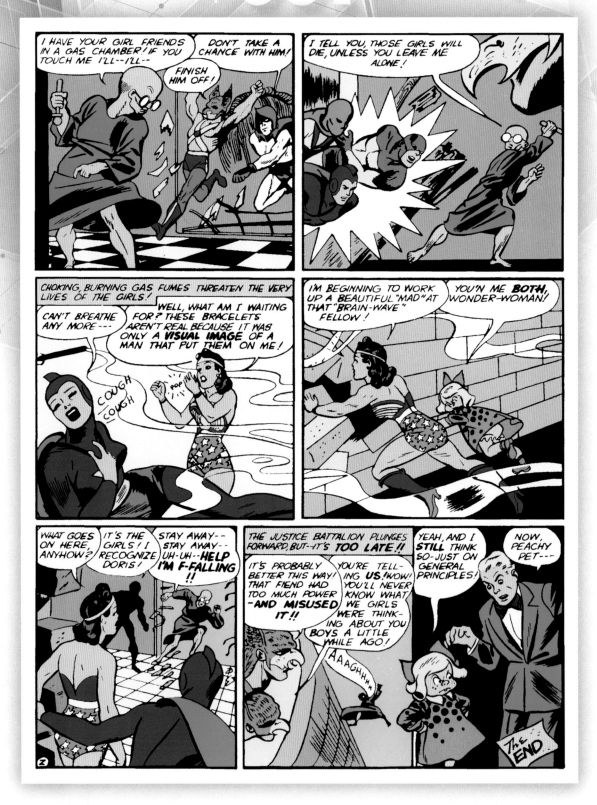

All-Star Comics #15, February 1943
Writer: Gardner Fox *Artists:* Joe Gallagher, Sheldon Moldoff, Stan Aschmeier,
Joe Simon, Jack Kirby, Ed Dobrotka, Bernard Baily & Howard Sherman

KATMA TUI

KORUGAR'S MOST FEARED CITIZEN, SINESTRO, LET THE POWER OF BEING A GREEN LANTERN corrupt him. He attempted to instill order with might, and the people came to fear him. He was stripped of his ring by the Guardians of the Universe and became their mortal enemy. To replace him, they selected Katma Tui to patrol Space Sector 1417. After her training and probationary period, she worked with scientist Imi Kahn to stop an amoeba-like creature from destroying their homeworld. During the battle, they fell in love, and she intended to leave the Corps to marry him until a visit from Earth's Hal Jordan, who convinced her to reconsider. After that, she became one of the finest officers and a close friend to her mentor.

52. HER TOUGHEST ASSIGNMENT

In a colorful career that included defeating the feared Ffa'rzz the Mocker, fighting the rogue Guardian Krona, the Weaponers of Qward, and the Anti-Green Lantern Corps, and succeeding Sinestro, Katma Tui excelled at her work.

Then came the assignment to the Obsidian Deeps, which needed a Lantern for that space sector. The region had no stars and therefore no light. In time, she found a world and the ring directed her to Rot Lop Fan, who listened with great interest. To him, it all sounded so fanciful, since, after all, he was blind and had no idea what the color green was or what a Lantern's light could do. His people, though, had developed extraordinary hearing. She considered this and finally settled on adjusting the oath taken by all Lanterns to one involving sound, constructing the first F-sharp bell to allow him to charge his ring. His uniform was modified from a lantern symbol to that of a bell, and "Green Lantern" was altered to "F-Sharp Bell" Corps. He went on to have a distinguished career, learning to work with his fellow Corpsmen.

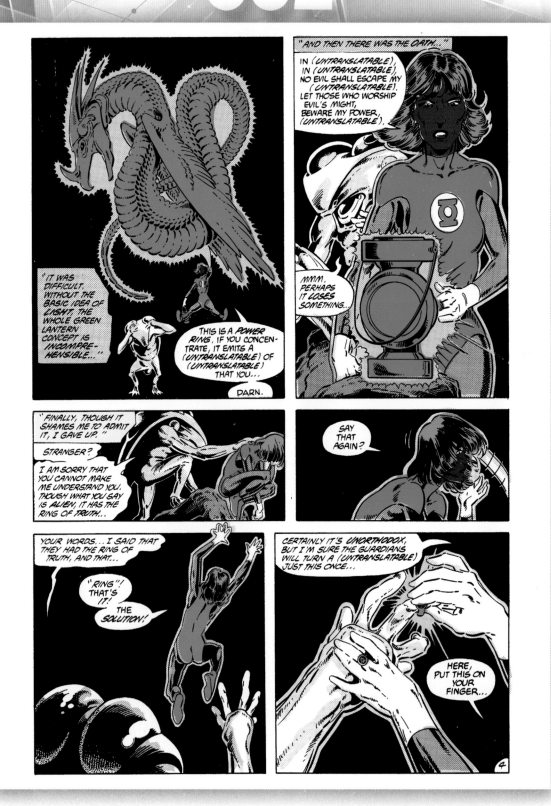

Katma Tui is at first puzzled by how to explain the Green Lantern Corps to an alien whose world had no light so his people had grown without sight.

Tales of the Green Lantern Corps Annual #3, April 1987
Writer: Alan Moore *Artists:* Bill Willingham & Terry Austin

Tales of the Green Lantern Corps Annual #3, April 1987
Writer: Alan Moore *Artists:* Bill Willingham & Terry Austin

KILLER FROST

CAITLIN SNOW WAS A S.T.A.R. LABS SCIENTIST ASSIGNED TO WORK ON A SELF-SUSTAINING Thermodynamic Ultraconductor Engine at Outpost #72 in the Arctic. Its inventor, Dr. Louise Lincoln, apparently had committed suicide. H.I.V.E. agents had earlier overrun the facility and posed as colleagues until Caitlin finished the machine. Having already killed Lincoln, they wanted the machine destroyed to protect their organization's energy investments. Snow hid in the engine, which they turned on in order to kill her. Instead, it triggered her metagene and transformed her into a living heat vampire. She needed to absorb heat from living beings in order to survive, and after wiping out the H.I.V.E. agents, she wandered until finding a Norwegian camp.

She worked her way back to her hometown of Pittsburgh, developing an exosuit that helped her retain heat. At one point, Killer Frost battled Firestorm and realized his powers could temporarily heal her condition. Repeatedly she tried and failed to recreate the Firestorm matrix so she could heal herself.

When the Crime Syndicate of America seemingly killed the Justice League and ruled the world, she traced the whereabouts of Martin Stein, creator of the matrix. At the same time, A.R.G.U.S. agent Steve Trevor arrived, seeking Stein's help in recreating Firestorm and freeing the JLA, trapped within the nuclear man. Frost agreed to help Trevor lead them on a mission to retrieve Wonder Woman's lasso of truth, needed to free the team. After the heroes were freed and the CSA subdued, Frost was arrested and taken to Belle Reve Penitentiary. There, she met Amanda Waller, who offered her a place on her Suicide Squad.

53. REDEMPTION

Almost immediately after Killer Frost joins the Squad, they enter into a pitched battle with the Justice League, triggered in part by Maxwell Lord. When the telepath is possessed by Eclipso, Batman needs all the help he can get and convinces Frost to join him. Eclipso tempts all by offering them their darkest desires, but it turns out all Frost desires is to make a difference. Once Lord/Eclipso is defeated, Waller agrees to remand Killer Frost to his charge, where she goes only by Frost.

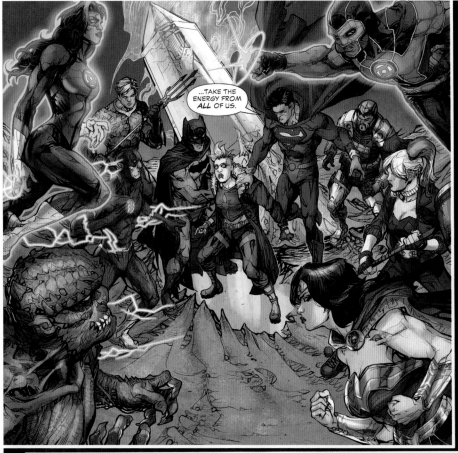

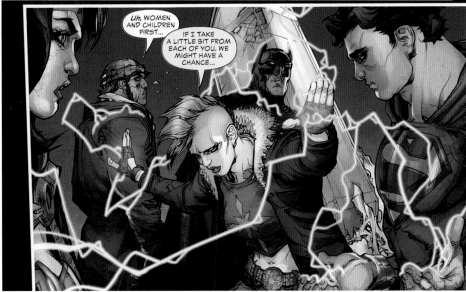

Killer Frost didn't ask for her powers or to be a criminal, and in time, she took control over her destiny and began making amends as a member of Batman's Justice League of America.

Justice League versus Suicide Squad #6, March 2017
Writer: Joshua Williamson *Artist:* Howard Porter

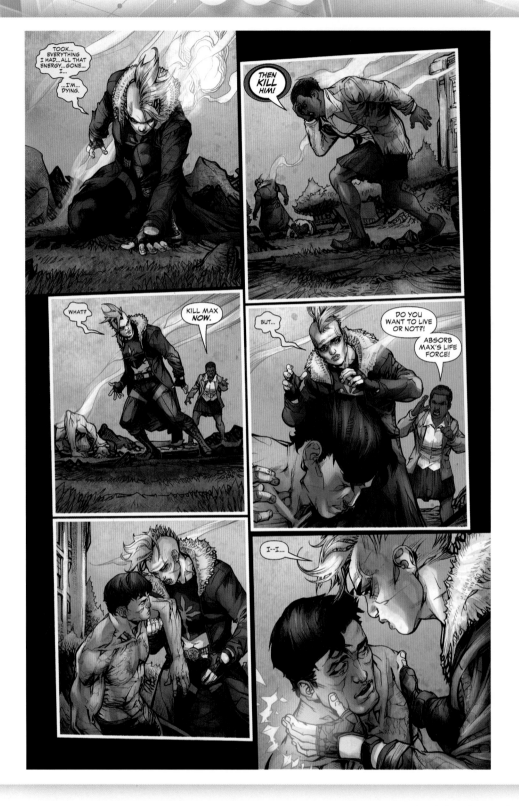

Justice League versus Suicide Squad #6, March 2017
Writer: Joshua Williamson *Artist:* Howard Porter

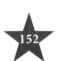

Justice League versus Suicide Squad #6, March 2017
Writer: Joshua Williamson *Artist:* Howard Porter

LIBERTY BELLE

"THE ALL-AMERICAN GIRL" WAS LIBBY BELLE LAWRENCE, DESCRIBED BY HISTORIAN TRINA Robbins as "a stronger and more interesting character than the usual super-heroine alter ego of mild-mannered secretary."

54. CHAIRING THE ALL-STAR SQUADRON

When Roy Thomas wanted a World War II–era title to write, he conceived of the All-Star Squadron and filled it with a variety of characters, most of whom did not have modern-day counterparts. With her powers, Liberty Belle made a fine stand-in for Wonder Woman, and Thomas placed her front and center from the outset. Lawrence was initially a winner at the American Intercollegiate Girls Athletic Tournament, receiving as part of her prize a medal containing a shard from the Liberty Bell. She goes on to win the gold medal for swimming at the 1936 Olympics in Berlin.

At the outbreak of World War II, Lawrence is personal secretary to her dad, Major James Lawrence, in Poland. He dies in a Nazi air raid, and with the help of Rick Cannon, Lawrence begins a harrowing journey across Europe to the Allied side. Along the way, she gathers important intelligence and then swims the English Channel to bring the information to the armed forces. Hailed the "Miracle of Dunkirk," she returns to America a hero, where she begins her journalistic career. While in Philadelphia, she realizes her connection to the Liberty Bell and its power.

The day after the attack on Pearl Harbor, Liberty Belle is on hand with other mystery men when President Roosevelt asks for them to form a team. Over the next few months, the roster expands, and finally they begin to organize themselves. At a large meeting, she explains, "Every group is doing what it can: businessmen are working as dollar-a-year men…labor had pledged no strikes for the duration…can we do any less?…We on the Home Front can play an important part, too, against saboteurs, against powerful Axis foes like Baron Blitzkrieg, against any criminals who'd try to take advantage of the situation." Based on this, she is unanimously elected the All-Star Squadron's first chair.

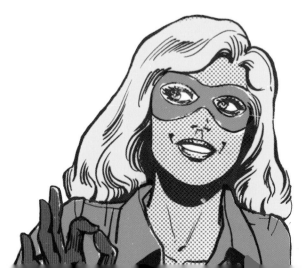

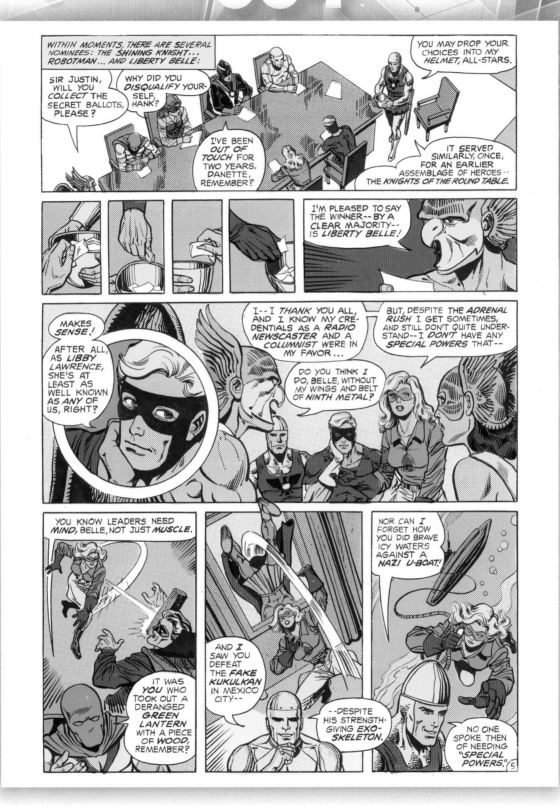

While the JSA only made Wonder Woman its secretary, the expansive All-Star Squadron let women be full members and even voted Liberty Belle to be its chair.

All-Star Squadron #13, September 1982

Writer: Roy Thomas *Artists:* Adrian Gonzales & Mike DeCarlo

LOIS LANE

WRITER JERRY SIEGEL KNEW HE WOULD NEED SOMEONE FOR SUPERMAN AND CLARK Kent to fall for, and as early as 1934, his plans included Lois Lane. Modeled after Torchy Blane (played by Glenda Farrell), star of nine Warner Bros. motion pictures, Lois was an established journalist by the time Clark arrived in Metropolis to work at the *Daily Star*. So began one of fiction's greatest triangles. Lois loved Superman and resented Clark for being a rival; he loved her regardless of guise.

55. THE FIRST SUPERWOMAN

During World War II, the content of the stories lightened up from social justice issues, with corrupt politicians and dictators being replaced by super-villains and more fanciful fare. It took a number of years, but Lois began to suspect that Clark and Superman might be the same, beginning a near-endless cycle of stories revolving around his secret identity.

Finally, there came a story where Lois is hit by a truck and knocked unconscious. In her dreamlike state, she imagines that the Metropolis Marvel revives her with a blood transfusion, which gives her super-powers. Playing it broadly, she demonstrates strength and speed but is still stereotypically frightened by a mouse. She goes home and sews a costume modeled after Superman's, complete with S-shield and red gloves. In most cases, her efforts work out fine and then she rescues Clark Kent, flying him high over the city to talk about what's happened to her.

She later rescues Superman from Dr. Skowl and declares, "For five long years you've led me on a dizzy chase on a romantic merry-go-round, my fine-feathered friend! Well, that's all changed. I've got some super-powers of my own now and *you're* going to listen to me!! I'm crazy, batty, dippy and slap-happy in love with you, you great big wonderful man…and the point of all this romantic by-play is that I want a *definite* answer to one little question: *will you marry me??*"

Then she wakes up.

After this fun tale, Lois manages to gain and lose powers for real throughout the Golden and Silver Ages. In many cases, she dons a costume and adventures as Superwoman.

56. LOIS LANE VERSUS CATWOMAN

As the Golden Age waned in the late 1950s, editor Mort Weisinger was expanding the Superman family of titles and sampled a Lois solo feature in the pages of *Showcase* before she earned an ongoing series, *Superman's Girlfriend Lois Lane*, which lasted into the 1970s.

In the 1950s, DC Comics decided to retire their costumed criminals in reaction to congressional scrutiny of the comic book field. That all changed in the 1960s as the New Look

Batman titles began to reintroduce the villains, fueled by the January 1966 debut of the ABC *Batman* series. Oddly, Catwoman returned to comics not in *Batman* or *Detective Comics* but in the pages of *Superman's Girlfriend Lois Lane*. Her purple and green cape retained the colors, but the gown became a bodysuit to more closely match Julie Newmar's purr-fect look.

In this story, Lois tracks down a freshly escaped Penguin only to be kidnapped by the Catwoman, who hypnotizes the reporter into acting as her double. Even though the World's Finest heroes capture the Penguin, Lois is still committing burglaries as Catwoman. Clark Kent realizes the switch only to be trapped in a lion pit, where his suit is shredded, revealing the red and blue costume underneath. When Catwoman takes over from Lois, she uses Circe's magic wand to transform the Man of Steel into a cat. Along the way, Lois finally is freed from the hypnosis, conveniently forgetting that she learned Superman's identity, and demands Catwoman turn the cat back into the man. Catwoman refuses even after being placed in prison.

The dilemma is carried over to the next issue, when Lana Lang learns of the problem. Her father, an archeologist, discovers a magical talisman that will grant a single wish, and it is used to restore Superman to his normal form.

57. LOIS LANE AND CATWOMAN

Lois Lane has endured through the many reincarnations of the DC Universe, her romance with Superman being one of the linchpins. Just prior to the Rebirth reality, she and Clark had a son, Jonathan, and then the three were seemingly wiped from existence. A new Superman and a new Lois

existed, unaware that the originals had returned and were operating in secret, far from Metropolis. In time, though, first Superman and then Lois died, and the originals took their places so effectively that no one suspected the change.

This Superman and the Rebirth Batman were wary allies in the Justice League, but they forged a friendship that became deep and abiding. When Batman proposed to Catwoman, and she accepted, one of the challenges was breaking the news to Superman, whose law and order attitude might preclude his accepting Selina Kyle as anything other than a criminal.

Finally, circumstances brought the four together, and it was inevitable that they went out and got to know one another. This even has them swapping outfits, an unintended homage to Lois and Selina's first meeting. Writer Tom King explored the dynamics and differences between the men, the women, and the couples in a simple night out at the carnival.

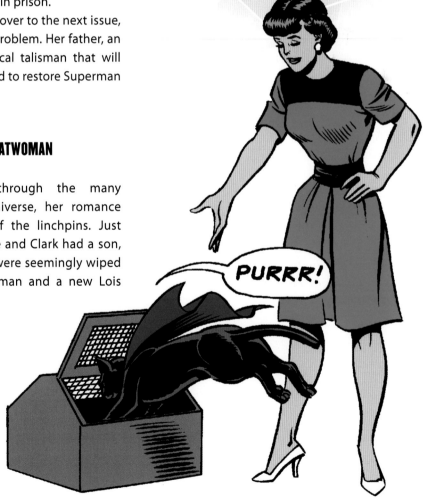

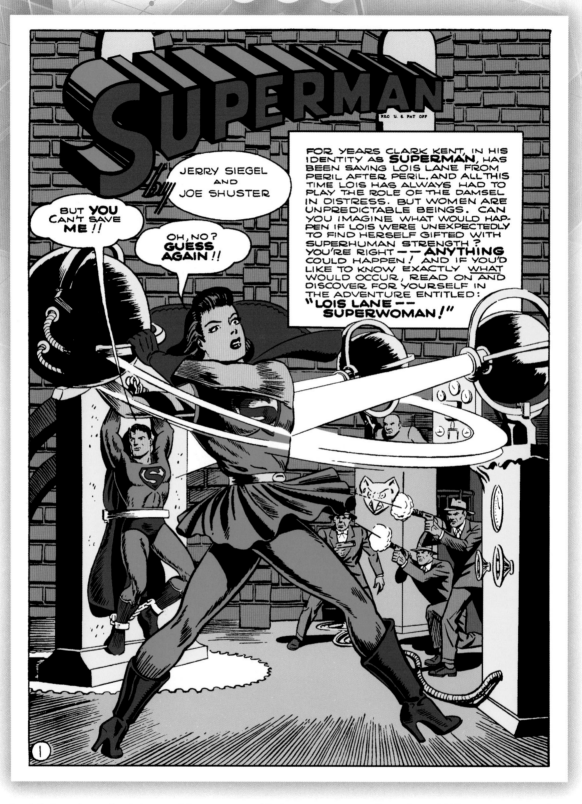

It might be a dream, but it is one of the most enjoyable dreams Lois Lane will ever have, fulfilling everyone's wish of having powers just like the Man of Steel.

Action Comics #60, May 1943
Writer: Jerry Siegel *Artists:* Joe Shuster & John Sikela

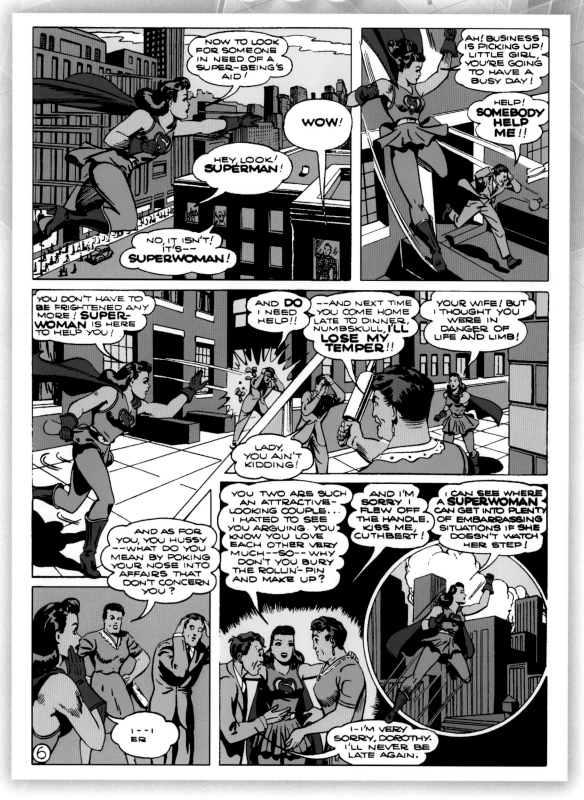

Action Comics #60, May 1943
Writer: Jerry Siegel Artists: Joe Shuster & John Sikela

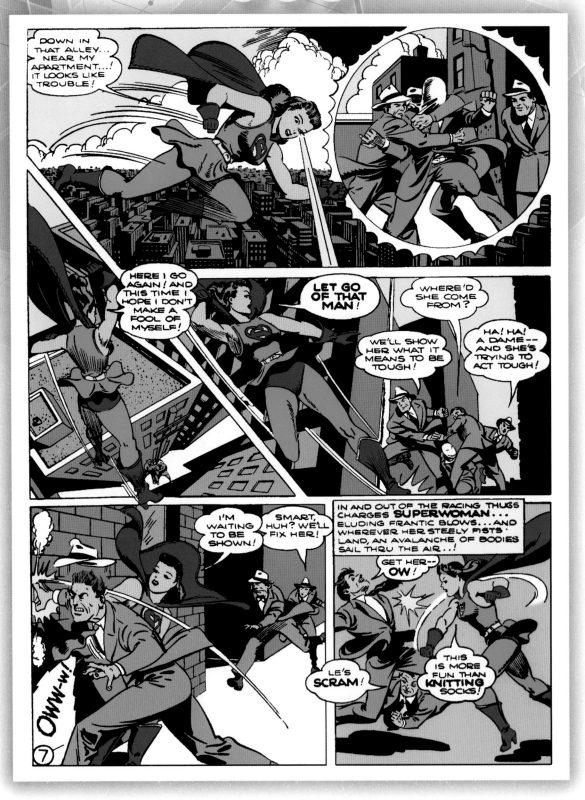

Action Comics #60, May 1943
Writer: Jerry Siegel *Artists:* Joe Shuster & John Sikela

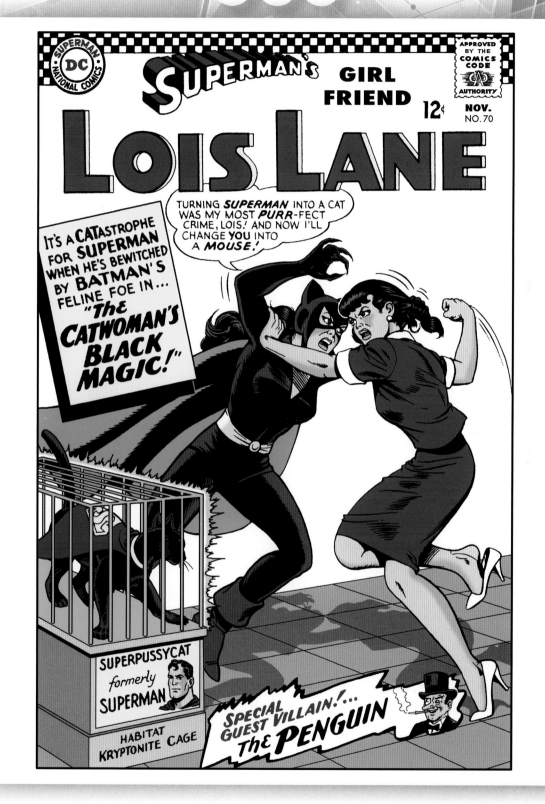

Lois Lane has her hands full, tracing the Penguin and then falling under Catwoman's hypnotic control.

Superman's Girlfriend Lois Lane #70–71, November 1966/January 1967

Artist: Kurt Schaffenberger

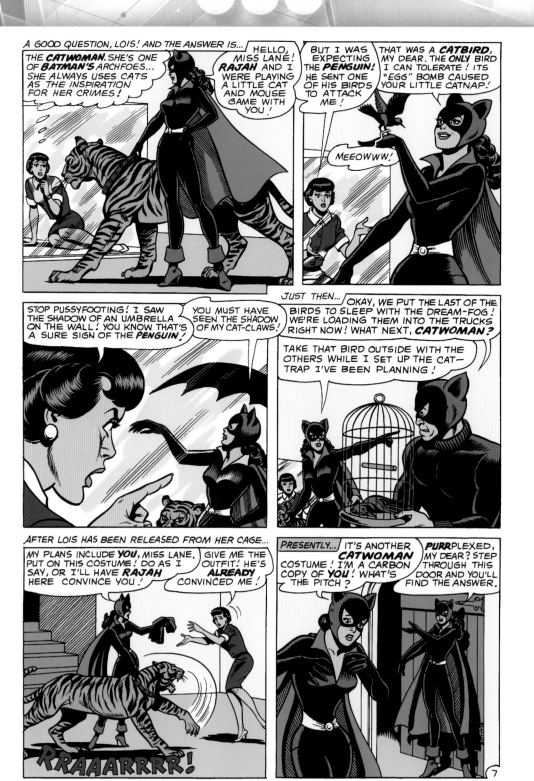

Superman's Girlfriend Lois Lane #70–71, November 1966/January 1967
Writer: Leo Dorfman *Artist:* Kurt Schaffenberger

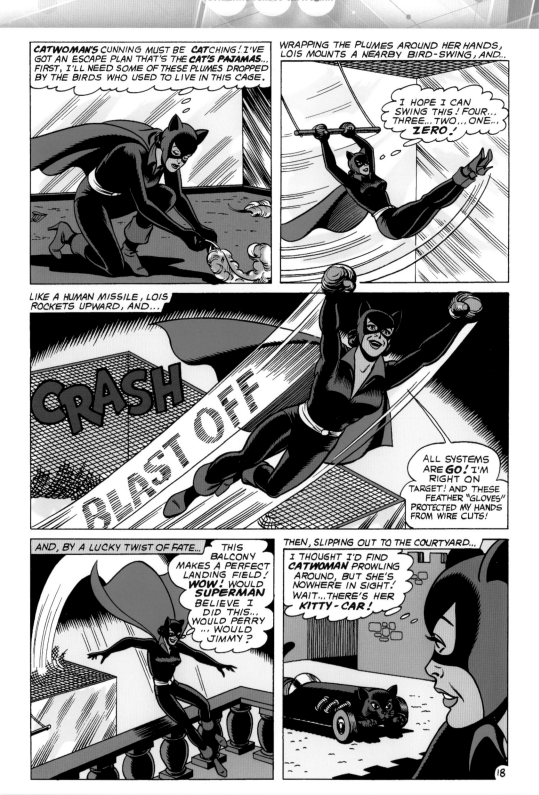

Superman's Girlfriend Lois Lane #70–71, November 1966/January 1967
Writer: Leo Dorfman *Artist:* Kurt Schaffenberger

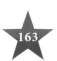

Just two women dishing about their men, but these women are far from ordinary, just like their partners.

Batman #37, February 2018
Writer: Tom King *Artist:* Clay Mann

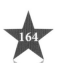

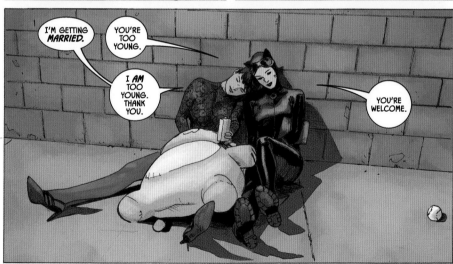

Batman #37, February 2018
Writer: Tom King *Artist:* Clay Mann

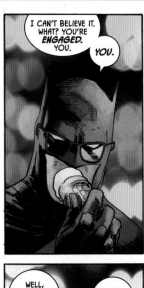

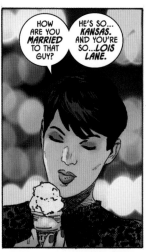

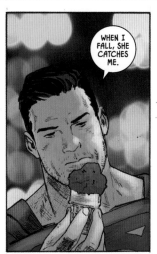

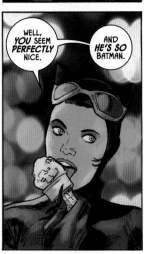

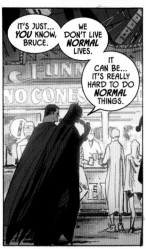

Batman #37, February 2018
Writer: Tom King *Artist:* Clay Mann

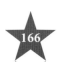

Batman #37, February 2018
Writer: Tom King *Artist:* Clay Mann

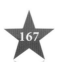

MA HUNKEL

SHELDON MAYER PRODUCED HIS SEMIAUTOBIOGRAPHICAL FEATURE ABOUT A BOY cartoonist named Scribbly with *All-American Comics* in 1940. Among the many characters to populate that world was Ma Hunkel, who ran the local grocer. Her daughter Sisty played with Scribbly's younger brother Dinky, so their worlds were intertwined.

58. BECOMING THE RED TORNADO

With the rise of comic books, Scribbly grew enamored of Green Lantern, which seemed to inspire Hunkel. When local toughs demanded "protection" money, she refused and chased them away, unaware that Sisty and Dinky had hidden in their car. She asked the police for help, but they refused, scared of the toughs' boss, a connected mobster. Taking matters into her own hands, she donned a pot and red long johns to rescue the kids as the Red Tornado. Readers responded to the gentle humor and Ma's antics, so the Red Tornado made numerous appearances in his strip, which led to a humorous cameo in *All Star Comics* #3, which brought All-American's heroes together to form the Justice Society of America.

In time, she was honored by other creators, and Red Tornado cameos popped up in unlikely places such as Mark Waid and Alex Ross's *Kingdom Come*. Later, Geoff Johns honored Mayer's creation by making Abigail Mathilda "Ma" Hunkel a caretaker of the JSA's New York City headquarters during his run on *JSA*. She acted as mentor to the youngest heroes, such as Stargirl, and even showed some gumption when wronged.

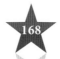

Ma Hunkel is loving and protective of her family, friends, and neighborhood. When required, she also becomes the Red Tornado, a cross-dressing hero who keeps everyone safe.

All-American Comics #22, January 1941
Writer/Artist: Sheldon Mayer

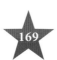

MARY MARVEL

59. MARY BATSON SAYS THE MAGIC WORD

In her introductory story, readers learned that Mary and Billy Batson were nursed by Sarah Primm, and when their parents died in a car crash, Sarah placed Billy in an orphanage but swapped Mary with an infant girl who had just died. On her deathbed, she summoned Billy from his radio assignment and revealed the truth, giving him half a locket with the news that Mary had the other half. As fate had it, one of the contestants on his radio show, Mary Bromfield, was wearing half a locket. As Captain Marvel, and accompanied by Captain Marvel Jr., they trailed Mary, which was fortuitous when she was kidnapped from her wealthy parents. The heroes swooped in to save the day, and then Mary realized that her locket matched Billy's. The boys were surprised by the kidnappers, who gagged them, but when Mary said, "Shazam," she was transformed into a powerful hero.

In the aftermath, the wizard explained that she drew her powers from Selena (grace), Hippolyta (strength), Ariadne (skill), Zephyrus (fleetness), Aurora (beauty), and Minerva (wisdom).

60. TEAMING WITH BULLETGIRL

Mary Marvel was rare in that she was a sibling rather than a significant other before becoming a hero. Rarer still, at a time when characters infrequently crossed over, Mary partnered with Bulletgirl (Susan Kent) to take on Doctor Riddle and the Weeper. In the 1946 story from brothers Otto and Jack Binder, it's clear that they know each other's identities and have a friendship despite the vast age difference. Interestingly, the story opens with Mary's high school graduation, which was missed by her brother and immediate friends, save for Susan. When Susan was attacked by her arch enemies, Mary said the magic word to come to her aid.

Mary Marvel and Bulletgirl's friendship survived the years, and after DC Comics acquired the Marvel Family of heroes, they worked alongside each other once more. In this case, the men were hypnotized by the seductive movements of a metahuman called Dreamdancer. When Mary sees Billy succumb, she seeks out Susan for help. Of course, Jim Barr (Bulletman) had also fallen prey to Dreamdancer's wiles, so it falls to Mary Marvel and Bulletgirl to put an end to the threat.

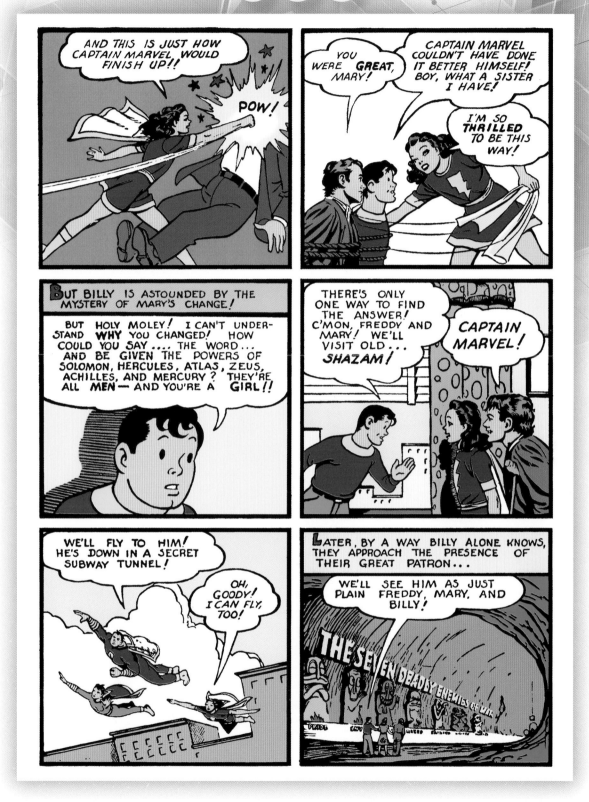

Mary Bromfield's world was turned upside down when Billy Batson revealed that he was not only her lost brother but also the World's Mightiest Mortal, Captain Marvel.

Captain Marvel Adventures #18, December 1942
Writer: Otto Binder *Artist:* Marc Swayze

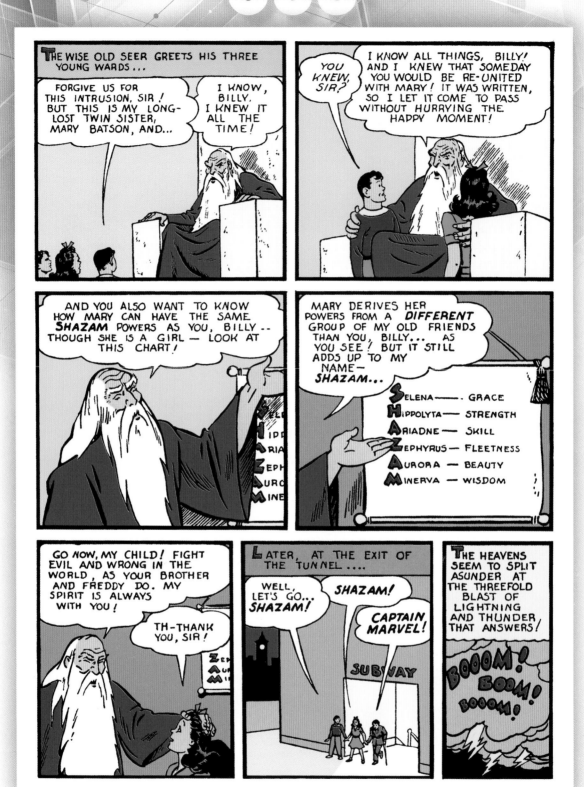

Captain Marvel Adventures #18, December 1942
Writer: Otto Binder *Artist:* Marc Swayze

Dreamdancer only thought she could control half the population and plunder at will. She hadn't counted on the high-flying partnership of Mary Marvel and Bulletgirl.

World's Finest Comics #255, February/March 1979

Writer: E. Nelson Bridwell *Artists:* Don Newton & Kurt Schaffenberger

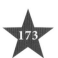

World's Finest Comics #255, February/March 1979
Writer: E. Nelson Bridwell *Artists:* Don Newton & Kurt Schaffenberger

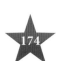

MERA

MERA FIRST ARRIVED ON EARTH AS A FUGITIVE, THE QUEEN OF AN OTHERDIMENSIONAL water-world who was being pursued by the usurper Leron. With the help of Aquaman, the villain was defeated, but Mera was smitten with her defender. Aided by her chief scientist Xebel, the red-haired queen made frequent returns to Earth, employing her formidable hard-water powers alongside Aquaman and Aqualad in their adventures.

Informed by Xebel that the dimensional unit would soon cease to function, Mera abdicated the throne and relocated to Earth permanently. Her arrival coincided with Aquaman's ascension to king of Atlantis, and a royal wedding soon followed. Within a year, the family unit expanded to include a son, Arthur Jr. Beside Aquaman, she ruled wisely and was largely beloved by her people, but his arch foes became her own.

61. TRYING TO SAVE HER SON

At one point, Black Manta managed to kidnap Mera's son, placing him within a translucent tank where he would suffocate. Vulko, the royal adviser, sent Mera back to her homeworld to find Xebel, the scientist that had a special healing machine that could save the child. When she arrived, Leron had once more taken the throne and had imprisoned Xebel. When he learned what Mera wanted, the device was tossed into the Great Pit. She struggled to obtain it, swimming deep and fighting monsters, and succeeded only to return to Earth and learn that she was too late. Her son had died.

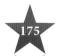

62. TAKING ON THE JUSTICE LEAGUE

In the Rebirth reality, Mera was raised by the king and queen of Xebel, taught to believe they were exiled to another dimension by the king of Atlantis. She was trained to slay the current king in an act of revenge, then go home to marry Nereus, their military leader. When she arrived through the dimensional barrier, she was stunned to learn that the king was also a brave, courageous hero. Over lunch they talked and learned about each other, and during this, she finally read a note from her mother, urging her to choose her own path. She chose Aquaman.

They adventured on land and undersea together. She didn't understand his fascination with living among humans in Amnesty Bay but grudgingly accompanied him and tried to keep an open mind. Together, they fought threats above and below the surface, managing the fragile peace between the realms. The Ocean Master, Aquaman's brother, sought to change that with an all-out war, but Mera's keen instincts led her to warn Aquaman and Batman. She fought alongside the Justice League to protect all life.

Later, she fended off an attack from her sister Hila, the Siren, and once more rejected Xebel. Not long after, Aquaman finally proposed, and they become engaged.

What neither anticipated was that the Atlantean people would grow weary of Aquaman's frequent absences. They replaced him with Corum Rath, making him an exile. He was believed killed by Murk, leader of the armed forces. In her grief and fury, Mera sought out the Justice League to vent her rage and singlehandedly took them down. Her emotions spent, they grieved with her and welcomed her to the team as his replacement, although none of them believed the Sea King dead. When Aquaman and Mera were united, they were presented with a radical idea from the forces opposing Rath: She would be named Atlantis's queen-in-exile, poised to reclaim the throne once Aquaman and his allies toppled the tyrant.

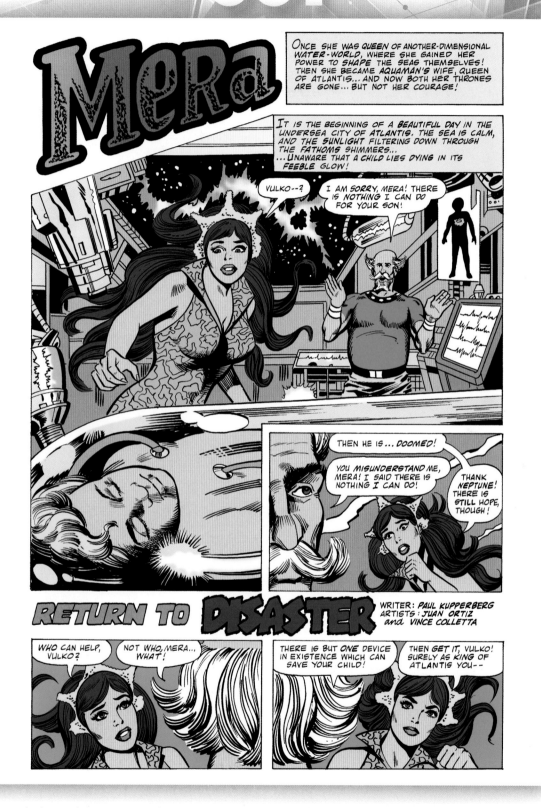

Mera risked everything to return to her home of Xebel and find the device that would save her son, only to learn she was too late.

Aquaman #58, November 1977
Writer: Paul Kupperberg *Artists:* Juan Ortiz & Vince Colletta

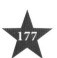

Aquaman #58, November 1977
Writer: Paul Kupperberg *Artists:* Juan Ortiz & Vince Colletta

Aquaman #59, January 1978
Writer: Paul Kupperberg *Artists:* Juan Ortiz & Vince Colletta

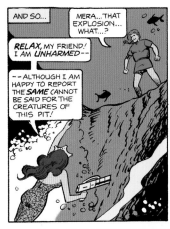

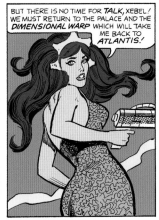

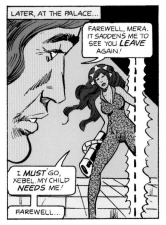

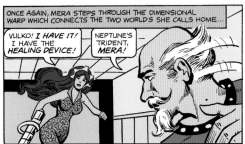

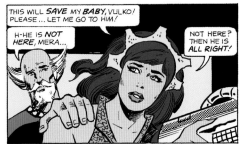

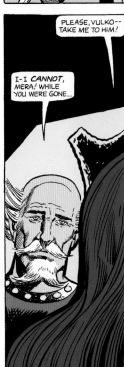

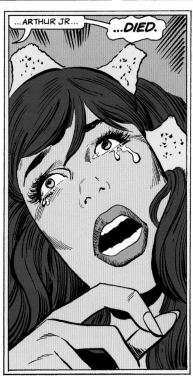

Aquaman #60, March 1978
Writer: Paul Kupperberg *Artists:* Juan Ortiz & Vince Colletta

Enraged over her betrothed's apparent death, Mera vented by taking on the Justice League, reminding them of her cunning and power.

Justice League #24, September 2017
Artists: Paul Pelletier, Sandra Hope & Hi-Fi Design

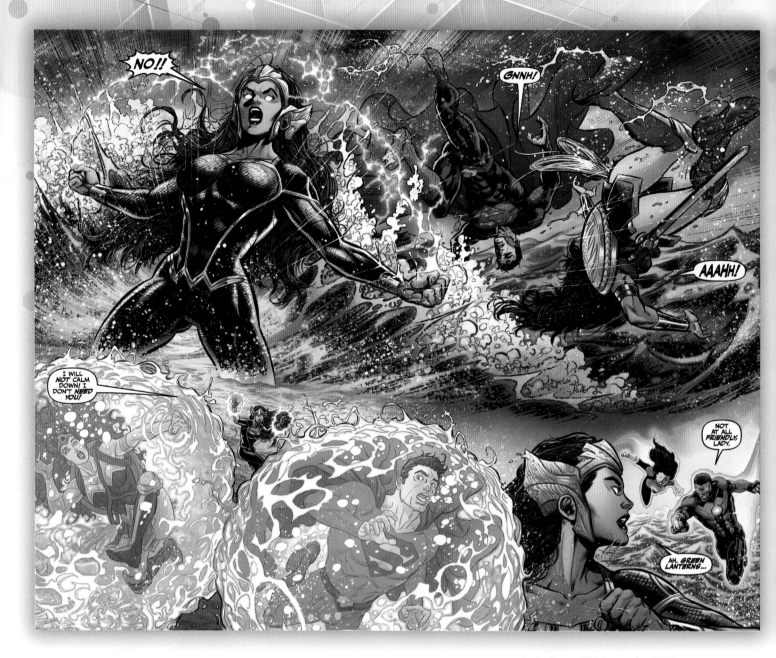

Justice League #24, September 2017
Writer: Dan Abnett Artist: Ian Churchill

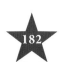

Justice League #24, September 2017
Writer: Dan Abnett *Artist:* Ian Churchill

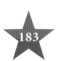

NIGHTSHADE

IN THE 1980S, DC COMICS ACQUIRED THE CHARLTON ACTION HEROES, AND NIGHTSHADE was integrated into the post–Crisis on Infinite Earths reality. Echoing her Charlton history, she hailed from another dimension where everyone could transform into two-dimensional shadows. When Maureen and her children, Eve and Larry, were attacked by something called the Incubus, she brought Eve to Earth. Young Eve swore she would find her brother.

Eve went to work for the government's Task Force X, initially partnering with King Faraday before adventuring as Nightshade. The public was led to believe she and Captain Atom were an item, but that was more to protect his cover. In time, Amanda Waller recruited her for the Suicide Squad, sending her and Nemesis to learn about the Middle Eastern terrorists called the Jihad. The mission deeply affected her, so Waller assigned Nightshade to keep an eye on the unstable Enchantress.

63. RESCUING HER BROTHER

Nightshade finally revealed her full backstory to the team, preparing them to help her rescue her brother, trapped somewhere in the Land of the Nightshades. Apparently, Maureen had brought both children to Earth, but when word reached her that the Incubus was dead, she brought them back to see. It had been a ruse, leaving Maureen dead and Larry taken by the Incubus's acolytes.

She took her team, including a drunken Captain Boomerang, into the Land of the Nightshades and was greeted by Larry, who was now possessed by the Incubus and wanted his sister to serve at his side.

Nightshade proved more mentally stable and was able to resist the possession and destroy the Succubus. Deadshot then dispatched the Incubus; Larry was long since gone.

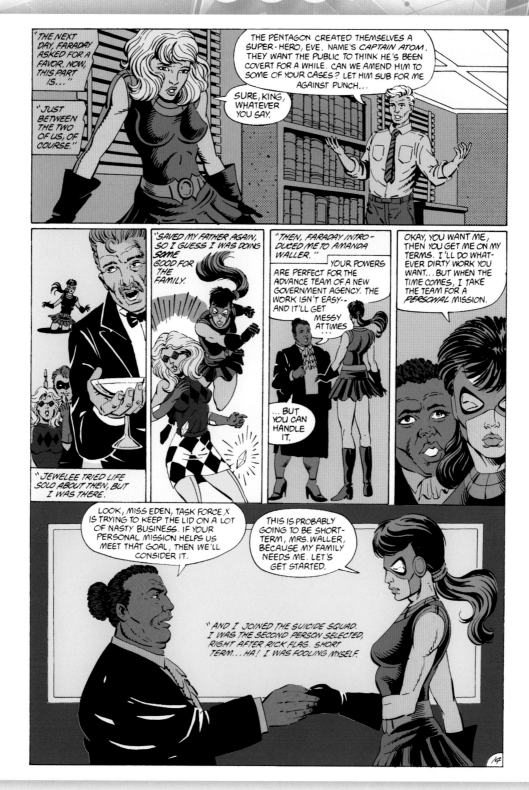

Nightshade agreed to join the Suicide Squad so they would help her rescue her trapped brother, never realizing they would all nearly die in the process.

Secret Origins #28, July 1988
Writer: Robert Greenberger *Artists:* Rob Liefeld & Bob Lewis

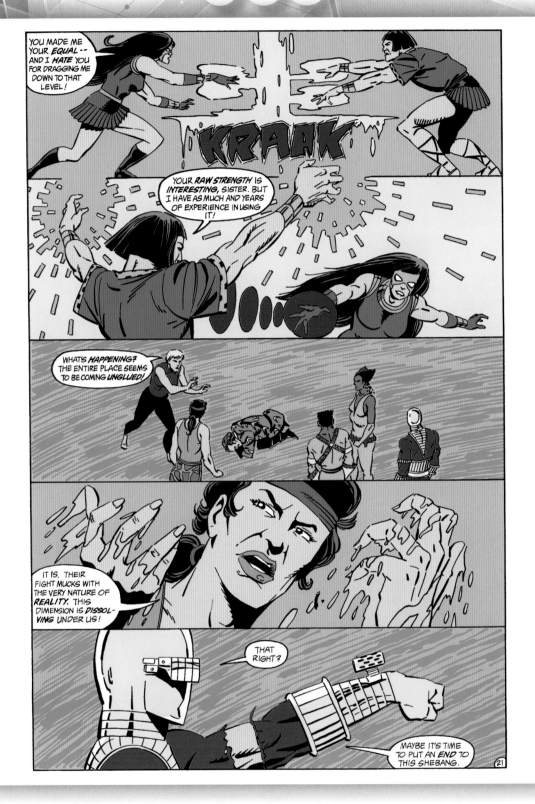

It's brother versus sister in the Nightshade dimension, and the Suicide Squad find themselves outpowered but unwilling to submit.

Suicide Squad #16, August 1988
Writer: John Ostrander *Artists:* Luke McDonnell & Malcolm Jones III

PHANTOM LADY

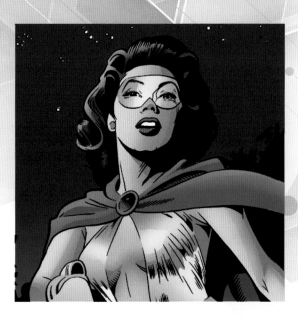

PACKAGED FOR QUALITY COMICS BY THE EISNER-IGER SHOP, *POLICE COMICS* WAS PACKED with interesting characters including Plastic Man and Phantom Lady. The latter, was Sandra Knight, the socialite daughter of Senator Henry Knight. She donned a green and yellow outfit, wielding a blackout gun and fighting crime.

DC Comics acquired the Quality heroes in the 1950s, and in the 1970s, they introduced Phantom Lady as a member of the Freedom Fighters, still waging World War II on Earth-X. After the Crisis on Infinite Earths left just one universe, she was fully integrated; not only was Henry her father, but now Ted Knight, another wealthy crime fighter, was her cousin.

Post-Flashpoint, Jennifer Knight was just a young child when her parents were killed. Her father was a *Daily Planet* reporter who got too close to a story about the criminal Bender family. As an adult, Jennifer tried to infiltrate the family but was exposed and sought help from her friend, scientist Dane Maxwell. He gave her a special suit and gloves, letting her fight as Phantom Lady.

64. AGAINST THE PRAIRIE WITCH

In one memorable flashback issue, Sandra Knight was operating in Opal City and encountered Abigail Moorland, the green-skinned Prairie Witch, who had distracted Starman by firebombing the Opal Orphanage. The witch was a true sorcerer who used her magic abilities to fly and unleash energy. With little choice, Phantom Lady sought the witch on her own, and they battled before she emerged victorious.

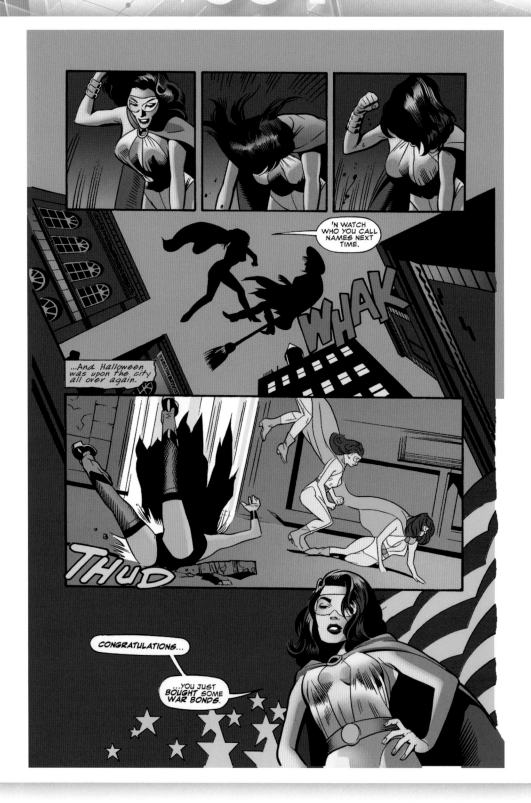

Sandra Knight demonstrates the abilities that make up a hero, including courage and bravery, as she takes down the more powerful Prairie Witch.

Starman #44, July 1998

Writer: James Robinson *Artists:* Mike Mayhew & Wade von Grawbadger

POWER GIRL

GERRY CONWAY HAD BEEN HIRED TO CREATE A NEW LINE OF COMICS AND DECIDED TO revisit the Justice Society of America, but rather than make it a book about aging heroes on Earth-2, he decided to add some fresh blood and play with the dynamics. It was easy to take an adult Dick Grayson and the Star-Spangled Kid from the existing continuity, but desiring raw strength, he needed to create someone new.

Earth-2 didn't have a Supergirl, so Conway created one, dubbing her Power Girl to help DC secure a fresh trademark.

65. JOINING THE JUSTICE SOCIETY OF AMERICA

In the last pages of *All-Star Comics* #58 (picking up the numbering from when the JSA last had their own series), Power Girl arrived to help Wildcat and the Flash deal with a volcano in Peking (now Beijing), China. She introduced herself as Superman's cousin, which was news to the heroes.

Power Girl was brash and aggressive, calling the heroes chauvinists and asserting her independence, as seen in her name and costume. She even bristled when Superman finally made an appearance to give the team his endorsement. She was a feminist icon during the height of the women's movement as it shifted from politics to pop culture. Readers thrilled to see her race the Flash or arm-wrestle Wildcat for fun.

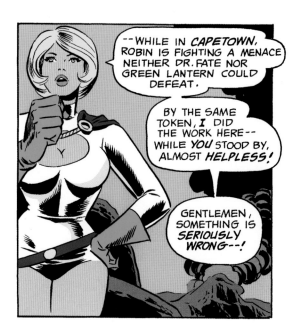

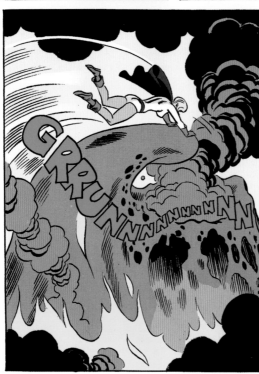
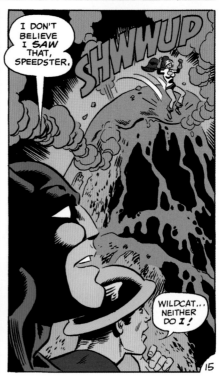

To a team of aging heroes, a young, fresh-faced woman with powers and abilities far beyond those of mortal men was something to behold.

All-Star Comics #58, January/February 1976
Writer: Gerry Conway *Artists:* Ric Estrada, Wally Wood & A. L. Sirois

PRINCESS PROJECTRA

A PRINCESS FROM THE WORLD OF ORANDO IN THE 30TH CENTURY, PROJECTRA WAS unique in possessing the ability to generate realistic three-dimensional illusions. As she neared adulthood, she left the royal family and journeyed to Earth, applying for membership in the Legion of Super-Heroes. She quickly acclimated herself to the advanced technology of the United Planets compared with her homeworld, acquitting herself as a Legionnaire. She fell in love with fellow new recruit Val Armorr, Karate Kid.

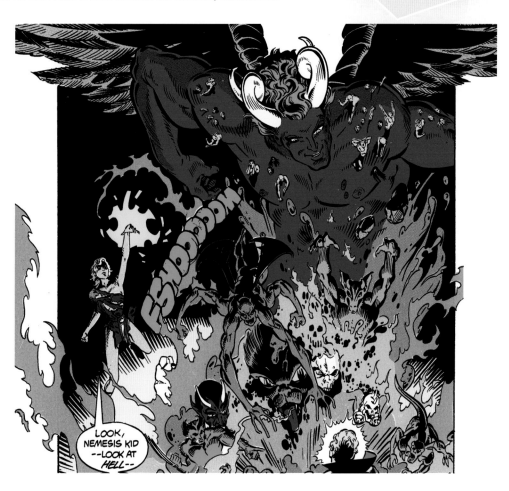

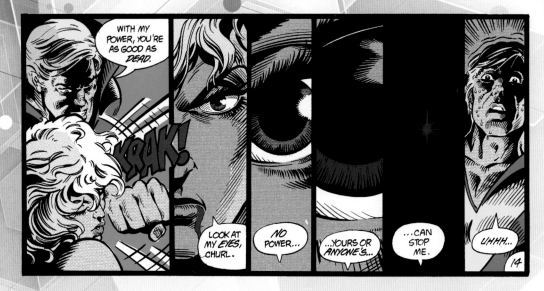

Jeckie, as she was nicknamed, joined the Legion on cases across time and space, but when her father, King Voxv, died, she had to return home and fight for the throne. She was challenged not only by her cousin Pharoxx but also her mentor and grandmother, Hagga. As Queen Projectra, she and her then-husband Karate Kid became Legion reservists after relocating to Orando.

66. EXECUTION

When danger arrived in the form of the Legion of Super-Villains, which invaded the world, Pharoxx invited them to use Orando as their new base of operations. Among their ranks was Nemesis Kid, who had joined the Legion at the same time as Projectra and Karate Kid but turned traitor. He wanted to move the world to another dimension from which the Super-Villains could covertly operate. The newlyweds returned from their honeymoon to find their former teammate awaiting them. Nemesis Kid and Karate Kid faced off in a confrontation that ultimately left Jeckie's husband dead, as he sacrificed himself to destroy the villains' power source.

After the Legion of Super-Heroes helped bring about the other team's defeat, the Queen invoked royal privilege and executed Nemesis Kid for his crime. Given the Legion's code against murder, she resigned from the team rather than besmirch their reputation. After Karate Kid's funeral, she used the Super-Villains' technology and original plan to relocate Orando to a separate dimension, where she hoped to keep them safe.

67. AGAINST THE EMERALD EMPRESS

Seeking solace, Projectra turned to studying Orando's mystic beliefs and not long after was told by the Council of Orakills to repent for indirectly bringing the villains to Orando. Her mission was to return to the other realm and gain admittance to the Legion as someone other than her royal self. Using her magically enhanced powers, she returned to the team in the guise of the masked Sensor Girl, where she served with distinction. The only member who knew the truth was cofounder Saturn Girl, who vouched for her. Along the way, Projectra used her illusionary powers to confound opponents and keep the Legion unaware of her true nature. For a time, Brainiac 5 and others thought the blonde hero might actually be a resurrected Supergirl, who had died during the recent Crisis on Infinite Earths.

It wasn't until she was in battle with the Fatal Five's Emerald Empress that her identity was finally exposed. The Empress sensed a kindred spirit in Sensor Girl, forcing her hand. Most Legionnaires remained unaware of this turn of events. The Council, aware of her bravery over the Empress, invited her to return and rule, but she rejected them in favor of her longtime teammates, who went on to vote her in as Legion leader for a term.

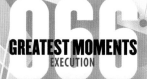

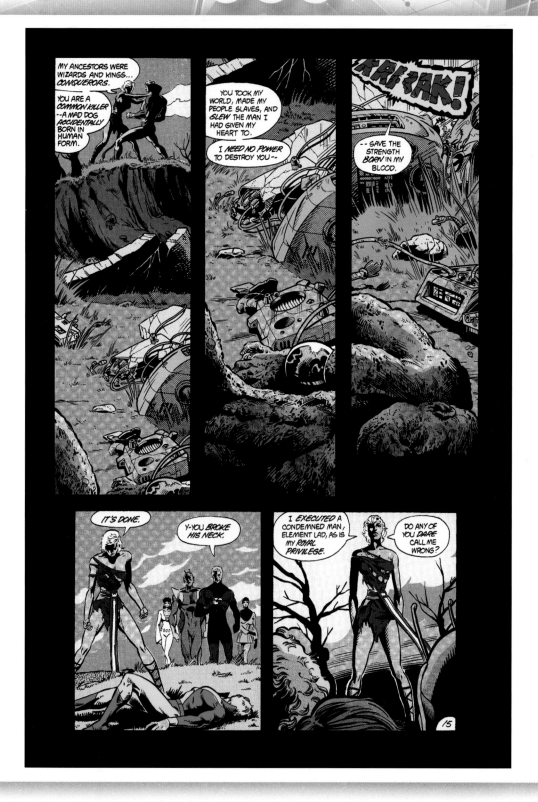

Queen Projectra was grieving but stoic when she chose to execute Nemesis Kid for the murder of her consort, Karate Kid.

Legion of Super-Heroes #5, December 1984
Writer: Paul Levitz *Artists:* Steve Lightle & Larry Mahlstedt

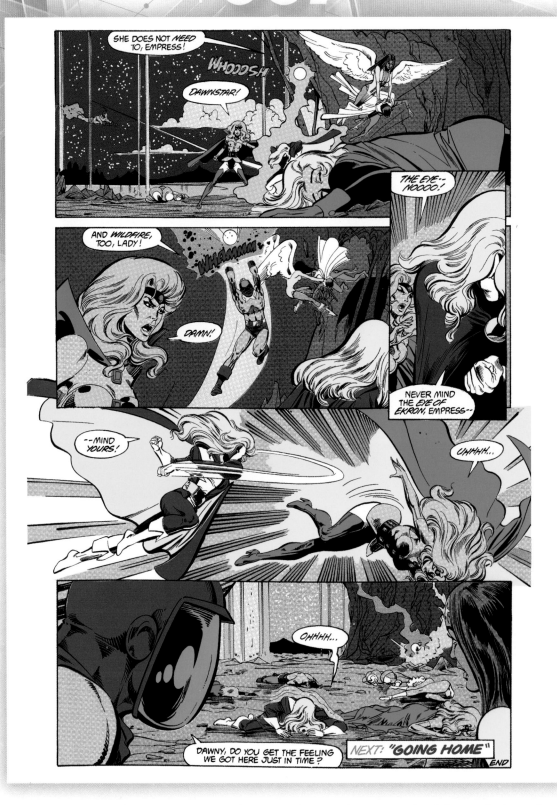

Having taken the role of Sensor Girl as an act of penance, she proved instrumental in defeating the latest threat to the galaxy from the Fatal Five.

Legion of Super-Heroes #26, September 1986
Writer: Paul Levitz *Artists:* Greg LaRocque, Mike DeCarlo & Arne Starr

RAVEN

IMAGINE DISCOVERING THAT YOUR MOTHER, ANGELA ROTH, HAD JOINED A SATANIC CULT resulting in her being raped by Trigon, the demon lord of a hellish dimension. Pregnant, she was to carry a vessel that would allow Trigon access to Earth. Instead, a pacifist cult takes Angela, now called Arella, to Azarath, a safe dimension where you, Rachel, also called Raven, are born. Now the granddaughter of Azar herself raises you, training you to use your gifts with sensitivity and control, to prevent your father from taking possession.

Then Trigon comes for you, and your soul self emerges for the first time, frightening you and confirming that you are the devil's daughter. Now you're eighteen and can feel Dad's influence growing within you, and you want to stop it but need help. You visit Earth for the first time and ask the Justice League for help, but Zatanna senses your father's presence and sends you away. Instead, you find yourself banding together with other teens, uniting to form a force to repel Trigon's eventual arrival.

Raven had manipulated the team into forming, but in time, she admitted her fault and her great need for help. She acquitted herself in combat and tentatively formed bonds of friendship, somehow earning Kid Flash's heart in the process. In time, Trigon arrived, and the Titans, forged in fire, managed to protect the Earth and turn aside Trigon's advance. Instead, Arella arrived to help, and with Trigon locked in an interdimensional prison, she became its gatekeeper.

68. DAUGHTER VERSUS FATHER

The terror of Trigon manifested itself by first destroying the gentle realm of Azarath, and the resurgence overwhelmed Raven, letting Trigon assert total control. Her skin turned red and she sprouted additional eyes and the bone-horns that were her father's legacy. Worse, when the Titans rallied to her side, they fell under Trigon's control and their dark personas emerged. During the battle, though, Raven died. As it turned out, this had to happen, allowing the souls of Azarath to use the corpse as a funnel, bringing their power to the battle. With Arella and fellow Titan Lilith beside her, the power was more than Trigon could handle, and he was beaten once again.

Raven's life force returned to her body, and in a burst of white light, she arose and seemingly vanished.

In time, she returned to Earth, captured by Brother Blood, but once more, the Titans came to her rescue. In the wake of that battle, the indigo-clad woman now wore white and for the first time in her young life experienced self-determination.

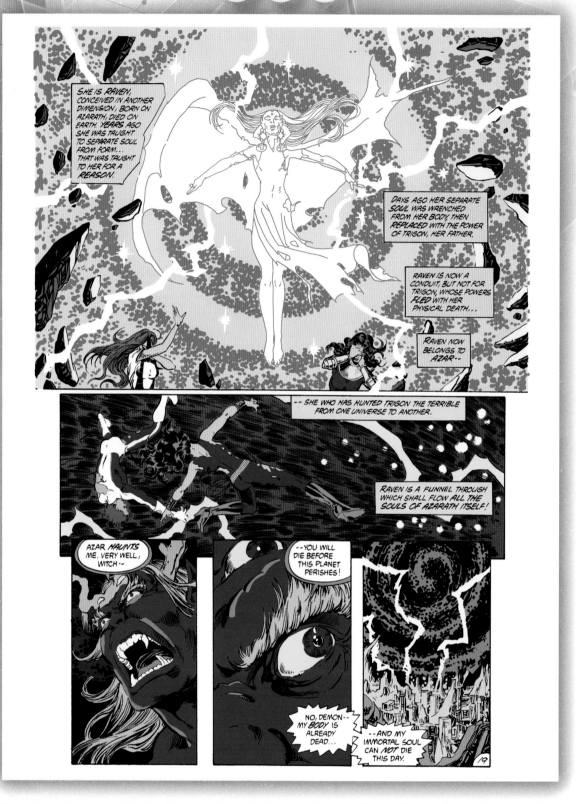

Raven is nearly consumed by her father, the demonic Trigon, and it takes all her willpower along with a lot of effort from her comrades in the Titans to prevail—and save the world.

New Teen Titans #5, February 1985
Writers: Marv Wolfman & George Pérez *Artists:* George Pérez & Romeo Tanghal

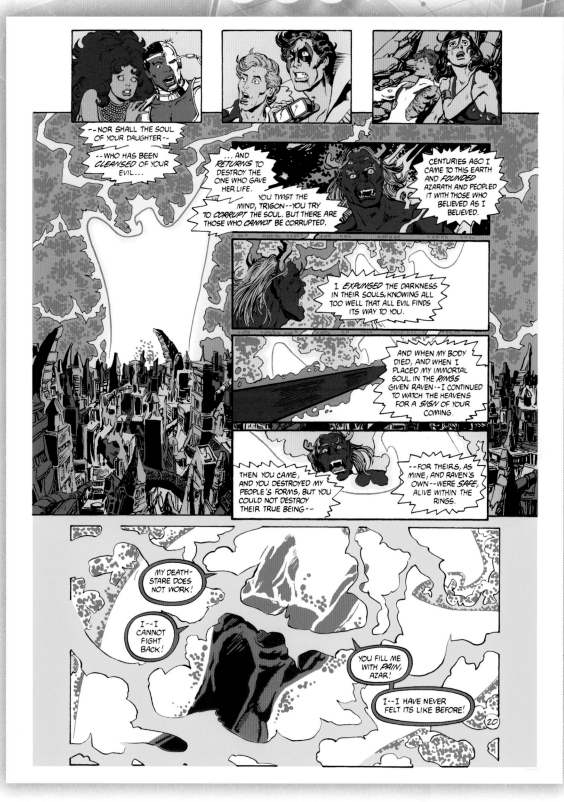

New Teen Titans #5, February 1985
Writers: Marv Wolfman & George Pérez *Artists:* George Pérez & Romeo Tanghal

ROBIN

BATMAN NEEDS A ROBIN. THAT HAS BEEN A RECURRING THEME SINCE THE FIRST SIDEKICK in comics was introduced as the "Sensational Character Find of 1940." Over the years, whenever Batman was on his own, he grew withdrawn, more violent, and in need of someone to temper his thirst for vengeance over justice. First came Dick Grayson, who grew up and adopted the identity of Robin. He was followed by street urchin Jason Todd, who was beaten to death only to be reborn as the Red Hood. Young Tim Drake deduced Batman's secret identity and after Todd's death, he proved his worth, becoming the third Robin.

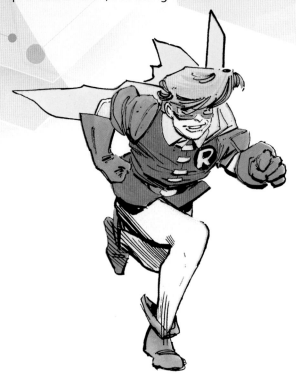

69. CARRIE KELLEY BECOMES ROBIN

Then came *The Dark Knight*, a speculative miniseries written and drawn by Frank Miller that postulated that at fifty or so, Bruce Wayne had aged out of crime fighting. However, a besieged Gotham City needed a champion, so once more he donned the cape and cowl. His actions inspired thirteen-year-old Carrie Kelley after she had been attacked by muggers and saved by the grizzled hero. With her lunch money, she acquired a makeshift Robin outfit and took to the streets with her slingshot.

Her optimistic attitude and disposition quickly made her a favorite part of the landmark miniseries.

70. STEPHANIE BROWN BECOMES ROBIN

Chronologically, though, following Tim Drake as Robin was Stephanie Brown, although she did not last long. She was the daughter of Arthur Brown, the costumed criminal known as Cluemaster. Stephanie came to resent her loser of a father and his constant return to crime, when it was clearly not something he was good at. In her mind, the only way to stop him was through an intervention, although her approach was unique. She designed and wore a purple-cloaked outfit and showed up to interfere with his crimes as the Spoiler.

A curious thing happened, though. Stephanie came to enjoy the life of a costumed adventurer and soon donned her outfit to run the Gotham City rooftops alongside Robin, on whom she'd developed a crush.

Another curious thing was how deeply she was loved by the readership, who cheered her on. They wanted the Tim-Stephanie romance to last and were delighted when she and Cassandra Cain became close friends, as the new Batgirl taught Spoiler to be a better fighter.

At one point, while Robin was out of town, Batman—who normally kept his distance from her—surprised Spoiler with an invitation to train together. He went further, revealing Robin's real name to her, something Tim Drake had kept to himself. She also received training for a time from Black Canary as a favor to her fellow Bird of Prey, Oracle. That all ended when the Dark Knight determined she did not have what it took for their dangerous careers and asked the Birds to end their help.

Undaunted, when she learned that Tim had hung up his cape at his father's insistence, she crafted her own Robin outfit and accessed the Batcave. She begged the Caped Crusader for a chance to be the fourth Teen Wonder. He agreed to train her and see if she could improve, but he warned her that if she disobeyed an order even once, she was through.

For seventy-one days, she trained hard and patrolled with Batman, absorbing more than she thought possible. In addition to her successes, she also did as he expected and saved his life by disobeying an order. When the mission was done, she was fired and banned from the Batcave.

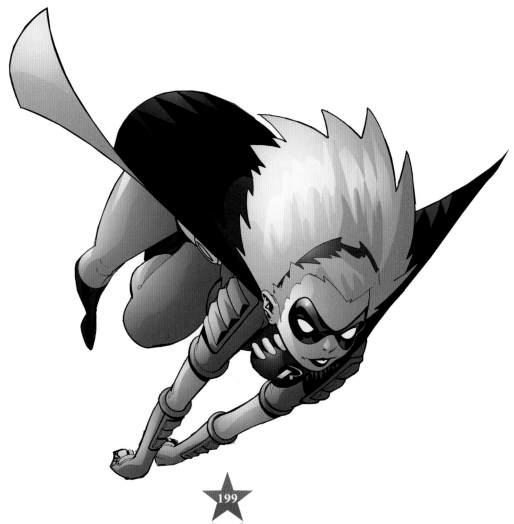

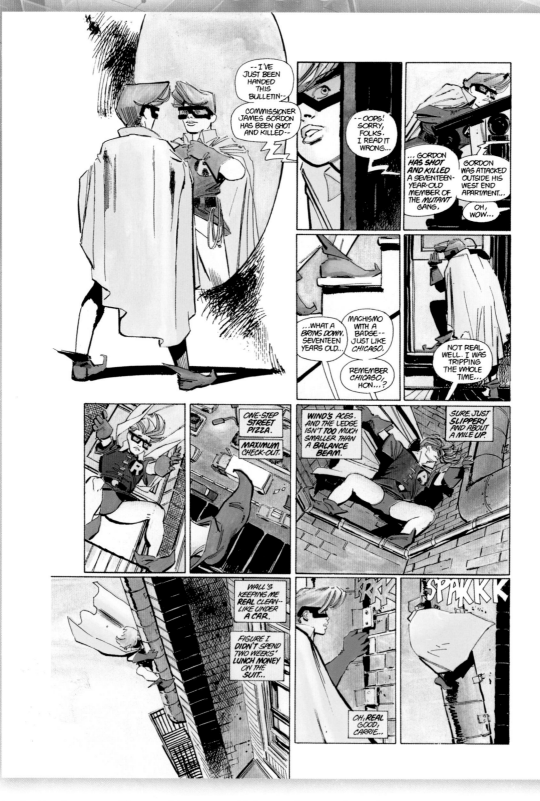

Inspired by the return of Batman, thirteen-year-old Carrie Kelley made herself a Robin outfit and proved incredibly plucky and loyal, perfect qualities for a sidekick.

Batman Dark Knight Returns #2, July 1982
Writer/Penciller: Frank Miller *Inkers:* Frank Miller & Klaus Janson

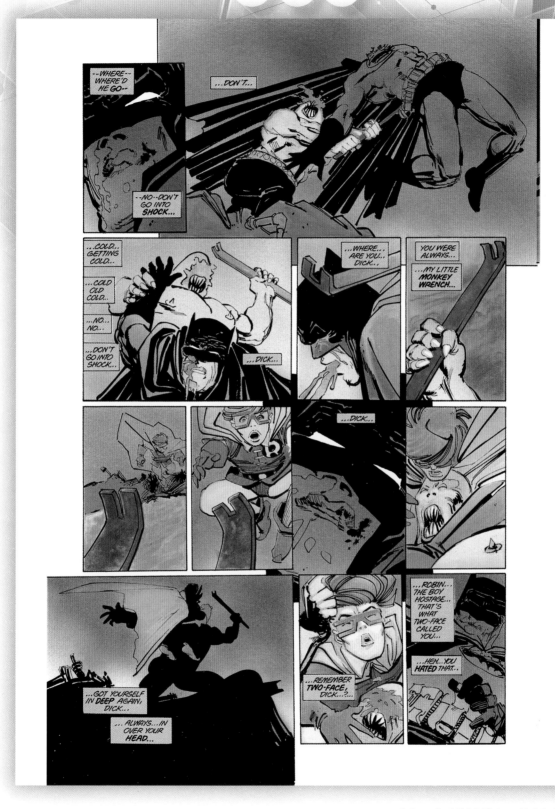

Batman Dark Knight Returns #2, July 1982
Writer/Penciller: Frank Miller *Inkers:* Frank Miller & Klaus Janson

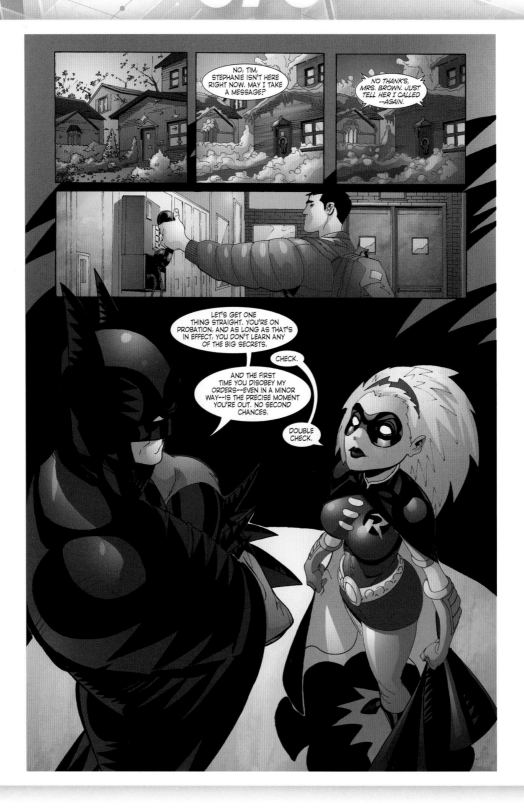

Batman trained Stephanie Brown for seventy-one days before she disobeyed an order that led him to fire her as the fourth Robin, something she never really got over.

Robin #126, July 2004
Writer: Bill Willingham *Artist:* Damion Scott

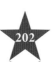

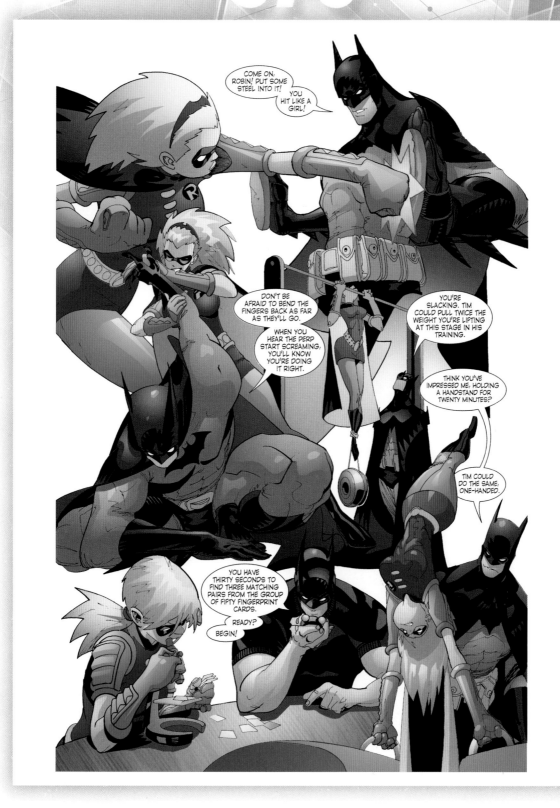

Robin #126, July 2004
Writer: Bill Willingham *Artist:* Damion Scott

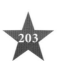

SATURN GIRL

IMRA ARDEEN WAS THE MOST ACCOMPLISHED TELEPATH ON TITAN, THE SATURNIAN MOON that had been colonized by man centuries earlier. En route to Earth to join the famed Science Police, she was instrumental in preventing billionaire R. J. Brande from being assassinated. Working seamlessly with Rokk Krinn, from Braal, and Garth Ranzz from Winath, they disarmed the man. Impressed, Brande suggested the teens band together and form a group, protecting all, much as Superboy did in the 20th Century. And so the Legion of Super-Heroes was born.

71. LEGION LEADER

As a cofounder, Saturn Girl was always well regarded, although she sometimes appeared cold and aloof, largely because of her mental shields, which kept her from intruding on others' thoughts. That did not prevent Garth, now called Lightning Lad, from falling in love with her. When she learned of a prophecy that a Legionnaire would die repelling the Khundish fleet of Zaryan the Conqueror, she used her powers to manipulate her teammates into voting for her as their next leader. Then, when the attack came, she ordered them not to use their powers, preparing to sacrifice her life for the team. Lightning Lad defied her, and was the member to die.

When the team discovered that there was a way to revive their comrade but at the price of one of their lives, Imra once more arranged things so she would die. And again, fate intervened, as Proty, Chameleon Boy's shape-shifting Durlan pet, masqueraded as her and sacrificed itself so that Lightning Lad and Saturn Girl would live. After the team learned of her manipulation, they recognized her self-sacrifice and allowed her to remain leader, which earned her a more legitimate second term a year later. Later on, she tied in a vote for leadership.

In seeing the depth of Lightning Lad's feelings, Imra finally opened herself up to loving him. In time, they would marry and have children. This led the pair to retire from action, which proved short-lived, as they answered the call during Mordru the Merciless's attack during the events of Earthwar. Being a Legionnaire meant everything to her, and regardless of which reality was being recorded, Saturn Girl was there from the beginning and served, saving Earth and/or the universe repeatedly.

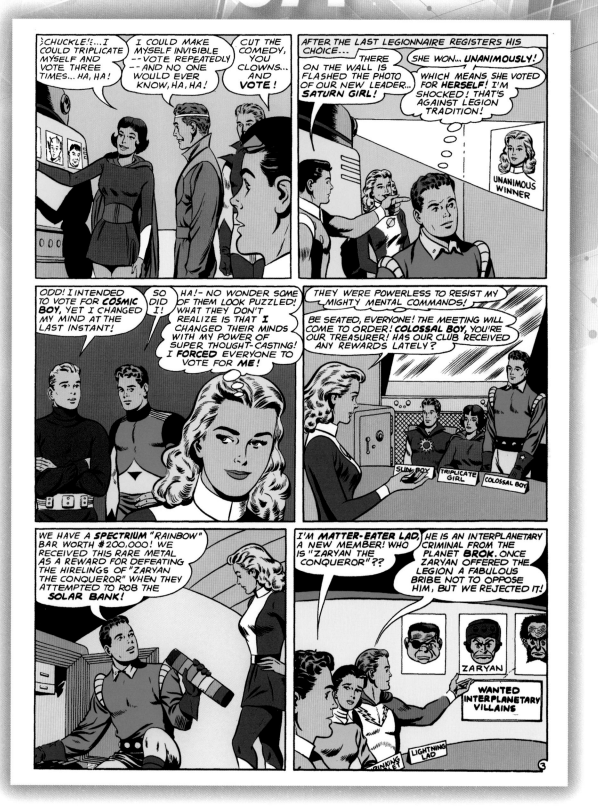

Though cofounder Cosmic Boy was the team's first leader, Saturn Girl's heroism earned her the title of the first two-term leader.

Adventure Comics #304, January 1963
Writer: Jerry Siegel *Artist:* John Forte

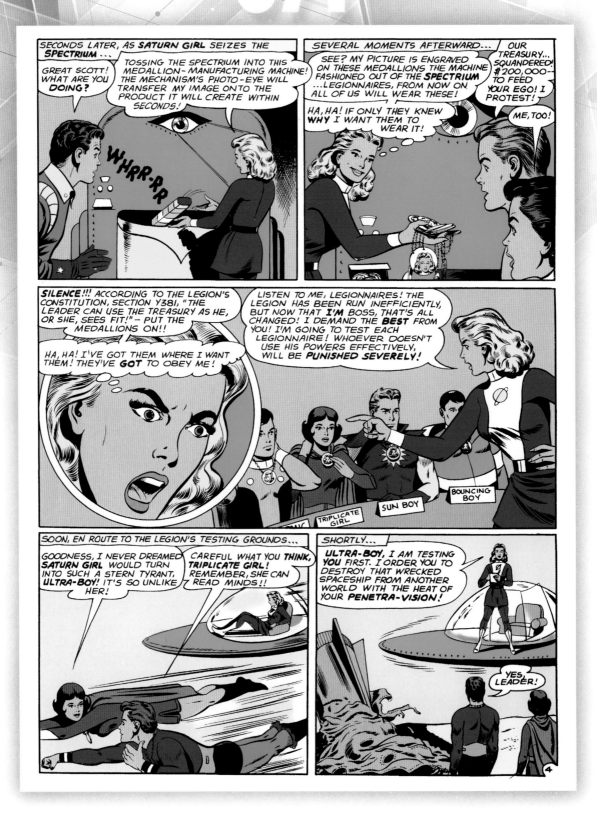

Adventure Comics #304, January 1963
Writer: Jerry Siegel Artist: John Forte

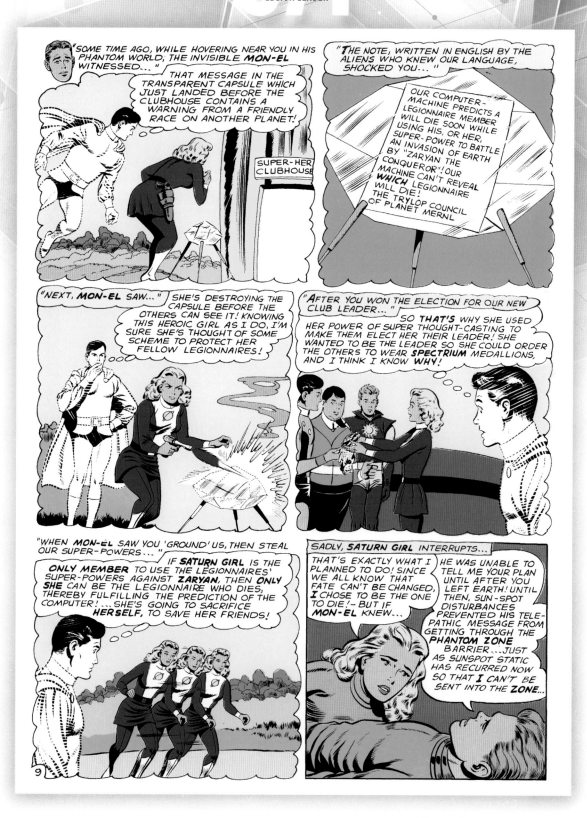

Adventure Comics #304, January 1963
Writer: Jerry Siegel Artist: John Forte

SCANDAL AND KNOCKOUT

LOVE IS A RARE COMMODITY ON APOKOLIPS, ESPECIALLY FOR THOSE RAISED BY GRANNY Goodness to serve as one of her Female Furies. The woman called Knockout was a curvaceous 6'1", 200-pound bruiser who liked her work. Still, inspired in part by Big Barda, she fled Granny for life on Earth, arriving in Hawaii. There, she battled Superboy for the sheer joy of it. He saw a spark of good in her and wanted to fan that into a flame, only to learn that she had remorselessly killed a police officer. He had her imprisoned for the crime.

In time, though, she was released and at some point met Scandal Savage, daughter of the immortal villain Vandal Savage. The two fell in love, and Scandal, a member of the criminal group Secret Six, asked her to infiltrate the Secret Society of Super-Villains.

They committed crimes, traveled the world, and let their romance deepen until the vacation in Bangkok where they were attacked by the sniper Pistolera. Knockout took the shot meant for her lover and threw Scandal into the ocean to prevent her from being harmed as the explosive bullets discharged. Her alien physique was badly injured, but she healed in time.

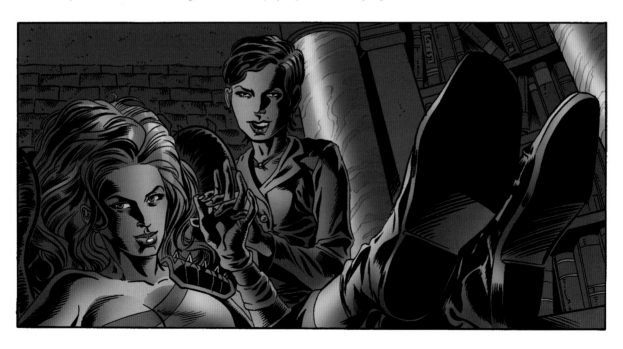

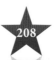

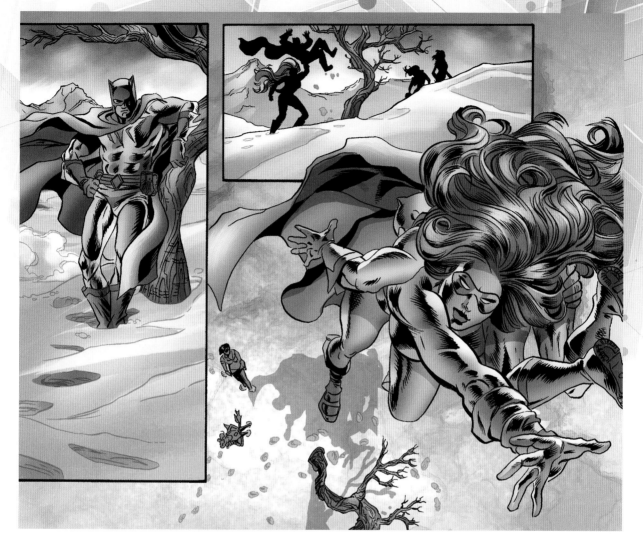

Knockout wound up sleeping with Deadshot after they were victorious on a mission, harming her romance with Scandal until it became clear that there was cultural miscommunication. Scandal left the Secret Six to get away from the betrayal and to track down Pistolera. She eventually learned that the hired gun had been sent by her father, who had used the attack as a warning that she needed to produce an heir for him, something she refused to do.

Later, the couple reunited and resumed their relationship just in time to partner with the Birds of Prey for a mission. This included a brawl with Big Barda that left Knockout dissatisfied. As she sought her fellow Fury for a rematch, she was attacked by Infinity Man, who had killed all the New Gods.

72. TRUE ROMANCE

A distraught Scandal felt adrift until she found Liana, a human exotic dancer who resembled her dead lover. They started a romance even though Liana was far gentler than Knockout, but then Scandal learned of the existence of a "Get Out of Hell Free" card and sought it. This led her to travel to the pits of Hell to rescue Knockout, leaving Liana vulnerable to an attack from a deranged customer. Scandal rescued Knockout and they both returned to save Liana.

The aftermath led Scandal to face the two women she loved, and as Liana recuperated in a hospital, Scandal proposed to both women, creating comics' first polyamorous marriage.

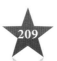

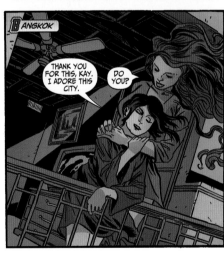

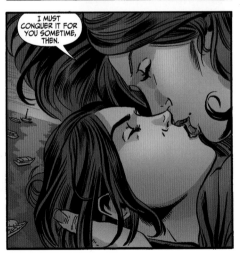

Scandal and Knockout were unconventional characters in their various comic book appearances, so it made sense that the last time we saw them, they were embarking on a unique new adventure.

Secret Six #1, July 2006
Writer: Gail Simone *Artists:* Brad Walker & Jimmy Palmiotti

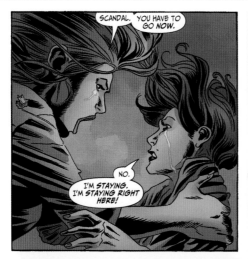

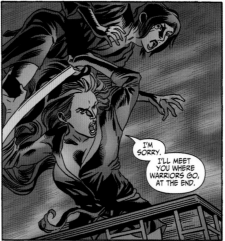

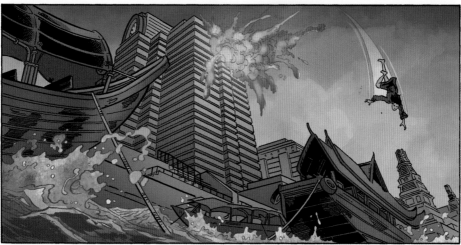

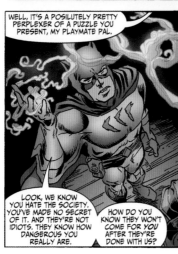

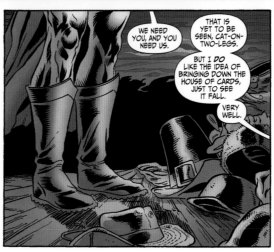

Secret Six #1, July 2006
Writer: Gail Simone *Artists:* Brad Walker & Jimmy Palmiotti

SPEEDY

MIA DEARDEN DIDN'T HAVE IT EASY, PROMPTING HER TO RUN AWAY FROM HER ABUSIVE father as a teenager. She survived but was miserable until she was rescued by Star City's savior, Green Arrow.

The Emerald Archer had just returned from the dead and was rebuilding his life, feeling that he didn't have time to help raise Mia. Still, she badgered him into training her in archery but was rebuffed when she asked to be his new sidekick, Speedy. After the failure with the first, Roy Harper, Ollie was reluctant.

73. HER BRAVEST ACT

Ollie saw to it that she attended high school, and Mia went on to volunteer at the Star City Youth Recreational Center. During this period, she learned that her life on the streets had led to her contracting HIV. Not wanting to hide her condition, she worked with the administration to bravely reveal the news to the entire student body during an assembly. This courageous act finally convinced Ollie to give her a chance to make a difference and allow her to become Speedy.

After acquitting herself, Mia spent a year training with the world's greatest martial artists. In addition to working with Team Arrow, she briefly served as a member of the Teen Titans.

In the Rebirth reality, Mia is the daughter of criminal John King, who relocated to Seattle to expand his empire. After witnessing King kill her mother, she flees to live on the streets, helping others like her. Over time, she becomes a pawn in the battle between King and Green Arrow. In the aftermath of their confrontation, Ollie invites Mia to stay with him, so she finally has a place to call home. She has not been recorded in costume or using a bow and arrow.

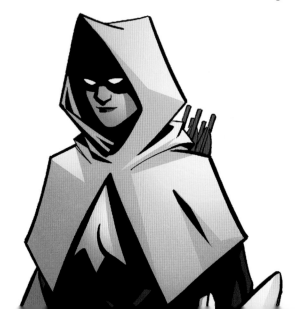

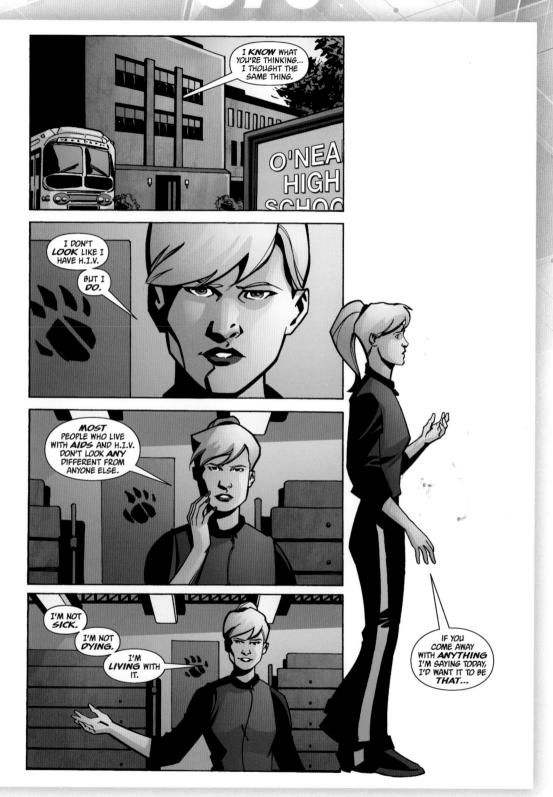

Nothing scared Mia more than standing before her high school classmates and admitting her HIV status, an act of courage equal to anything she did in her guise as Speedy.

Green Arrow #45, February 2005
Writer: Judd Winick *Artists:* Phil Hester & Ande Parks

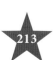

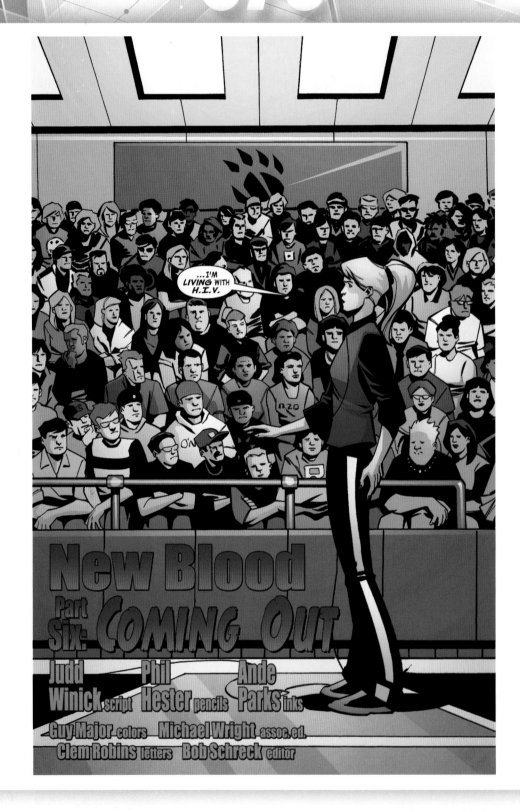

Green Arrow #45, February 2005
Writer: Judd Winick *Artists:* Phil Hester & Ande Parks

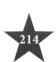

STAR SAPPHIRE

EDITOR JULIE SCHWARTZ DIDN'T SHY AWAY FROM MAKING HIS FEMALE SUPPORTING characters powerful ones. As vice president of Ferris Aircraft, Carol Ferris was left in charge when her father decided to travel the world. Soon after, her lover and best test pilot, Hal Jordan, became the Green Lantern of Space Sector 2814 and she found herself attracted to both his secret identity and his alter ego.

74. CAROL FERRIS'S DESTINY

Then came the day when she was taken by the Zamarons, an all-female race (later revealed to be the female Oans, who rejected the males as they became the unemotional Guardians of the Universe). They saw her as the heir to the powerful Star Sapphire and wanted her to leave Earth to be their next queen.

When using the powerful gem, her personality transformed, and while she was Green Lantern's equal, she saw him as an opponent and not a partner. He defeated her and she reverted to Carol, unaware of her previous actions. This cycle repeated over time.

Hal and Carol remained in love even after he left Ferris Aircraft and drifted from job to job, his Lantern duties becoming increasingly time-consuming. Jordan managed to cure her of the Sapphire's powers, but a third personality briefly emerged as the powerful, male Predator. Green Lantern defeated this incarnation and merged it with the Star Sapphire. This new version of Carol chose to leave Earth for Zamaron to finally rule.

All that changed after the Crisis on Infinite Earths and both Guardian and Zamaron alike left for another dimension.

Multiple revisions of reality later, the Star Sapphire was one of the seven colors of the emotional spectrum, in this case violet, representing love. While either gender could wield the sapphire ring, most men were not worthy. During one adventure, Carol was given the ring and learned of its history and that she was offered the ring in order to save Hal Jordan during the War of Light. She accepted and then fulfilled her destiny as the most powerful Star Sapphire, leading a new Corps throughout the galaxy.

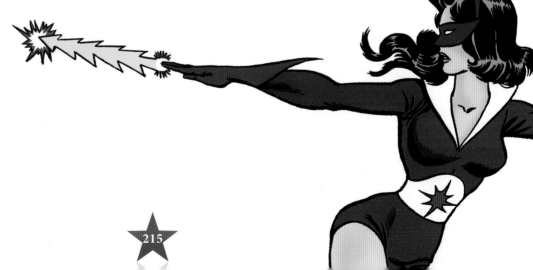

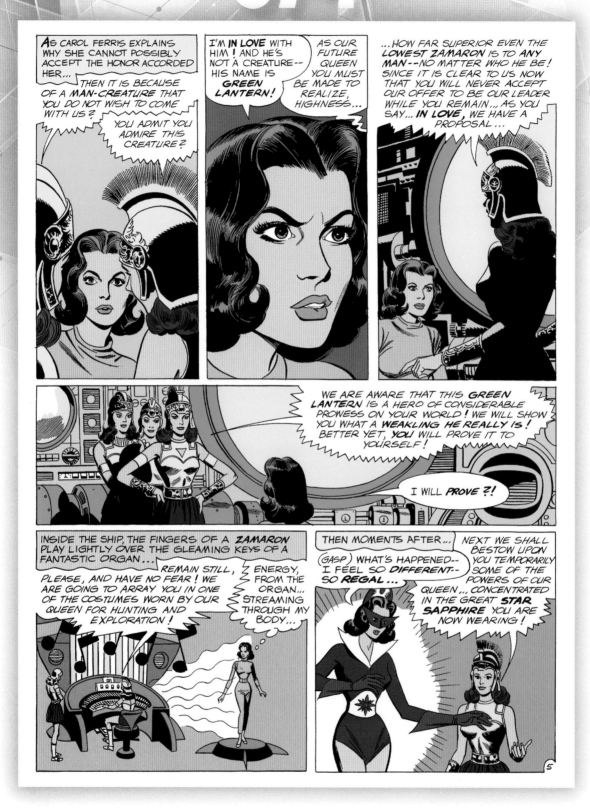

Just as the power ring chose Hal Jordan to fulfill his destiny, so, too, did the Zamarons select Carol Ferris to wield the Star Sapphire to be their queen.

Green Lantern #16, October 1962

Writer: John Broome *Artists:* Gil Kane & Joe Giella

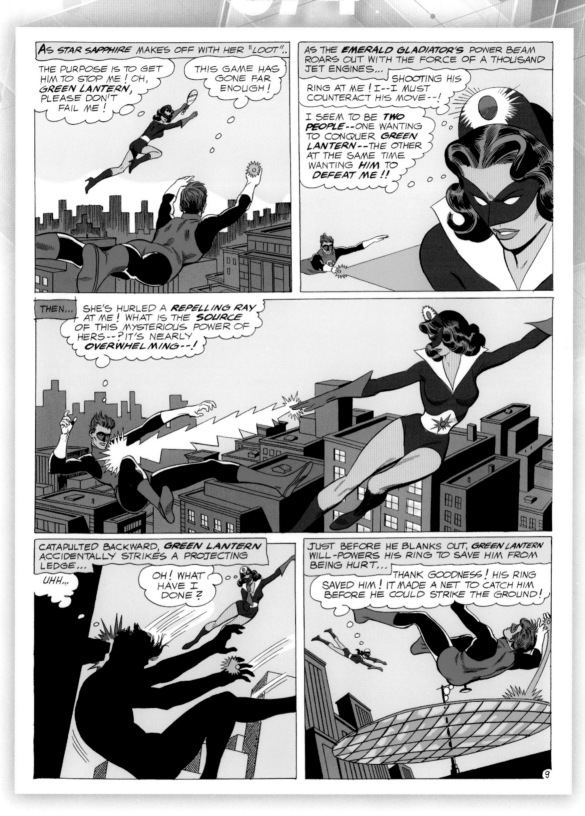

Green Lantern #16, October 1962
Writer: John Broome *Artists:* Gil Kane & Joe Giella

STARFIRE

DEEP IN SPACE LIES THE VEGAN STAR SYSTEM WITH ITS TWENTY-TWO WORLDS. ON ONE, Tamaran, the people are born with certain abilities, including flight. When Komand'r, the eldest daughter of the royal family, was born without that ability, she was pitied. She was also passed over in the line of succession, which now favored the second child, Koriand'r, sowing seeds of anger that would come back to haunt the people.

When they came of age, both sisters were sent to the Warlords of Okaara to be trained in the ways of war and leadership. In time, Komand'r rejected her heritage and left to ally herself with the Citadel, which controlled all Vegan worlds except Tamaran. To save his people, King Myand'r sacrificed Koriand'r to the Citadel, where Komand'r had her sent to be a slave for six years. During this period, the Psions abducted both sisters and experimented on them to slake their unquenchable scientific curiosity. The results left the women, who were already able to absorb solar energies, to now channel that power and emit it as energy blasts. Using these starbolts of destructive energy, the sisters escaped their captivity, with Koriand'r taking a spaceship into deep space.

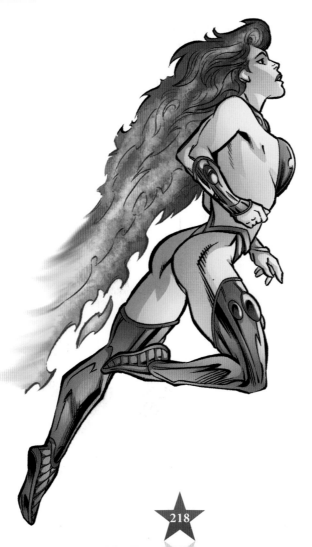

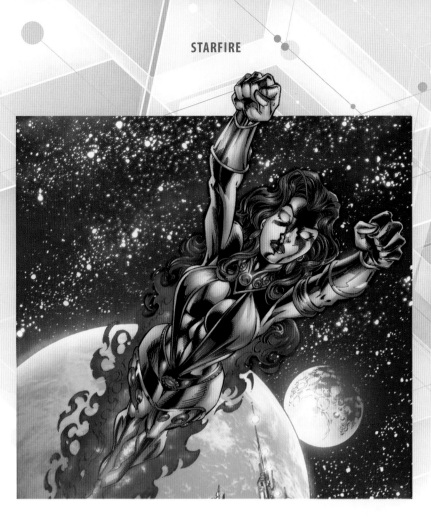

75. ESCAPE TO EARTH

Now chased by the Citadel, her ship entered the Sol system and crashed on Earth. With Raven already gathering teens to help her fight the coming of her father Trigon, they first rallied to aid Koriand'r and help her remain free from the Citadel's warriors. In the aftermath, the group reformed the Teen Titans and welcomed Koriand'r to remain with them. Using her people's innate ability to absorb knowledge through skin contact, she passionately kissed Robin, learning English and capturing his heart.

Taking the name Starfire, she was quickly accepted by the others, living in Titans Tower.

76. SISTER AGAINST SISTER

While Starfire was adjusting to life on a new world, enjoying her romance with Robin, her thoughts continued to drift back home, worrying about her younger brother Ryand'r and the whereabouts of Komand'r.

Those latter thoughts became a harsh reality when Komand'r, now using the name Blackfire, tracked her sister to Earth. Seething with anger and hatred, she abducted Koriand'r and brought her back to the Vegan system and delivered her to the Citadel's Lord Damyn. The act was just part of a long-term plan, which would see Blackfire take control of the Citadel and rule all twenty-two worlds. However, after she killed Damyn, her rule was challenged by the Citadel's chief adviser, who pitted sister against sister in a duel to the death.

The Titans traveled to Vega to lend their assistance and were on hand to witness Blackfire's seeming demise. After ensuring that Tamaran remained free and briefly visiting her parents and brother, Starfire chose to remain on Earth.

As it turned out, Blackfire survived and remained an enemy, repeatedly seeking revenge. In time, Starfire put her obligations to Tamaran behind her, focusing on her own life on Earth. She nearly married Robin, but in time, their relationship shifted and they became friends. Koriand'r also briefly took over leadership of a new incarnation of the Titans, becoming their mentor, and finally using her Okaaran training.

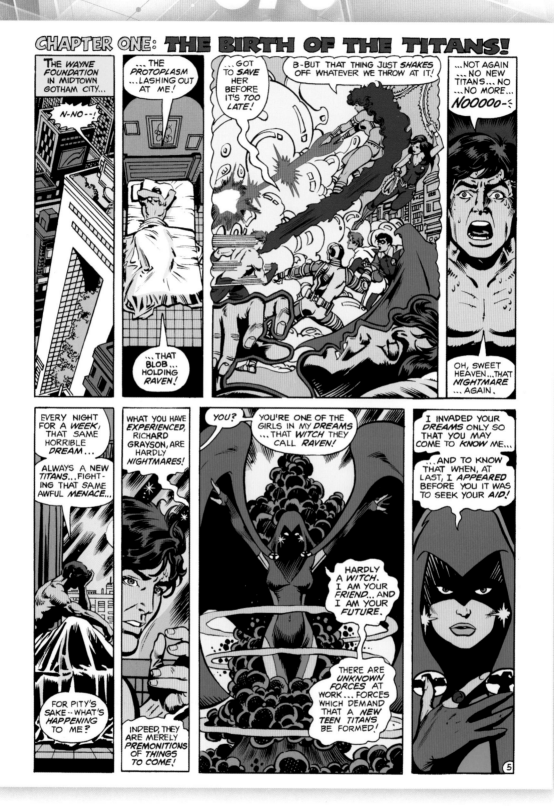

She nearly lost her homeworld of Tamaran, endured six years of slavery, and was a test subject for the Psions. Yet Koriand'r never lost her optimism, which was rewarded when she met the Teen Titans.

New Teen Titans #1, November 1980
Writer: Marv Wolfman *Artists:* George Pérez & Romeo Tanghal

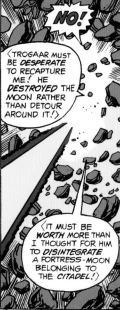

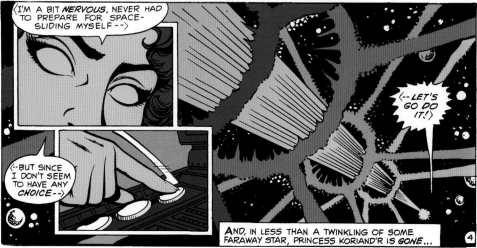

New Teen Titans #1, November 1980
Writer: Marv Wolfman *Artists:* George Pérez & Romeo Tanghal

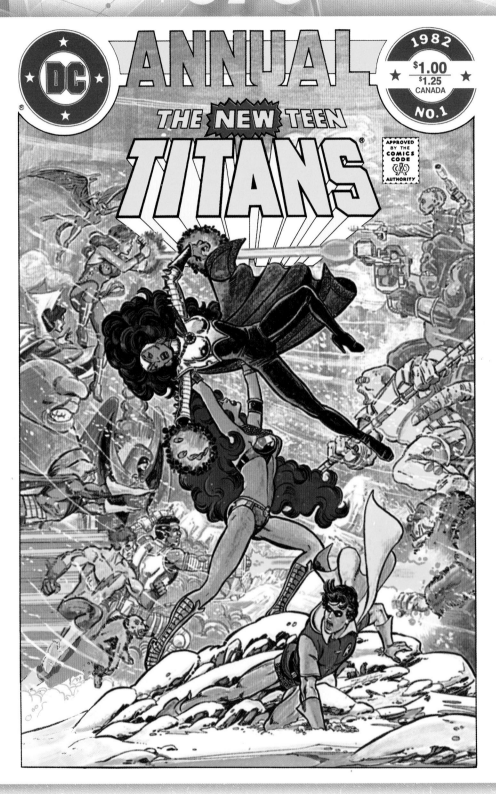

Komand'r wanted to rule the entire Vegan star system; Koriand'r just wanted her sister back. Now they are pitted in a battle to the death.

New Teen Titans Annual #1, November 1982
Artist: George Pérez

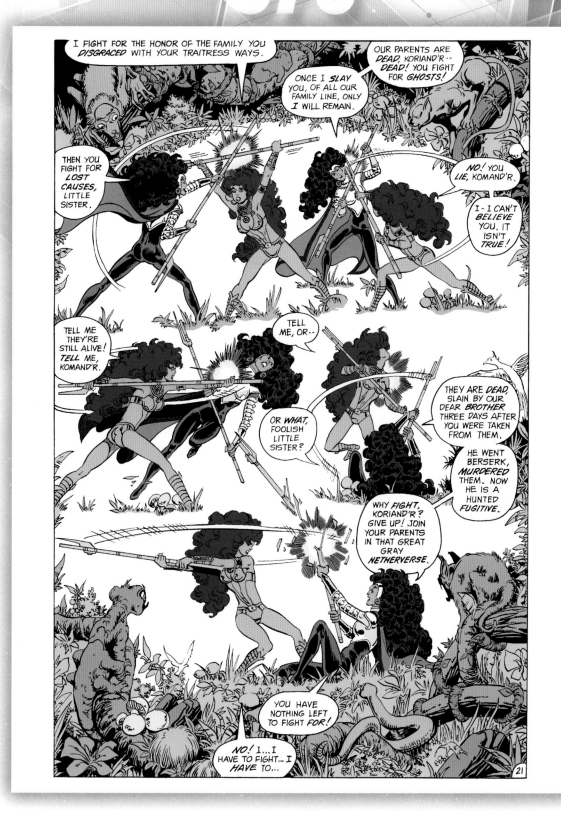

New Teen Titans Annual #1, November 1982
Writers: Marv Wolfman & George Pérez *Artists:* George Pérez & Romeo Tanghal

STARGIRL

COURTNEY WHITMORE DIDN'T ASK TO BE PART OF A SUPER-HERO LEGACY, LET ALONE two, but that's what happened after her mother remarried and relocated the family to Blue Valley, Nebraska. She discovered the costume and energy-converter belt of the Star-Spangled Kid among her stepfather Pat Dugan's belongings. Using them, the teen emerged as a new hero, prompting Pat to build a robot, dubbed S.T.R.I.P.E., to guide and protect her.

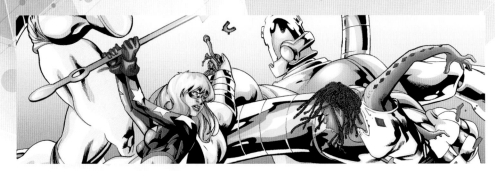

77. INHERITANCE

Courtney became acquainted with the legendary Justice Society of America. Jack Knight, son of the original Starman, bequeathed the cosmic rod, now a staff, to her. To honor this new legacy, she renamed herself Stargirl, serving with joy and dedication. It wasn't all easy for her, as she confronted Merry Pemberton, the Star-Spangled Kid's sister, who worried about the risks the younger generation was facing. She was subsequently slightly more cautious although certainly not discreet with her identity, as Courtney's friends and fellow heroes learned her real name.

She dated Billy Batson, Captain Marvel, before falling hard for Atom Smasher, remaining loyal to him after he defected to Black Adam's side and even went to prison for his crimes.

Courtney proved adept at strategy and leadership and was instrumental during the events of Infinite Crisis and Final Crisis. Before that reality ended, she wound up becoming a mentor to the next generation of heroes, including Black Lightning's daughter, the granddaughter of the first Red Tornado, and others.

In the Rebirth reality, Courtney was raised by Barbara Whitmore in Los Angeles. While Courtney disliked her mother's boyfriend, Pat Dugan, she did like his inventions, which she found while cleaning his office. Spotting a fire nearby, she donned the outfit, cinched the belt, and grabbed the staff, taking to the air. Her actions launched her super-hero career and made her a viral sensation. Pat realized what had happened and warned her away from a career, alluding to the tragedy of the equipment's previous owner. They reached an agreement whereby he would train her, but then they encountered the Shadow-Thief, who later attacked her home, wounding her mother and Pat. The enormity of her role finally hit her.

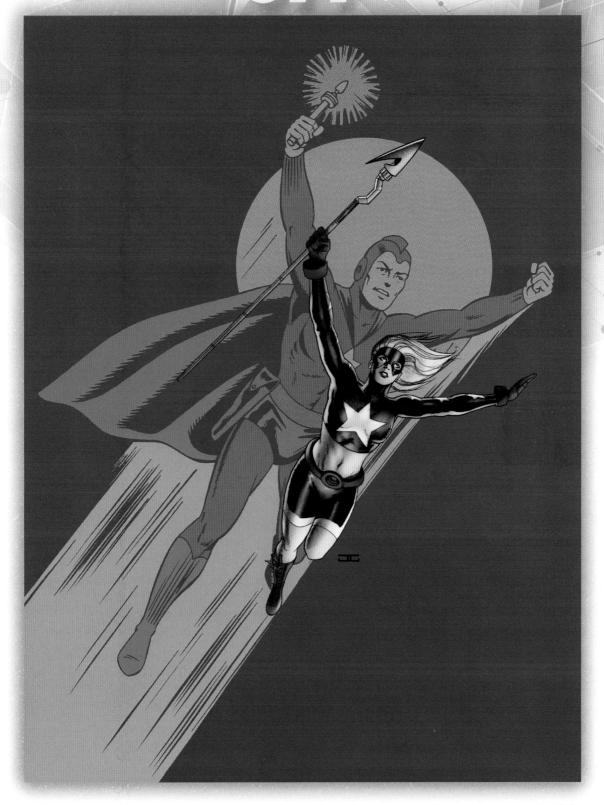

Starman harnessed first gravity and then cosmic radiation, channeling the energy through his cosmic rod to fight crime in simpler times. The rod became a staff as it was passed on to his children and finally to Courtney Whitmore.

JSA All-Stars #4, October 2003
Artists: John Cassaday, Mark Lewis & David Baron

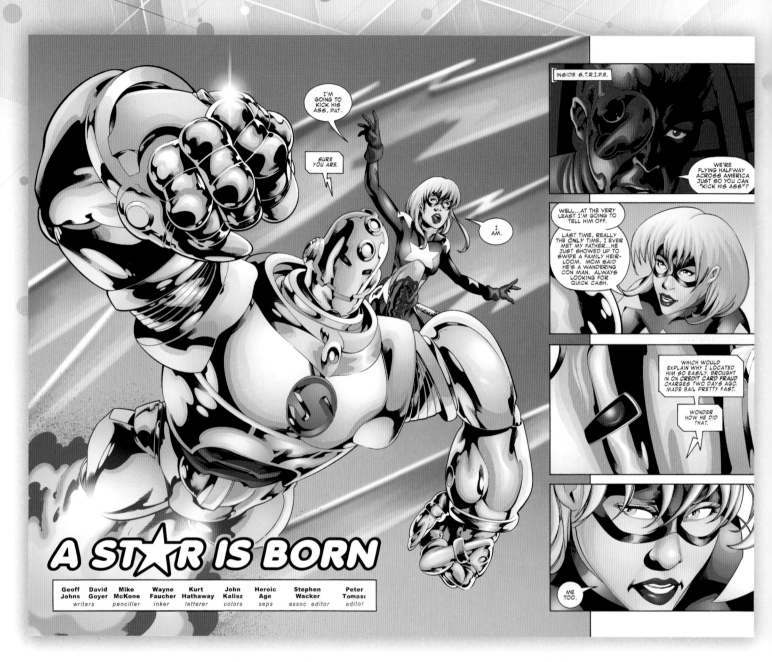

JSA All-Stars #4, October 2003
Writers: Geoff Johns & David Goyer Artists: Mike McKone & Wayne Faucher

SUE DIBNY

MARRIED CHARACTERS HAVE ALWAYS BEEN IN SHORT SUPPLY IN COMICS, CONSIDERED by creators as making the characters too old and unrelatable. It made each couple that was married a rarity, and few were as beloved as Ralph and Sue Dibny, modeled after Dashiell Hammett's Nick and Nora Charles.

Sue Dearbon Dibny was a socialite turned author who delighted in traveling the world beside her husband, Ralph, who was known to all as the Elongated Man.

The two met at her debutante ball, which Ralph crashed hoping to see more of the captivating woman he had spied earlier that day. By then, Ralph had discovered that an extract of gingold allowed him to stretch his form and began adventuring as the Elongated Man. They fell in love almost immediately, and the socialite married the sleuth, with the Fastest Man Alive, the Flash, as best man.

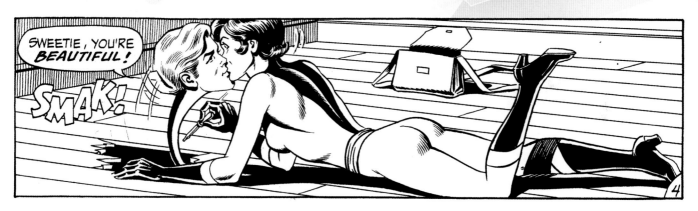

78. SUE THE STRETCHABLE SLEUTH

Over the next few years, the couple traveled the globe, investigating mysteries and enjoying the celebrity that came with being heroes. While she didn't resent his using the gingold, she wasn't able to drink it herself due to an allergy. In one memorable instance, she resourcefully faked stretchable powers and donned her husband's costume when Ralph was kidnapped. Sue was delighted when Ralph was formally inducted into the Justice League of America. She eventually got more involved with the JLA, working as an administrator through several incarnations.

Sue finally took to writing and published at least one bestselling detective novel, which made her the center of attention for a change. During her book tour, she and Ralph worked with Batman on a mystery.

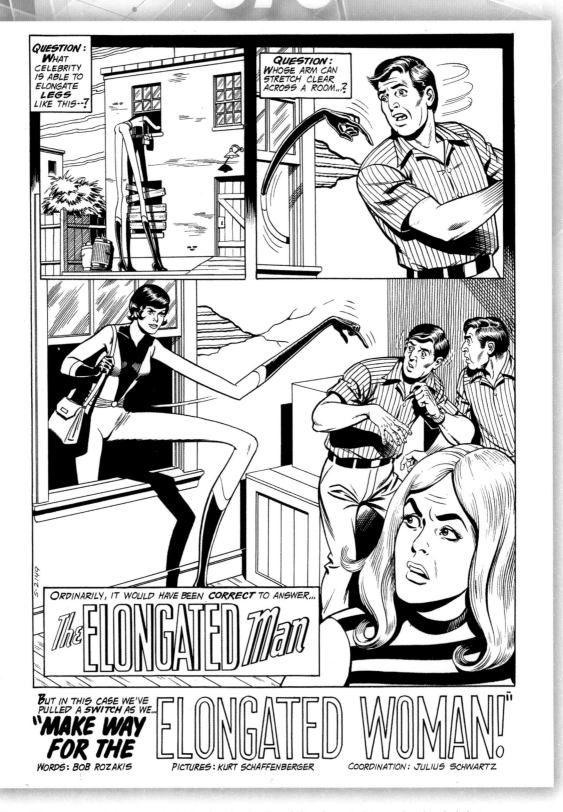

If Sue Dibny had any interest in stretching like her husband the Elongated Man, she decided that one case was sufficient.

Detective Comics #457, March 1976
Writer: Bob Rozakis Artist: Kurt Schaffenberger

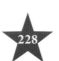

SUPERGIRL

THROUGH THE YEARS, MANY A CHARACTER HAS USED THE NAME SUPERGIRL, BUT THE ONE known best, now seen weekly on the eponymous CW series, first arrived in 1959, as editor Mort Weisinger was expanding the Superman mythos.

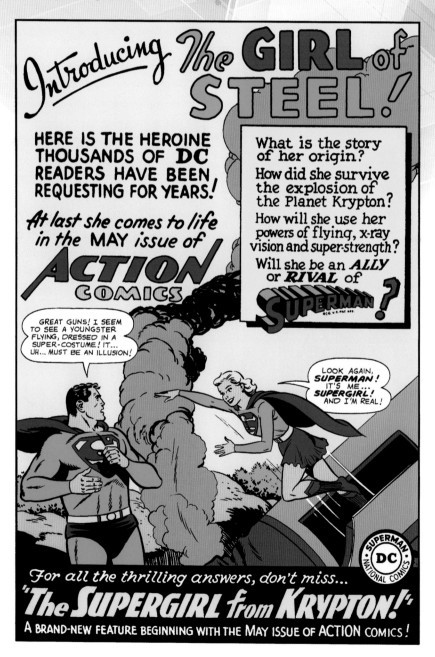

79. SUPERGIRL ARRIVES ON EARTH

Superman was surprised by the arrival of his cousin aboard a rocket. Out burst a young teen girl in an outfit similar to his own. She greeted him as a cousin and explained she was Kara Zor-El, daughter of his uncle Zor-El. Kara explained that Argo City, where her family lived, was hurled into space intact as Krypton exploded. As chief scientist, Zor-El quickly oversaw the construction of a dome to retain oxygen until they could find a place to settle. Things remained peaceful for a time, but slowly, the remains of Krypton that the city was built atop began to alter into deadly kryptonite. Zor-El ordered the land lined with lead to shield them, a temporary solution at best. Sure enough, when Kara was fifteen, meteors tore through the dome and ripped the lead, causing them to lose atmosphere and weaken from the radiation.

Kara was thrilled to be reunited with family, while Superman was overjoyed to have someone from his homeworld as an ally, unlike the Phantom Zone criminals he had been dealing with since he was a youth. The Man of Steel was determined to train her in the proper use of her powers and give her a chance to

acclimate to life on Earth. He convinced her to live at an orphanage in Midvale, not far from Metropolis. She would adopt a human identity and learn about life on the planet while training. Kal-El asked Kara to select a human name, and she chose Linda Lee. Superman took Kara, now hiding her blonde curls under a brunette pigtailed wig, to Midvale Orphanage and explained to the director that her parents died in a natural disaster and vouched for her, cutting through the red tape and paperwork that would otherwise have slowed her admission.

Dubbing her his secret weapon, Superman was cautious in letting Supergirl operate in sight of others and was slow to even tell his closest friends and fellow heroes about her. At first, only Superman knew her secret identity, but after she was adopted by Fred and Linda Danvers, they, too, learned of her alter ego. In time, he introduced her to the president of the United States, entrusting him with the secret. Eventually other costumed champions were told as well.

Superman built her a series of Supergirl robots in addition to a Linda Lee robot to help protect her secret. They were stored on the orphanage grounds in a hollowed-out tree, and after her adoption, they were hidden within the Danverses' home.

While they often trained together, Linda began covertly performing feats on her own, keeping herself out of sight.

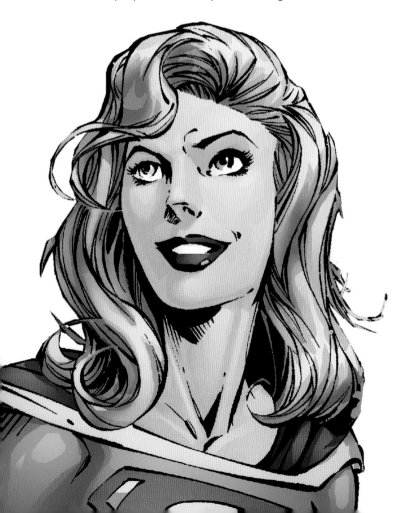

80. SUPERGIRL REVEALED TO THE WORLD

When the time was right, Superman made a public announcement of her existence, introducing her to the president and the citizens of Metropolis, and that was when the Danverses learned of their adopted daughter's secret. At the United Nations in New York City, Supergirl was given a special "golden certificate," matching one they had previously given the World's Greatest Super Hero, granting her unfettered access to enter and leave member countries without a visa and authorizing her to make arrests.

Although the world did not know of Supergirl, residents of the future did. In time, she was visited by the members of the 30th Century's Legion of Super-Heroes. After testing her, much as they did Superboy

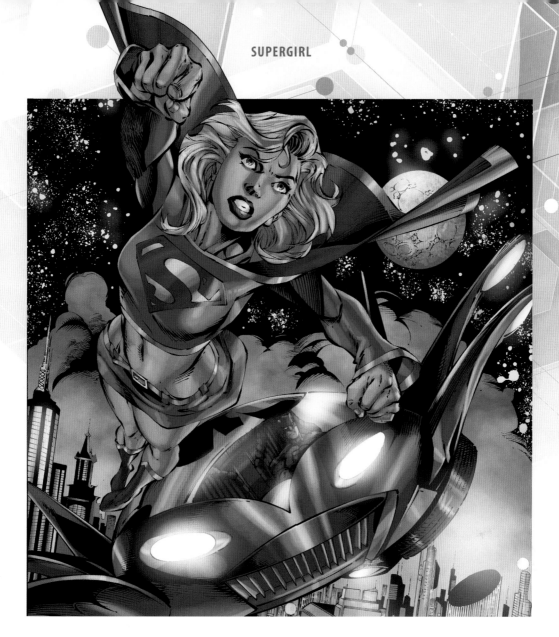

in an earlier era, they welcomed her to the team, where she frequently encountered a younger version of her cousin. In time, she also developed a romance with Brainiac 5, in addition to Dick Malverne at Midvale High and Jerro, a mer-teen who resided in Atlantis.

Supergirl was shocked to discover that her parents had survived Argo City's destruction by finding a realm called the Survival Zone, similar to the Phantom Zone, but it had no projector to allow them their freedom. After an awkward attempt at coexistence on Earth with the Danverses, Zor-El and Alura decided that they'd be happier in the city of Kandor. The bottle city subsequently became a wonderful home away from home for the Girl of Steel. She also promised the Kandorians that, like her cousin, she would make every effort to find a way to enlarge them and locate a world they could call their own.

81. SUPERGIRL'S ULTIMATE SACRIFICE

Superman and Supergirl kept their promise and restored Kandor to its proper size on the planet renamed Rokyn. Kara was delighted to see that her parents once more had options in their future.

Then came the Crisis on Infinite Earths, as the multiverse was being eradicated by the Anti-Monitor, who wanted to rule a single anti-matter universe and was concluding an age-old battle with his doppelganger, the Monitor. It took the combined efforts of the heroes from the remaining five parallel Earths to forestall total devastation. Supergirl was among those who sought to take the battle to the Anti-Monitor. She watched as her cousin was easily knocked aside. In a rage, she pounded away at the armored entity, actually causing him pain, while he

unleashed beam after beam of energy that slowly hurt her. With a final blast of energy, he mortally wounded the Maid of Might. She died in her cousin's arms. Soon after, Superman took her remains to Rokyn, and he shared Zor-El and Alura's grief.

82. SUPERGIRL APPEARS TO DEADMAN

Just a short time later, her spirit was seen by Boston Brand, a fellow dead hero, during the Christmas season. The poignant short story violated the rules in force at the time: that any mention of the Crisis or those who died would never be seen again. The blonde ghost never named herself, but she sure looked like Kara Zor-El and with executive editor Dick Giordano drawing the story, no one complained.

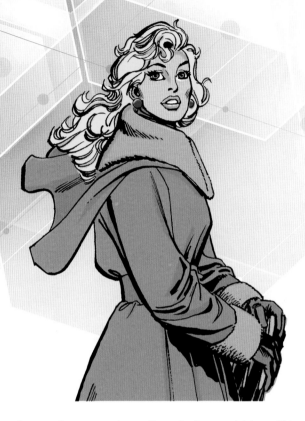

83. MATRIX BECOMES SUPERGIRL

In the post-Crisis reality, there was a pocket universe where the Legion still operated in a version of Earth-1. When three Kryptonians escaped the Phantom Zone, they laid waste to the world. That world's Lex Luthor was desperate for help and created a protoplasmic being, using Lana Lang's DNA to give it a semblance of humanity, and sent it across the dimensional barrier. The capsule arrived hundreds of thousands of years in the past, buried in a glacier until late in the 20th Century.

This being looked and acted like a female Superman, and Superman took the being, called Matrix, to be socialized and raised by Ma and Pa Kent, who called her "Mae." In time, she took the form of Supergirl to honor the Man of Steel, after he exiled himself as punishment for going to the pocket universe and killing the three criminals.

Matrix, or Supergirl, was left to wonder about her existence after her recent experiences, wondering about how she had been birthed, and whether or not she even had a soul. At much the same time, the post-Crisis Linda Danvers was beginning to have doubts of her own. The artistic teen was living on her own in the small town of Leesburg, Virginia. She found herself inspired by Supergirl and often sculpted the hero. A

demon known only as Buzz insinuated himself into Linda's life and used her loss of faith as a wedge to turn her into his next victim. He led her away from her parents—police officer Fred Danvers and his wife, Sylvia—and friends, sent her spiraling down a dark path that resulted in her joining a demonic cult without realizing she would be his sacrifice to Lord Chakat. It was also intended to draw to him the real Supergirl and gain her power and soul.

The Maid of Steel arrived in time to save Linda's soul, but the woman was seriously wounded. Mad with grief over failing and spiritually empty, Supergirl found her protoplasmic self merging with the dying teen, giving them both a second chance by becoming a new Linda Danvers. It took some time for the new person to fully integrate the two personalities, each with her own experiences and memories. It also left her ready to become something more.

In the performance of her duties, she suddenly sprouted flaming wings, to her astonishment. In time, she learned that this new Linda Danvers was now an Earth-Angel known as the Angel of Fire. She was also astonished to learn that a Chaos Stream flowed beneath Leesburg, which made it a focal point for supernatural activity.

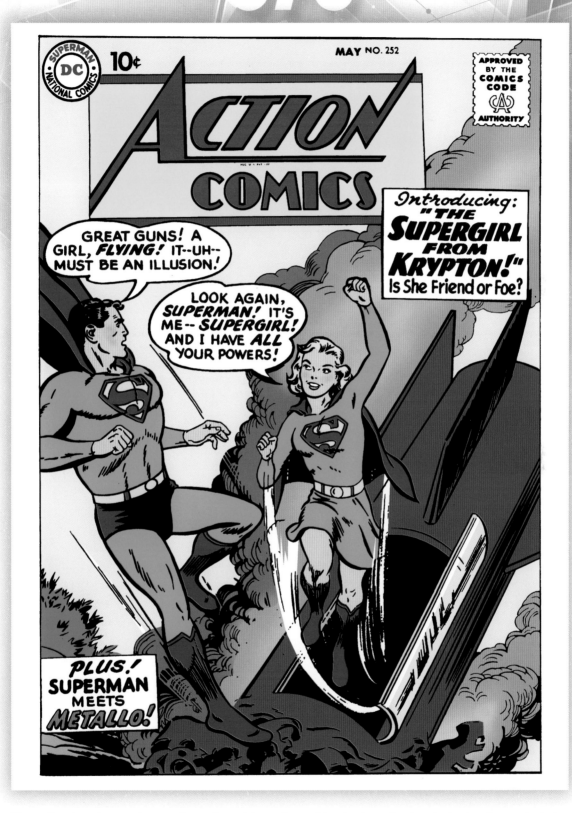

The mail and reader reaction was instantly positive as Supergirl arrived, earning her the backup feature in *Action Comics* for a decade.

Action Comics #252, May 1959
Artists: Curt Swan & Al Plastino

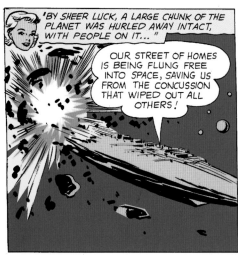

"BY SHEER LUCK, A LARGE CHUNK OF THE PLANET WAS HURLED AWAY INTACT, WITH PEOPLE ON IT..."

OUR STREET OF HOMES IS BEING FLUNG FREE INTO SPACE, SAVING US FROM THE CONCUSSION THAT WIPED OUT ALL OTHERS!

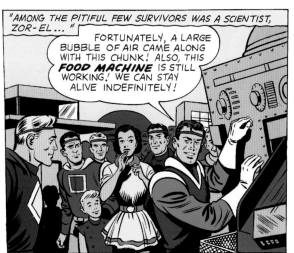

"AMONG THE PITIFUL FEW SURVIVORS WAS A SCIENTIST, ZOR-EL..."

FORTUNATELY, A LARGE BUBBLE OF AIR CAME ALONG WITH THIS CHUNK! ALSO, THIS FOOD MACHINE IS STILL WORKING! WE CAN STAY ALIVE INDEFINITELY!

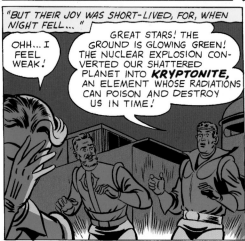

"BUT THEIR JOY WAS SHORT-LIVED, FOR, WHEN NIGHT FELL..."

OHH... I FEEL WEAK!

GREAT STARS! THE GROUND IS GLOWING GREEN! THE NUCLEAR EXPLOSION CONVERTED OUR SHATTERED PLANET INTO KRYPTONITE, AN ELEMENT WHOSE RADIATIONS CAN POISON AND DESTROY US IN TIME!

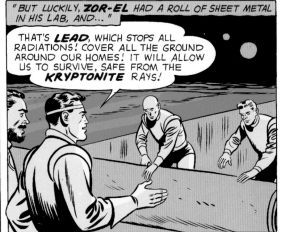

"BUT LUCKILY, ZOR-EL HAD A ROLL OF SHEET METAL IN HIS LAB, AND..."

THAT'S LEAD, WHICH STOPS ALL RADIATIONS! COVER ALL THE GROUND AROUND OUR HOMES! IT WILL ALLOW US TO SURVIVE, SAFE FROM THE KRYPTONITE RAYS!

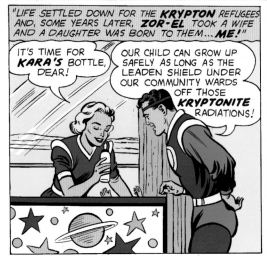

"LIFE SETTLED DOWN FOR THE KRYPTON REFUGEES AND, SOME YEARS LATER, ZOR-EL TOOK A WIFE AND A DAUGHTER WAS BORN TO THEM.... ME!"

IT'S TIME FOR KARA'S BOTTLE, DEAR!

OUR CHILD CAN GROW UP SAFELY AS LONG AS THE LEADEN SHIELD UNDER OUR COMMUNITY WARDS OFF THOSE KRYPTONITE RADIATIONS!

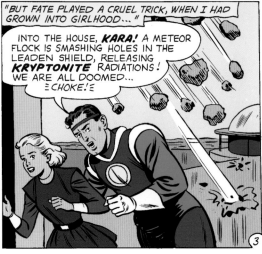

"BUT FATE PLAYED A CRUEL TRICK, WHEN I HAD GROWN INTO GIRLHOOD..."

INTO THE HOUSE, KARA! A METEOR FLOCK IS SMASHING HOLES IN THE LEADEN SHIELD, RELEASING KRYPTONITE RADIATIONS! WE ARE ALL DOOMED... ≡CHOKE!≡

3

Action Comics #252, May 1959
Writer: Robert Bernstein Artist: Al Plastino

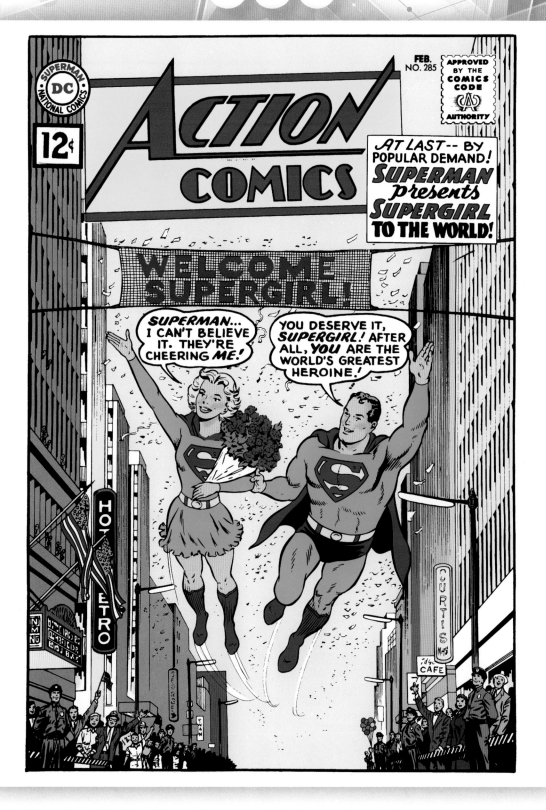

The buildup to the public debut of Supergirl was a rare serialized story in the pages of *Action* that tested her fortitude, before Superman introduced her to a surprised populace.

Action Comics #285, February 1962
Artists: Curt Swan & George Klein

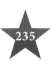

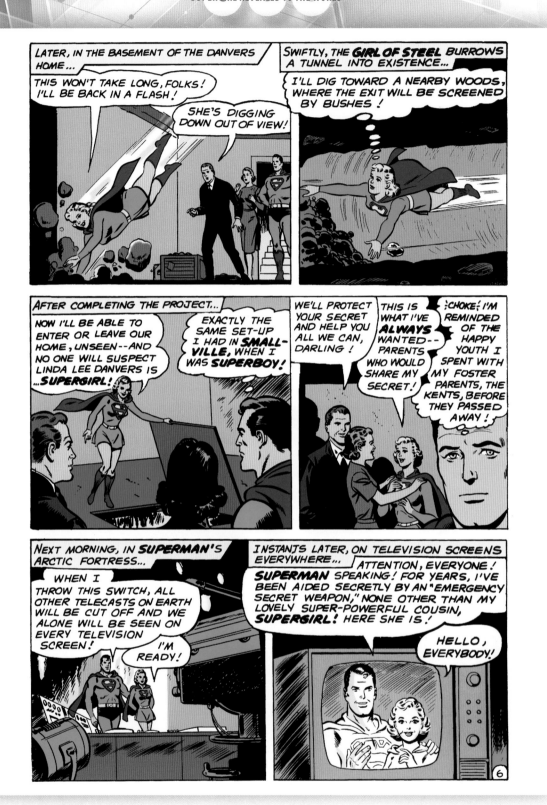

Action Comics #285, February 1962
Writer: Jerry Siegel *Artist:* Jim Mooney

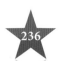

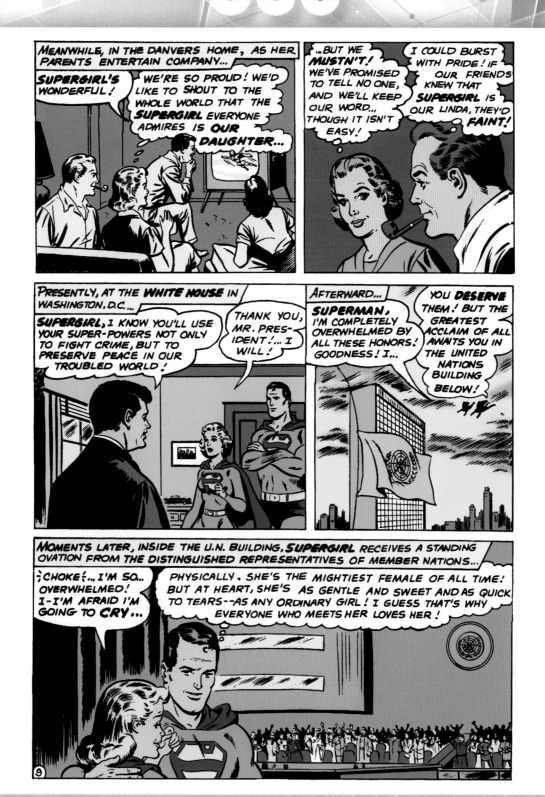

Action Comics #285, February 1962
Writer: Jerry Siegel *Artist:* Jim Mooney

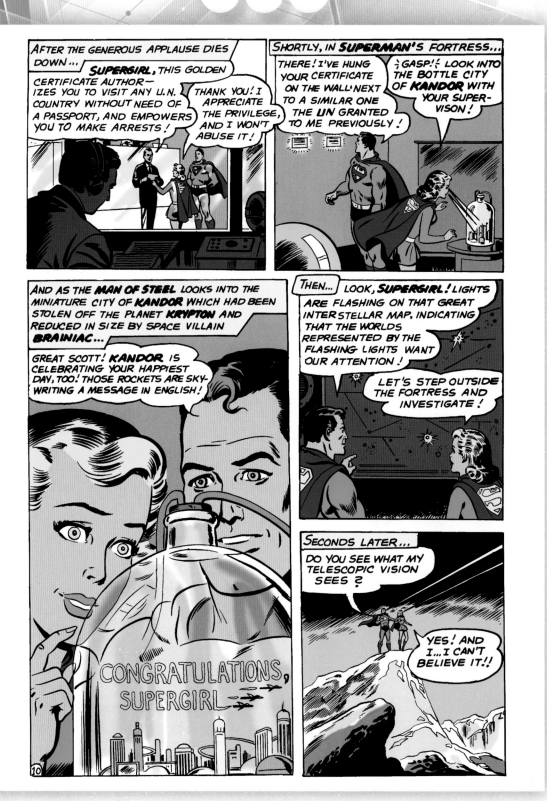

AFTER THE GENEROUS APPLAUSE DIES DOWN... SUPERGIRL, THIS GOLDEN CERTIFICATE AUTHORIZES YOU TO VISIT ANY U.N. COUNTRY WITHOUT NEED OF A PASSPORT, AND EMPOWERS YOU TO MAKE ARRESTS!

THANK YOU! I APPRECIATE THE PRIVILEGE, AND I WON'T ABUSE IT!

SHORTLY, IN SUPERMAN'S FORTRESS... THERE! I'VE HUNG YOUR CERTIFICATE ON THE WALL NEXT TO A SIMILAR ONE THE UN GRANTED TO ME PREVIOUSLY!

GASP! LOOK INTO THE BOTTLE CITY OF KANDOR WITH YOUR SUPER-VISON!

AND AS THE MAN OF STEEL LOOKS INTO THE MINIATURE CITY OF KANDOR WHICH HAD BEEN STOLEN OFF THE PLANET KRYPTON AND REDUCED IN SIZE BY SPACE VILLAIN BRAINIAC...

GREAT SCOTT! KANDOR IS CELEBRATING YOUR HAPPIEST DAY, TOO! THOSE ROCKETS ARE SKY-WRITING A MESSAGE IN ENGLISH!

CONGRATULATIONS, SUPERGIRL

THEN... LOOK, SUPERGIRL! LIGHTS ARE FLASHING ON THAT GREAT INTERSTELLAR MAP, INDICATING THAT THE WORLDS REPRESENTED BY THE FLASHING LIGHTS WANT OUR ATTENTION!

LET'S STEP OUTSIDE THE FORTRESS AND INVESTIGATE!

SECONDS LATER... DO YOU SEE WHAT MY TELESCOPIC VISION SEES?

YES! AND I...I CAN'T BELIEVE IT!!

10

Action Comics #285, February 1962
Writer: Jerry Siegel *Artist:* Jim Mooney

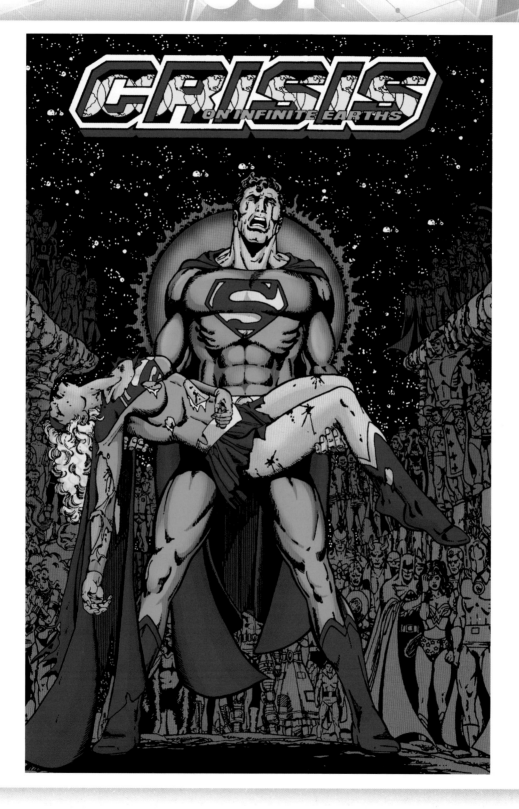

If Superman taught her anything, it was to give it your all and commit to your actions. With courage, she did exactly that, distracting the Anti-Monitor so that her cousin and the others could complete their mission.

Crisis on Infinite Earths #7, October 1985
Artist: George Pérez

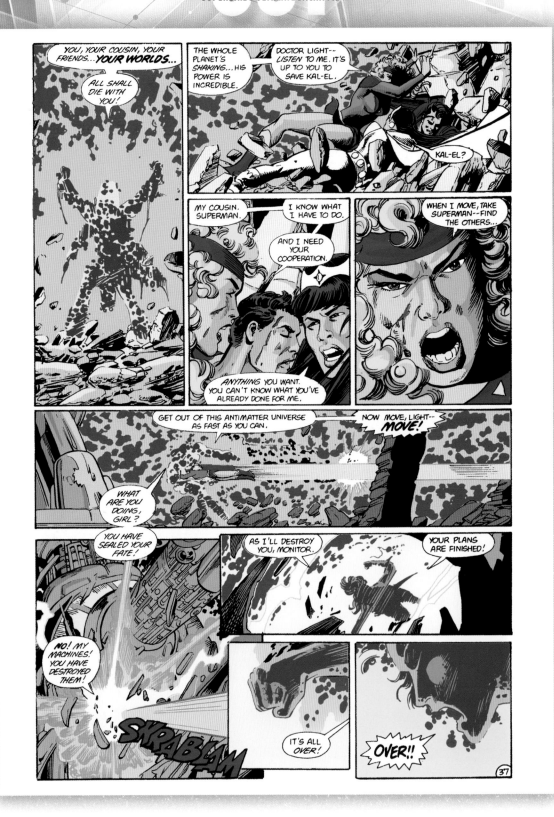

Crisis on Infinite Earths #7, October 1985
Writer: Marv Wolfman *Artists:* George Pérez & Jerry Ordway

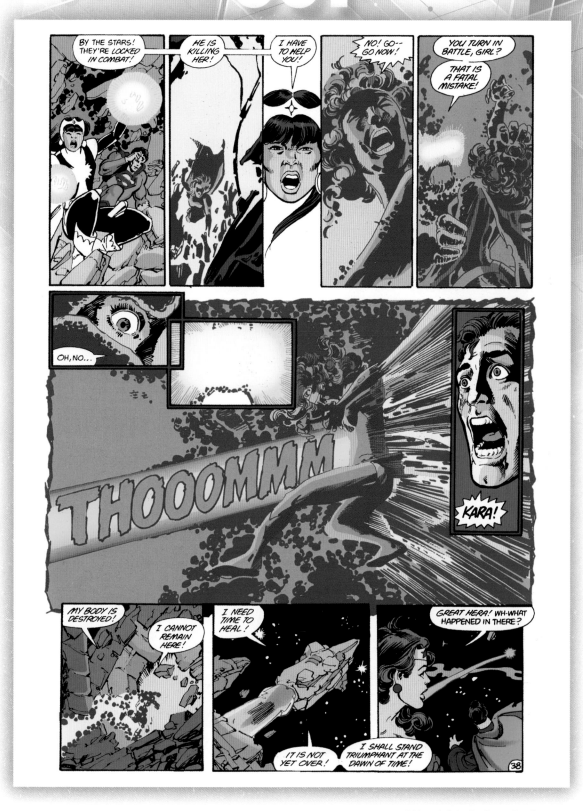

Crisis on Infinite Earths #7, October 1985
Writer: Marv Wolfman *Artists:* George Pérez & Jerry Ordway

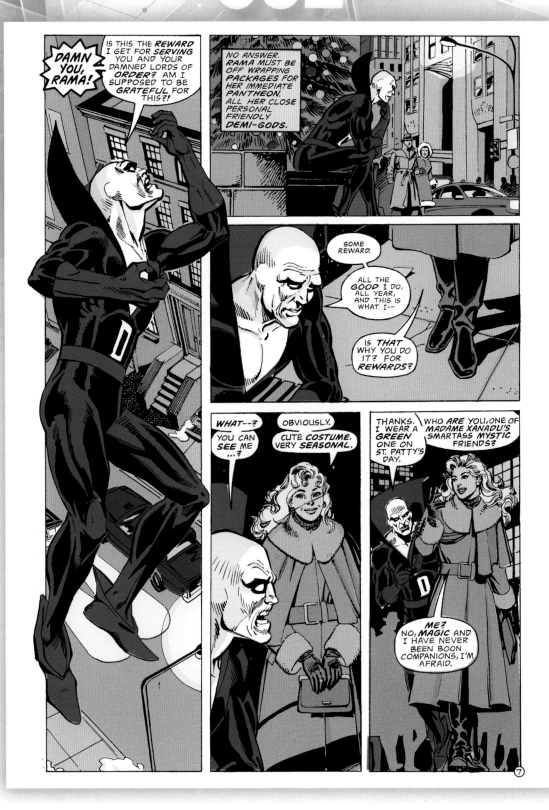

Is this blonde woman conversing with Deadman really the ghost of Kara Zor-El? Although DC editors never outright admitted it, they did so with a wink.

Christmas with the Super-Heroes #2, October 1989
Writer: Alan Brennert *Artist:* Dick Giordano

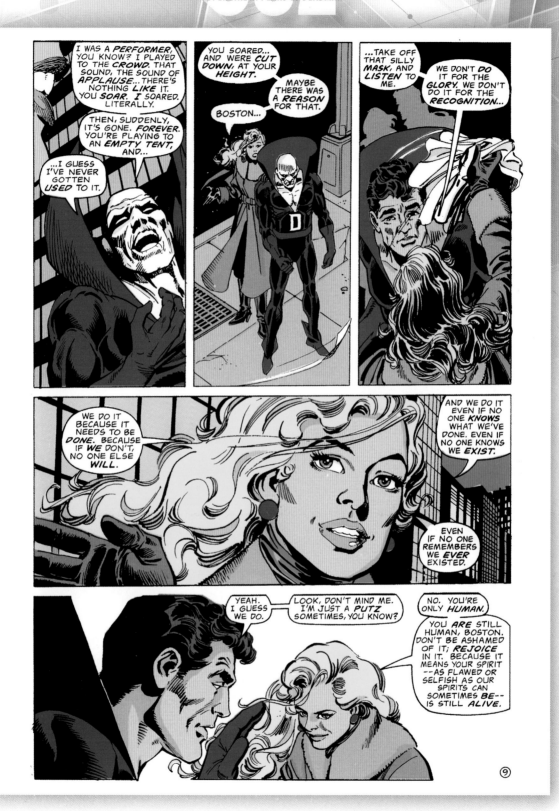

Christmas with the Super-Heroes #2, October 1989
Writer: Alan Brennert *Artist:* Dick Giordano

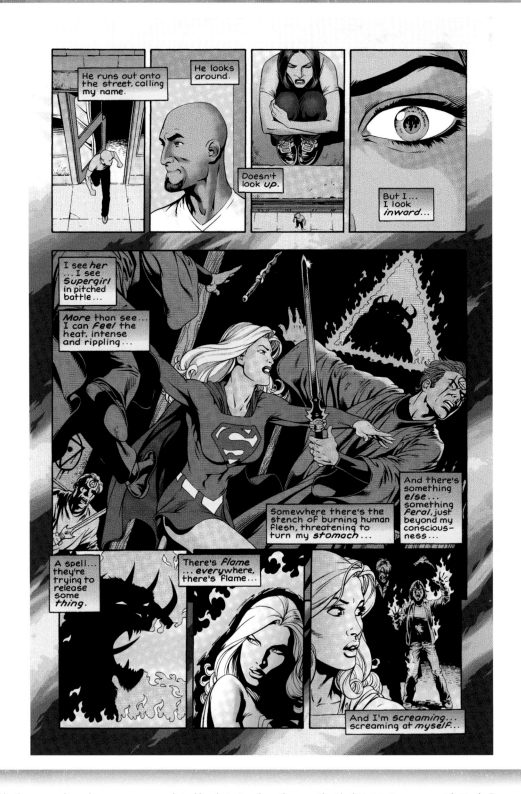

While there may have been more convoluted backstories than the one that led Matrix to merge with Linda Danvers to create Supergirl, her adventures took on a tone and outlook that made it unique among 1990s comics.

Supergirl #1, September 1996
Writer: Peter David *Artists:* Gary Frank & Cam Smith

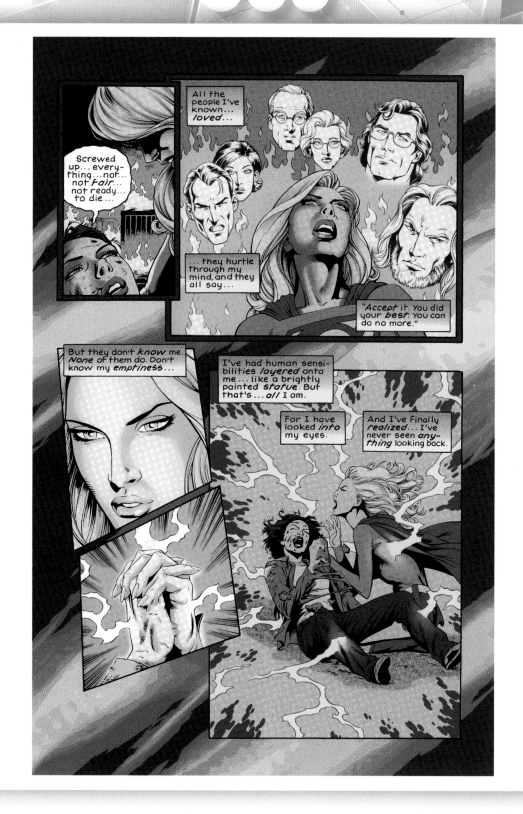

Supergirl #1, September 1996

Writer: Peter David *Artists:* Gary Frank & Cam Smith

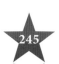

Supergirl #1, September 1996
Writer: Peter David *Artists:* Gary Frank & Cam Smith

SUPERWOMAN

84. TWO BECOME ONE

Growing up, Lana Lang and Clark Kent were inseparable friends, especially as he shared the secret of his super-powers with her. In time, though, he went on to fulfill his destiny as Superman in Metropolis, while she became an accomplished engineer.

Superman's body was a solar battery, but as he tragically learned, his body could be overwhelmed with solar energy, and he died. The expended energy spread through the air and was eventually absorbed by Lana and Superman's girlfriend, Lois Lane. They discovered, to their shock and dismay, that Lana had the power to convert solar radiation into various forms of electromagnetic energy, while Lois's body channeled his powers of flight, strength, and invulnerability. Lana constructed identical but different-colored containment suits, and they agreed to share the name and responsibilities of Superwoman to honor the man they loved.

Lex Luthor called their attention to a strange ship near Metropolis, and there they encountered Mercy Graves, who revealed herself to be a female Bizarro. She bombarded Lois with the same overflow of solar radiation, and she, too, died. While the Superman and Lois Lane from the post-Crisis reality were already on Earth and assumed the vacant roles, Lana was left to be Superwoman on her own. In time, she confided her secret to her lover, John Henry Irons, who assisted her.

After a brief time, Lana saved Metropolis from becoming trapped in a void created by a being known as Midnight. After saving the city, she and Midnight were now trapped in one body, which lay catatonic. In Metropolis, friends came to say farewell, fearing the worst. Midnight experienced those emotions and offered Lana a way out, but it would mean sacrificing her super-powers. She readily agreed, and in a flash of light, Midnight was gone and Lana Lang woke up, ready to resume her life as a normal mortal.

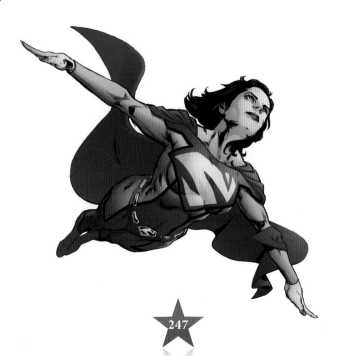

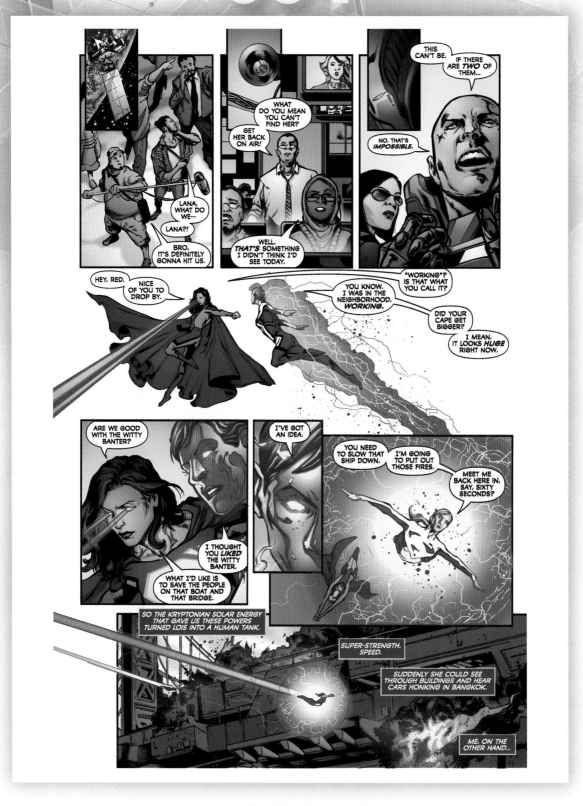

After growing up wondering what it must have been like to have super-powers, Lana Lang unexpectedly gained them when Clark Kent was killed and she honored him as Superwoman.

Superwoman #1, October 2016
Writer/Penciller: Phil Jimenez *Inker:* Matt Santorelli

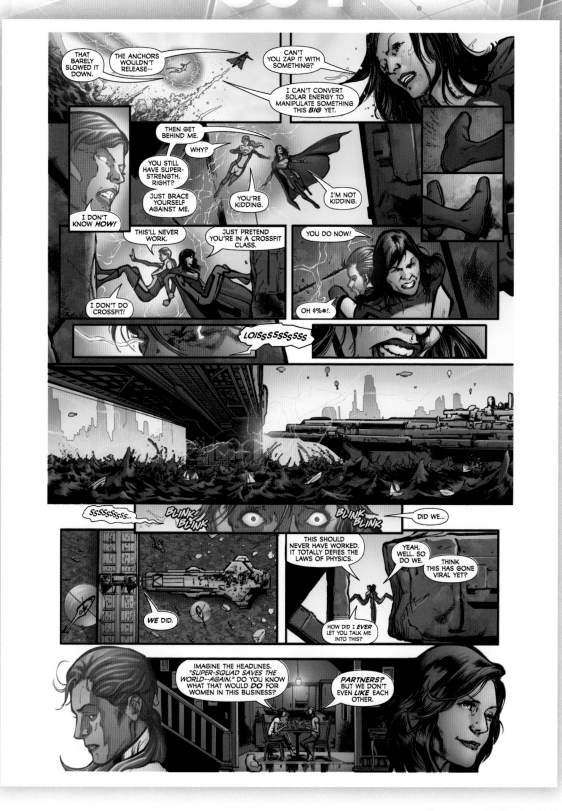

Superwoman #1, October 2016
Writer/Penciller: Phil Jimenez Inker: Matt Santorelli

TERRA

IN THE EARLY 1980s, DC COMICS HAD ONE MAJOR, SURPRISE HIT: *THE NEW TEEN TITANS*. Under writer Marv Wolfman and penciller George Pérez, the younger heroes gained gravitas and had eye-opening adventures on Earth, in space, and across the dimensions.

As Marv wrote in his introduction to *The Judas Contract*, "I decided if some fans thought we were an X-Men clone, then why not play with them a bit? The X-Men had just introduced a new member to their group, a young fourteen-year-old cute-as-a-button girl with incredible powers. I'd do the same. I'd play her first as a villain, then seemingly reform her and have her join the Titans. Only I'd have her constantly lie to the Titans, change her stories, do suspicious things, and, in general, make her a louse. I could do that, I knew, because comic book convention would demand that readers ignore all the evidence and assume she was a good girl. After all, the X-Men's Kitty Pryde was a heroine, so even the lying, cheating, conniving Tara Markov had to have a heart of gold.

"Right?

"Wrong. From the very beginning Tara was conceived as a villainess. It was the first time a member of a super-hero group ever proved to be a spy (not a traitor—she was always working for The Terminator). Playing on the comic readers' expectations worked."

85. BETRAYAL AND SACRIFICE

For over a year, readers warmed to Terra, hoped her romance with Changeling would become deeper, and so on. Given the similarity in her powers to the brand-new hero Geo-Force in *Batman and the Outsiders*, Wolfman and *Outsiders* writer Mike W. Barr agreed to make them half-siblings and adjusted the costume to be similar in design and color scheme.

Then came the reveal. She was working for Slade Wilson, aka Deathstroke the Terminator, who was using her to infiltrate and destroy the team from within.

The team was destabilized by other events, such as Kid Flash quitting and Robin seemingly retiring only to emerge as Nightwing. Still, Terra used her intelligence to tip off Deathstroke, who captured the team and brought them to the H.I.V.E. base within the Colorado Rocky Mountains. Nightwing went to rescue them, while Deathstoke's son Jericho used his abilities to possess the mercenary's body to free the team. Terra, feeling ultimately betrayed, lashed out with all her anger, pushing her powers to the limit and causing a rockslide. The mountains crumbled, and she died under the rubble.

A crestfallen Changeling found her body, and she was memorialized near Titans Tower.

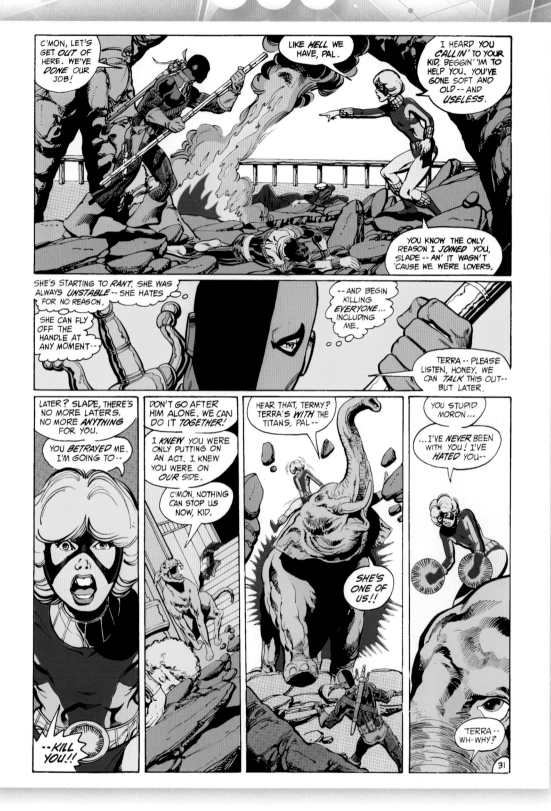

No one saw it coming—a traitor from within the Teen Titans, and then a final act of rage, making Terra's last act a heroic one.

Tales of the Teen Titans Annual #3, July 1984
Writers: Marv Wolfman & George Pérez *Artists:* George Pérez & Romeo Tanghal

HER NAME IS TARA MARKOV AND SHE IS LITTLE MORE THAN SIXTEEN YEARS OLD, AND DUE TO THE FAULT OF NO ONE BUT HERSELF, SHE IS *INSANE*.

NO ONE TAUGHT HER TO HATE, YET SHE HATES... WITHOUT CAUSE, WITHOUT REASON.

NO ONE TAUGHT HER TO DESTROY, YET SHE DESTROYS ... WITH *GLEE*, WITH *RELISH*.

DON'T LOOK FOR REASONS WHICH DO NOT EXIST -- PLAINLY, TARA MARKOV IS WHAT SHE IS. AND SHE HAS TAKEN A GREAT POWER AND MADE IT AS *CORRUPT* AS SHE.

HERS WAS THE POWER OVER THE *EARTH* ITSELF. SHE COULD HAVE BROUGHT *LIFE* TO DESERTS, *HEAT* TO THE FROZEN TUNDRA, *FOOD* TO STARVING MILLIONS.

SHE COULD HAVE DAMMED RAGING RIVERS AND FUNNELED WATER TO LANDS PARCHED, DRY, AND DEAD. HER POWERS WERE LIMITED ONLY BY THE *MIND* WHICH CONTROLLED THEM.

A MIND WHICH SOUGHT NOT HOPE... NOT LOVE... NOT LIFE...

...BUT *DEATH*.

AND SHE FOUND DEATH. BUT NOT HER ENEMIES'.

HER OWN.

Tales of the Teen Titans Annual #3, July 1984
Writers: Marv Wolfman & George Pérez Artists: George Pérez & Romeo Tanghal

VIXEN

ACCORDING TO LEGEND, ANANSI THE SPIDER WAS ASKED BY A WARRIOR NAMED TANTU TO create a totem to help control the animal kingdom. The spider god agreed if the bearer would use it only to protect the innocent, and so Tantu became the first in an unbroken legacy.

In the 20th Century, Mari Jiwe was raised in the M'Changa province of Zambesi, hearing of the famed totem. When poachers killed her mother, Mari was raised by her father, the Reverend Richard Jiwe, who was unaware that he possessed the totem. Richard's half-brother, the cruel General Maksai, wanted the totem for himself. He wound up killing his brother to obtain the power, and Mari fled. In time, she settled in America and took the surname McCabe. To avenge her father, she returned to Zambesi and confronted her wicked uncle, taking the totem that was her birthright. The power flowed through her, and she took the costumed identity of Vixen.

After a period fighting crime and learning the scope of her abilities, she approached Justice League chair Aquaman, requesting to join his freshly reconfigured team. He accepted her, and she proved her worth time and again. During this period, her uncle seized the totem from her, but since his intent was evil, it transformed him into a beast, one Vixen had to subdue, leading to his death.

86. AGAINST PROFESSOR IVO

She served with distinction, saving her teammates from the likes of Amazo, until someone began killing members. After Vibe and Steel were murdered, the Martian Manhunter disbanded the team, although Gypsy and Vixen were still being targeted. It turned out a dying Professor Ivo was trying to destroy the JLA before his time ran out.

Using her powerful ability to sense scent, she traced Ivo through the Detroit sewers until she located the madman. To her surprise, he invited her to dine before they fought and offered her a poisoned glass of wine. A host of android warriors were activated, but Vixen's savage fury was more powerful. Ivo then recalibrated the androids' programming, and they pummeled her senseless. The Martian Manhunter arrived to aid her, and once the androids were defeated, the two confronted Ivo. While the Manhunter preached incarceration, Vixen decapitated Ivo, revealing it was an android. The real, mentally deranged professor had been locked away by his creations, which were responsible for the killings.

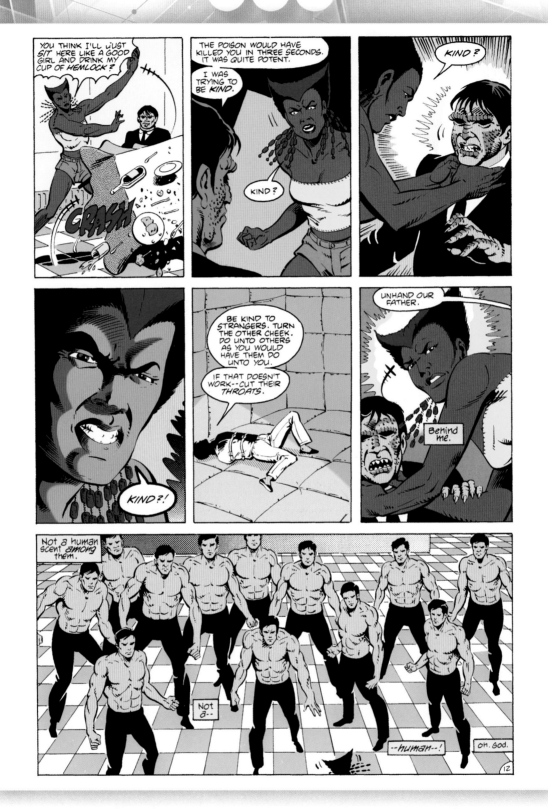

Mechanized creations and madmen posed little problem to a fully enraged, magically powerful Vixen as she avenged the murders of her fellow heroes in the closing issue of *Justice League of America*.

Justice League of America #261, April 1987
Writer: J. M. DeMatteis *Artists:* Luke McDonnell & Bob Lewis

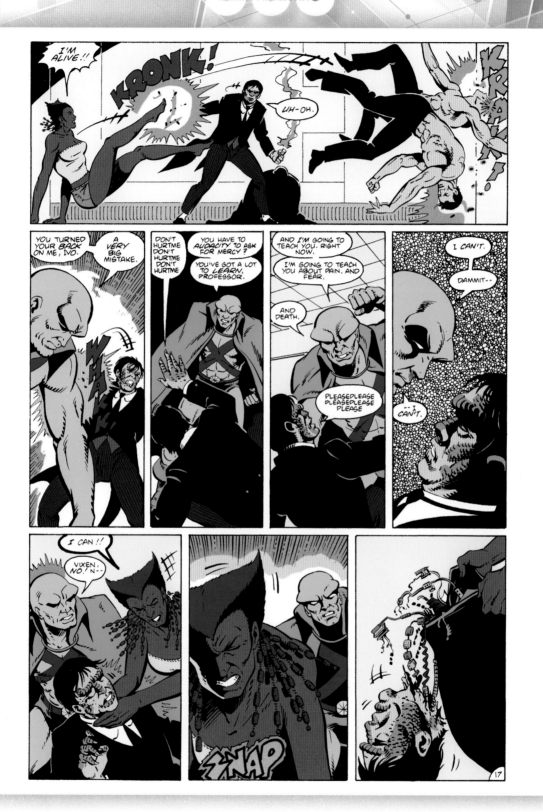

Justice League of America #261, April 1987
Writer: J. M. DeMatteis *Artists:* Luke McDonnell & Bob Lewis

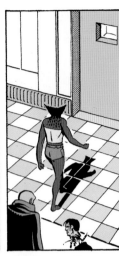

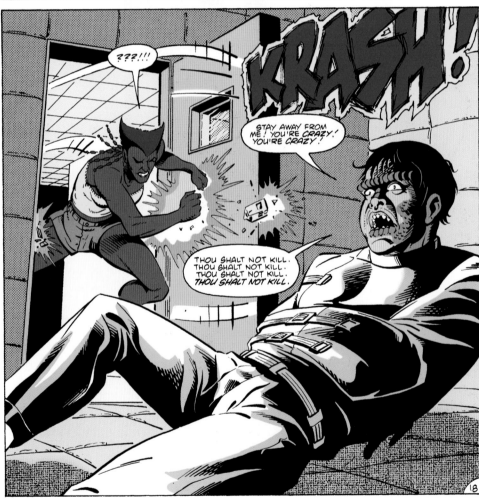

Justice League of America #261, April 1987
Writer: J. M. DeMatteis *Artists:* Luke McDonnell & Bob Lewis

WONDER GIRL

YOUNG CASSANDRA SANDSMARK WAS BEING RAISED BY HER SINGLE MOTHER, DR. HELENA Sandsmark, and spending lots of time at Gateway City's Museum of Antiquities. When Helena hired a newly arrived Wonder Woman to work with her, Cassie was infatuated. As threats challenged the Amazon Princess, Cassie decided to help and fashioned a costume, grabbing the Sandals of Hermes and Gauntlet of Atlas to wade into battle as a new Wonder Girl.

In time, she prayed to Zeus, asking for natural super-abilities. The Greek gods agreed to the request, although they also granted Helena the ability to turn them off. Much later, Cassie learned that she was a real demigod and that Zeus was her natural father.

Cassie also met Donna Troy, the first Wonder Girl, who bestowed upon her one of her earlier uniforms. Cassie adventured on her own and with Wonder Woman, showing a penchant for getting into trouble but also for having courage and perseverance. She developed a deep crush on Superboy (Conner Kent), and wound up joining the teen group Young Justice to be near him.

When Gateway City was threatened, she exposed her alter ego rather than take the time to change. Later, her identity was again exposed when fighting Silver Swan in her high school. Regardless, Cassie excelled as Wonder Girl, proving she could lead, and she became Young Justice's leader. In time, that group evolved into a new incarnation of the Teen Titans, and Ares gifted her with a lasso, suggesting dark times were coming.

He was right, and the Infinite Crisis threatened all life on Earth and the space-time continuum. To her shock, Superboy, who had been her first lover, was killed in battle.

87. DREAM DATE

In her grief, she joined a cult that followed Kryptonian tenets in the hopes of being able to resurrect Superboy. Her personal grief led her to fight, join, and leave the Titans, becoming adrift. All along, she and Robin (Tim Drake), Conner's best friend, felt an attraction, but when they tried to date it didn't work. Not long after, reality was shifting as the Final Crisis was approaching, and the Legion's Brainiac 5 managed to resurrect Conner. He went to live with Ma Kent on the Smallville farm as he acclimated to life once more. Ma invited Cassie to dinner, which was really a date, allowing the teens to be alone. Cassie revealed her conflicted emotions, and he shared his hopes, dreams, and fears about their future.

With renewed commitment to her role, Cassie returned to lead the Titans.

257

Quiet moments for two champions of justice are few and far between. This date seemed impossible given Superboy's death, but his resurrection allowed them to reconnect.

Adventure Comics #2, November 2009
Artists: Francis Manapul & Brian Buccellato

WONDER WOMAN

FOR NEARLY EIGHTY YEARS, WONDER WOMAN HAS BEEN A HERO, AN ICON, A PRINCESS, and a legend. She has become as recognized as any of the ancient Greek gods who gave her life, and in contemporary times, she has been a rallying symbol for feminism and equality.

Her beginnings were far simpler, though. Dr. William Moulton Marston was a psychologist who is credited for inventing the systolic blood pressure test, or lie detector, and was a university professor before his unconventional lifestyle cost him his post. He had married fellow researcher Elizabeth Holloway Marston, before embarking on a romance with student turned assistant Olive Byrne. The three lived together, raising a family of four, and Marston wrote articles and Elizabeth held a job in Manhattan.

Marston was a rare male to fully subscribe to the radical feminist movement of the early 20th Century. He believed that sometime within the next millennium, women would be running the world.

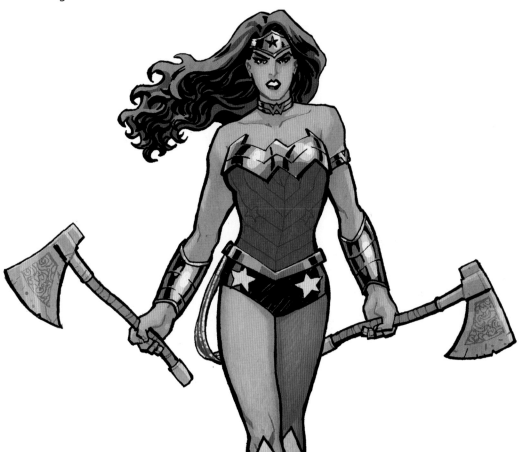

88. ARRIVAL IN MAN'S WORLD

Marston wanted to write a new super hero, one who conquered through love, not violence. Elizabeth encouraged him but insisted it be a woman. In short order, Marston created Suprema the Wonder Woman and presented it to editor Sheldon Mayer. Mayer immediately shortened the title and got Marston working on scripts while veteran illustrator Harry G. Peter was hired. The character was based on Elizabeth and Olive.

The introductory story arrived in the back of *All Star Comics* #8 in the weeks prior to the attack on Pearl Harbor. In her star-spangled costume, Wonder Woman was the perfect patriotic hero at a time when America needed as many heroes as possible.

She was quickly granted the cover feature to *Sensation Comics*, released a month later, and was then awarded her own series. Diana also shared cover billing with the Flash and Green Lantern in *Comics Cavalcade*, maximizing her exposure to readers. Wonder Woman was added as a member of the Justice Society of America, although, in a blow to Marston's designs for her symbolism, as its relatively inactive secretary.

When super heroes gave way to other genres, Wonder Woman was one of the few to retain her own title, although the emphasis shifted. Part of that was changing tastes and part of that came from Robert Kanigher replacing Marston, who died in 1947, as writer and editor. As the Silver Age of comics dawned, Peter finally retired and Kanigher rebooted the character, indulging in greater fantasy and less super heroics. No matter what he did, sales slipped, and Kanigher was removed in favor of Jack Miller, who brought in rookie writer Denny O'Neil. Embracing a concept from new series penciller Mike Sekowsky, they stripped the Amazon of her powers.

89. REGAINING HER POWERS

Despite some interesting global stories and a new threat from Doctor Cyber, readers were unimpressed, and after a sales bump, things slid backward. Between public criticism and poor sales, DC Comics was in a bind. Kanigher was put back in the editor's seat, and in a few panels he undid the last five years' worth of stories. Not only that, but in bringing back the Amazons and Paradise Island, he introduced Nubia, the first black Amazon, who was positioned as a rival and then friend to Diana.

90. SUPER HEROINES VERSUS QUEEN BEE

Kanigher didn't last long, and within a year, the struggling series was handed to Julie Schwartz, figuring his magic touch might help. For the first time in comics' history, Superman, Batman, and Wonder Woman were being edited by the same man. However, he wasn't sure what to do with her and bought time by having her earn her place back on the Justice League by performing a dozen tasks, replicating the labors of Hercules, each one monitored by a guest-starring member of the team. The ostensible reason was that

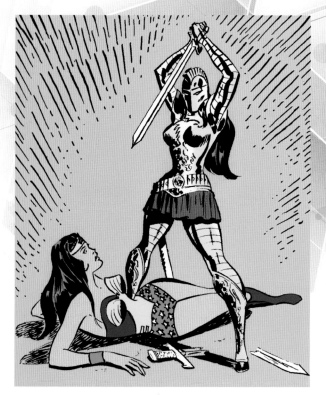

omnipotent powers and was tasked to act as judge, jury, and executioner, passing sentence over unworthy dimensions, including Earth-1.

The problem was, the Adjudicator was mentally unbalanced to begin with, and the incredible powers he was gifted with further corrupted his mind. By the time he reached a nexus of the multiverse, he was completely insane, threatening multiple earths at once. With the multiverse endangered, Wonder Woman collected an army, consisting of Earth-1 champions Supergirl, Starfire, Raven, Zatanna, Black Canary, Wonder Girl, and even Madame Xanadu, along with Earth-2's Power Girl and Huntress and Earth-X's Phantom Lady. Lois Lane was also a participant but was more of an embedded reporter. Earth-3's Superwoman was also a brief participant.

In the end, the lasso of truth forced the Adjudicator to admit his origins, allowing the heroes to convince the Overseers of their error.

she had no recollection of her time being unpowered and Wonder Woman felt she might be compromised. It wasn't until 1976 and *Justice League of America* #128 that the Amazon was welcomed back to the ranks.

Not long after, she began collaborating with other female heroes for the first time, as seen in the first such instance, in which it took Wonder Woman, Supergirl, and Black Canary to stop a threat from Queen Bee, one that had incapacitated the JLA. It was far from the last time the stories emphasized the sisterhood of heroism or pitted the heroines against a female opponent.

91. LEADING THE CHARGE AGAINST CIRCE

Wonder Woman continued to adventure long after her television exploits ended, fighting all manner of villain. Her sales were never spectacular, but she continued to attract some of the biggest names in comics, including Roy Thomas and Gene Colan. Thomas worked with plotter Paul Levitz to create an all-female three-part epic that brought the heroines together to fight the Adjudicator. Created in another dimension by the Overseers, he was granted near

92. AGAINST ARES

In the wake of the Crisis, Wonder Woman was born anew on Themyscira, growing up among the Amazons. Her world, as conjured by writer Greg Potter and coplotter and penciller George Pérez, was steeped less in Marston's ideas of feminism and more in the Greek myths, something that has endured since 1987.

She remained on Themyscira initially, earning the uniform of Wonder Woman, designed to honor Steve Trevor's mother, a pilot who had crashed on the island years before. Providence had it that Steve Trevor also crashed near the island, awakening Diana's interest in the world beyond the paradise that was Themyscira. With the gods' blessing, she was poised to do battle against the global threat of Ares, god of war. At that point, Ares's machinations endangered Olympus itself, plus all of Earth.

Wonder Woman, against all odds, battled Ares and was badly beaten. Near death, she refused to give up and snared him in her lasso of truth, forcing Ares to realize that if he went through with his plan, all life on the planet would be eradicated, leaving no one to worship him. Seeing the bleak future that

awaited him, he averted nuclear war and then gave Diana the obligation to enter Man's World and teach all of the follies of war.

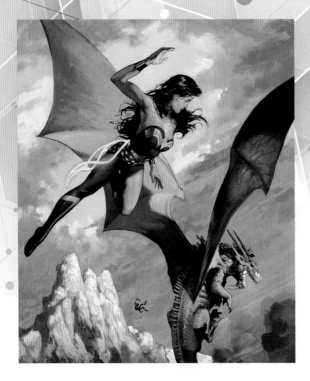

93. THE DRAGON

Wonder Woman took prophecies seriously, as well as her role in protecting the entire world. While playing with a mermaid and a wood nymph, whom she knew in childhood, she was told that the Oracle of Delphi had news of her. The Oracle said that the Drakul Karfang, a feared dragon, would awake from a centuries-long slumber and fight the Justice League at the cost of their lives. Wonder Woman then proceeded to incapacitate her teammates in order to travel to Europe and face Karfang on her own.

Karfang was aware of the prophecy and that it promised multiple deaths, so fighting the Amazon was of little consequence. Aware that a dragon could only be killed if the dragon's heart was destroyed, Wonder Woman told Karfang that she knew where Karfang's had been hidden. The ploy worked, and Karfang unwittingly led Wonder Woman to the heart's location. However, the goblins involved in Karfang's captivity warned Wonder Woman that the gold Karfang had been consuming over the years

was turning the dragon evil. Their battle was sad but brutal, as Karfang's twisted nature burned under Wonder Woman's lasso of truth's touch. Karfang's heart was destroyed, but not before Wonder Woman was drowned, seemingly killing her. Superman arrived in time to perform CPR, saving her life.

94. A CHAT WITH LOIS LANE

Superman and Wonder Woman always seemed like a natural couple. After decades of being merely teammates, in the 1990s writers began playing with the notion, despite Superman and Lois Lane already being married. *Wonder Woman* writers Phil Jimenez and Joe Kelly explored the dynamic and not-quite-rivalry in an issue entitled "A Day in the Life." The narrative captions are written as a Lois Lane column, examining the hero's poise, beauty, and ability to captivate everyone's attention even just standing in a room. It's a globe-trotting story, with a speech in France, an American television appearance, and a meeting with US President Lex Luthor, in which she sought his support for Themyscira. Along the way, Lois marvels at the contradictions she sees in Wonder Woman, as well as the sheer humility and humanity.

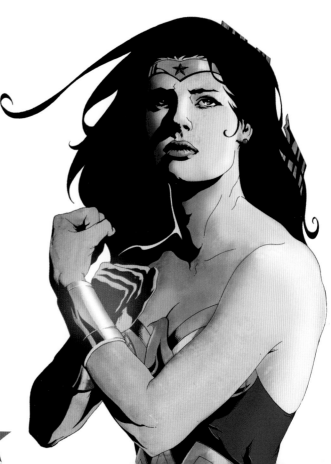

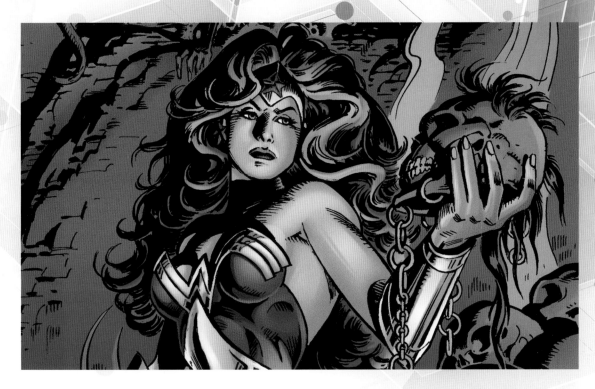

95. BLINDING HERSELF

Greg Rucka succeeded Jimenez as writer of the Amazon's adventures and scaled things back, focusing less on heroics than on politics. As Rucka told an interviewer, "There's plenty of action, there's just not a lot of violence. And considering who Wonder Woman is—the Themysciran Ambassador to the UN, an Amazon trained for war but bred for peace, a near-goddess blessed with the wisdom of Athena—violence is never going to be an ill-considered response. It's against everything in her character. When Diana goes to the sword, she goes to the sword understanding precisely what that means, understanding just how unpredictable and dangerous violence is."

She was certainly the best-known ambassador to the UN, given her exploits with the JLA and on her own. The public perception of her changed when she had to battle Medusa. The chief of the Gorgons was resurrected by Circe's magic, and she made her presence known by attacking the Embassy and, in Ares's name, challenged Diana to a battle. Wonder Woman accepted and they met in Yankee Stadium, with the god of war televising the confrontation around the world. To ensure that

Medusa couldn't turn her to stone, Wonder Woman used the acid from one of the snakes atop Medusa's head to blind herself. The two fought fiercely until Diana decapitated her anew.

96. THE SNAP HEARD AROUND THE WORLD

Not long after, Wonder Woman was caught up in a new threat to the super-hero community and the world. Maxwell Lord, one-time financier for the Justice League, gained telepathic powers, which altered his personality, making him a danger. He was systematically undermining the world's heroes and came to gain mental control over Superman. Wonder Woman was the only hero capable of going toe-to-toe with the Kryptonian. Lord made Superman imagine someone was attacking those he most loved, in this case, Diana. Her bracelets smacking against Superman's head left his ears ringing, distracting him so she could ensnare Lord in her lasso. When she asked Lord how to end his control over Superman, Lord admitted that the sole way was for Lord to die.

Despite a satellite beaming the confrontation around the world, Wonder Woman did as her Amazon training had taught her. With only one option, and

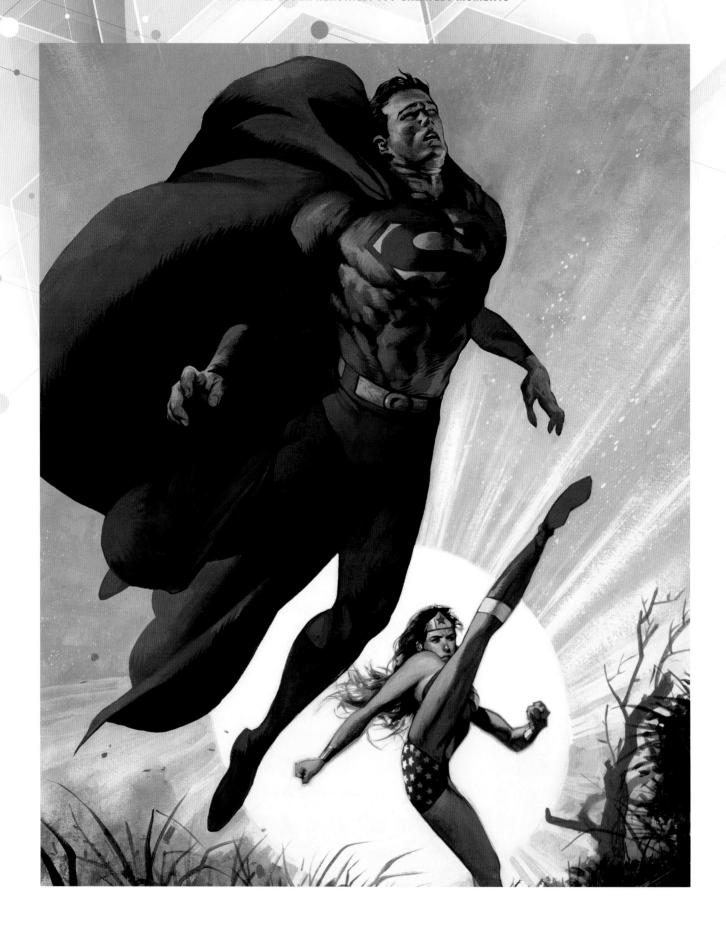

the fate of the free world at stake, she calmly and decisively snapped Lord's neck, killing him and freeing the Man of Steel.

97. COMPASSION

Wonder Woman brought peace and love wherever she went, befriending people from all walks of life. When Zatanna approached her with a prophecy regarding ill tidings coming to Barbara Gordon, Diana saw to it that the Gothamite was given one last night of pleasure. Zatanna and Diana met Batgirl and convinced her to have a girls' night out: dining, drinking, and dancing. To Barbara, it was a great time; to the others it was tinged with melancholy. Later, in her apartment, Barbara answered the door, only to be shot and crippled by the Joker. The continuity implant from writer J. Michael Straczynski was poignant and lived up to the ideals the Amazon had been infused with when Marston conceived her.

98. A VISIT FROM THE PATRONS

In the Rebirth reality, Rucka returned to writing the series and retold her origins with a modern twist. This was a powerful woman in a world where she didn't know the language, leaving her bewildered and, in time, imprisoned. Despairing of failing her mission, she prayed in her tiny cell.

The Patrons of the Amazons, the Greek gods, all appeared before her in animal form to offer comfort and support. The following morning, a revivified Diana met Barbara Minerva, who recognized the archaic Greek she spoke and finally opened lines of communication.

99. BERATING SUPERMAN

In *The New Frontier*, Darwyn Cooke celebrated DC Comics' 1950s era of publishing, a time when heroes came with and without super-powers. In the opening chapter, Superman and Wonder Woman met for the first time as they helped the people of Indo-China. However, the Man of Steel was horrified to find a trail of bodies and to see the Amazon celebrating with a hut full of young women. After rescuing a downed American plane, Wonder Woman had discovered a group of kidnapped women. She had disarmed their Cambodian captors but left them alive, and had freed the women and let them choose what to do next.

Angered, Superman tried to berate Wonder Woman, arguing that she was to set an example for others. Then the Amazon dressed down the Kryptonian regarding human dignity and free will. The moment was a classic, as ideals and words took precedence over violence.

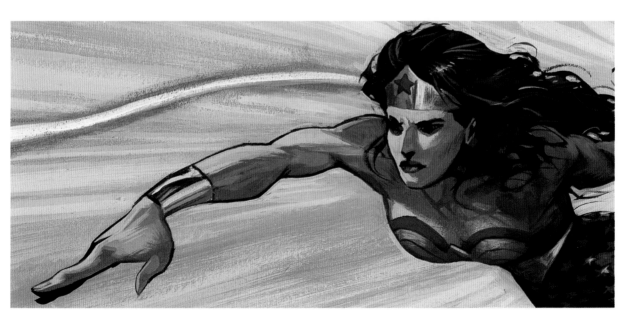

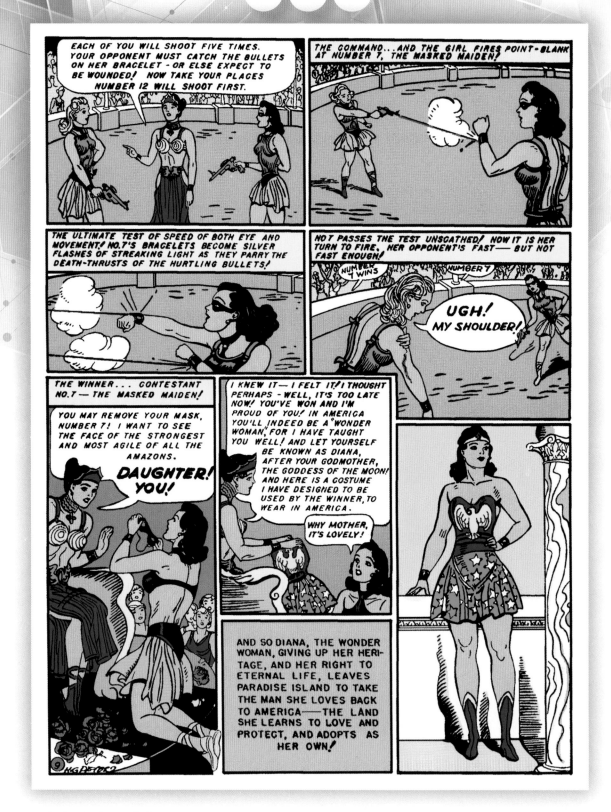

Tucked in the back of *All Star Comics*, readers had no idea they were being introduced to the world's most popular female hero and a global icon.

All Star Comics #8, December 1941
Writer: Charles Moulton *Artist:* Harry G. Peter

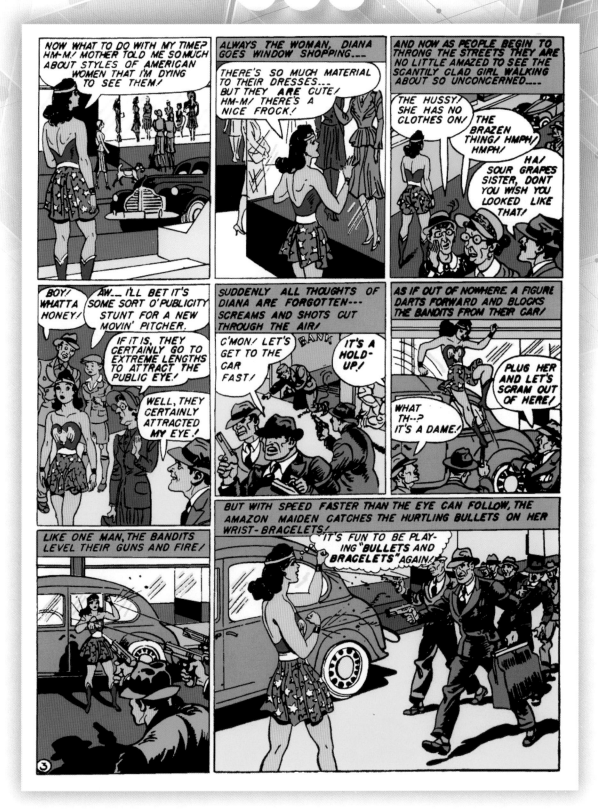

Sensation Comics #1, January 1942
Writer: Charles Moulton *Artist:* Harry G. Peter

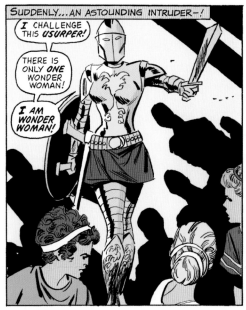

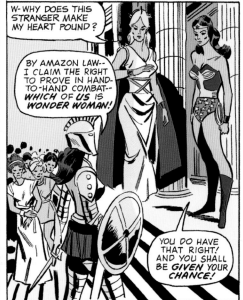

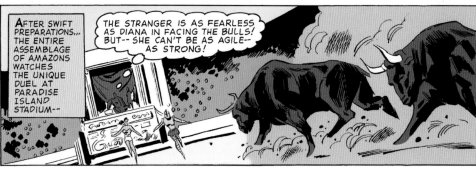

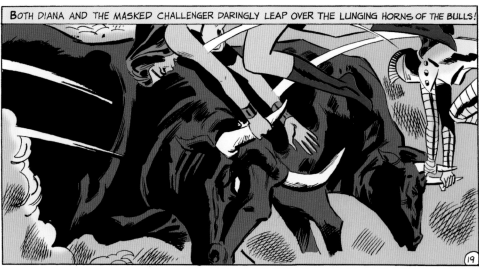

After a period without her gods-given gifts, Diana was once more reunited with her Amazon sisters and competed for the right to represent them to the world as Wonder Woman.

Wonder Woman #204, January–February 1973
Writer: Robert Kanigher *Artists:* Don Heck & Dick Giordano

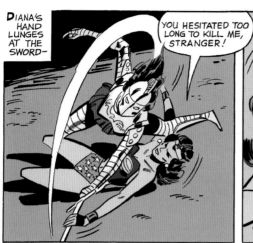

Wonder Woman #204, January–February 1973
Writer: Robert Kanigher *Artists:* Don Heck & Dick Giordano

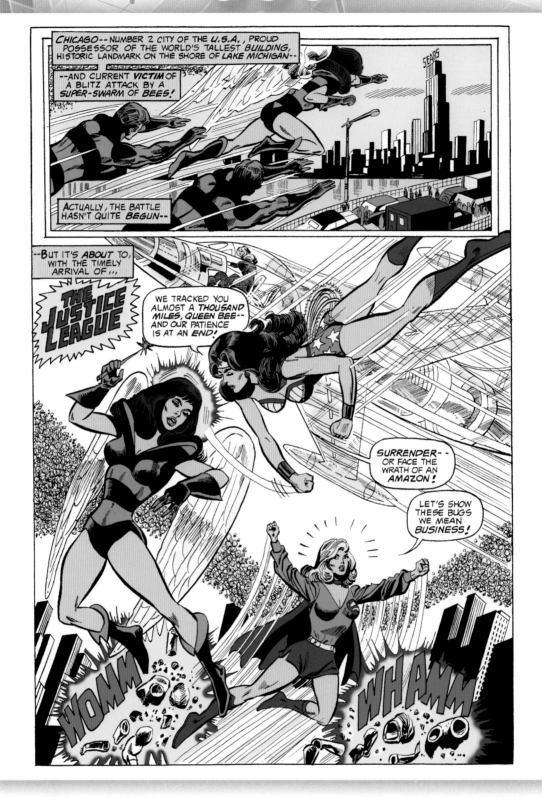

Reunited with the Justice League, Wonder Woman was able to end a threat from the alien Queen Bee—with a little help from Black Canary and Supergirl.

Justice League of America #132, July 1976
Writer: Gerry Conway *Artists:* Dick Dillin & Frank McLaughlin

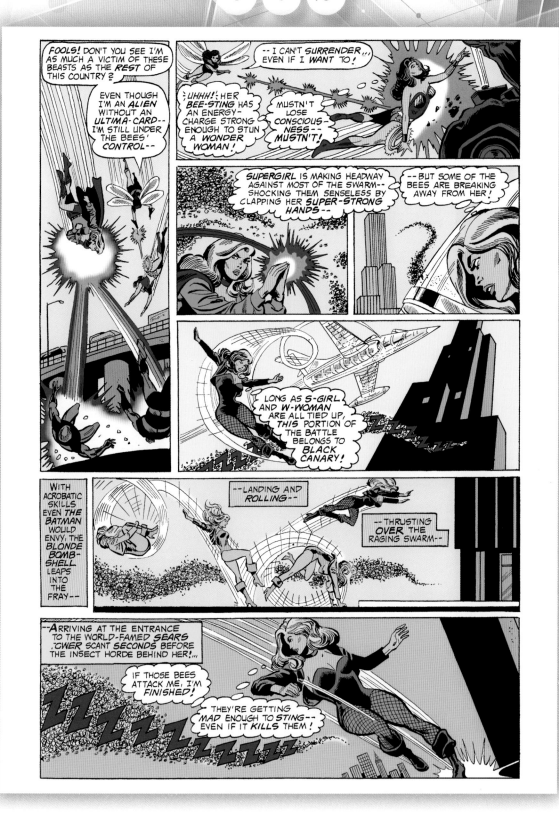

Justice League of America #132, July 1976
Writer: Gerry Conway *Artists:* Dick Dillin & Frank McLaughlin

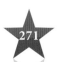

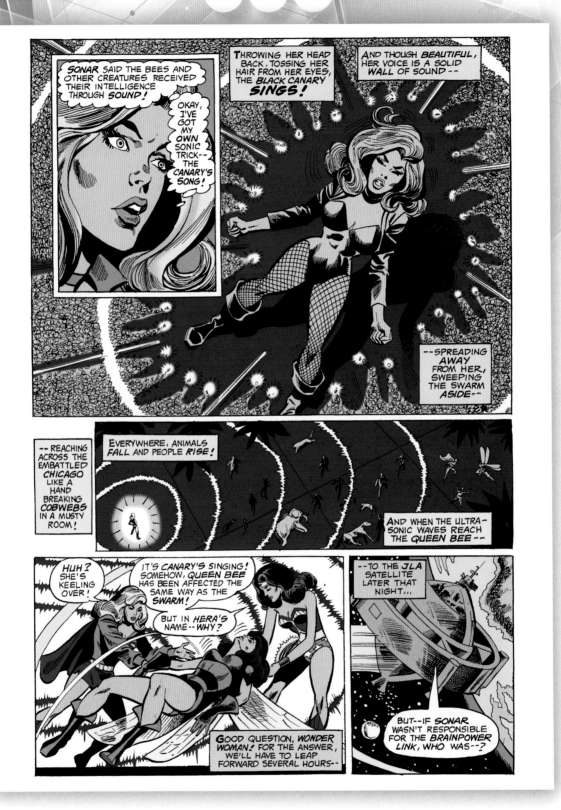

Justice League of America #132, July 1976
Writer: Gerry Conway *Artists:* Dick Dillin & Frank McLaughlin

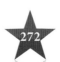

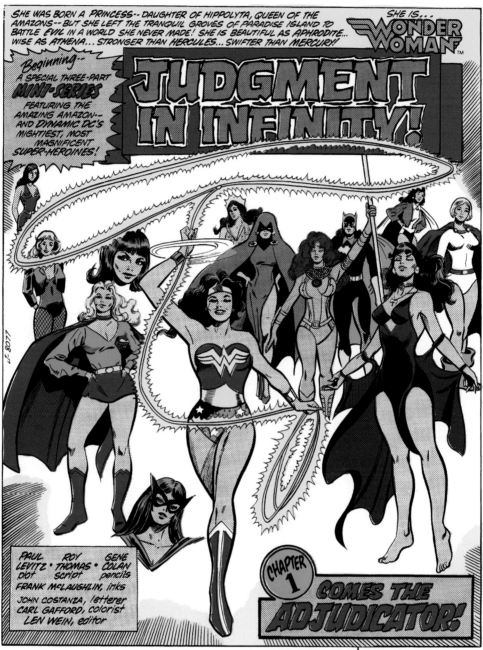

The Adjudicator came from another reality to execute realities he found wanting, causing the heroes from multiple earths to act together to save their worlds.

Wonder Woman #291, May 1982

Writers: Paul Levitz & Roy Thomas *Artists:* Gene Colan & Frank McLaughlin

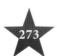

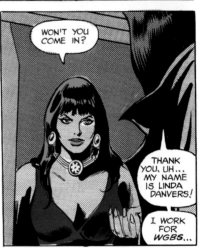

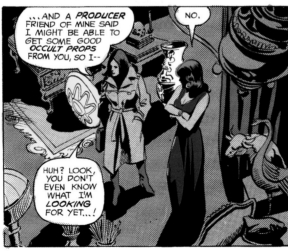

Wonder Woman #292, June 1982
Writers: Paul Levitz & Roy Thomas *Artists:* Gene Colan & Frank McLaughlin

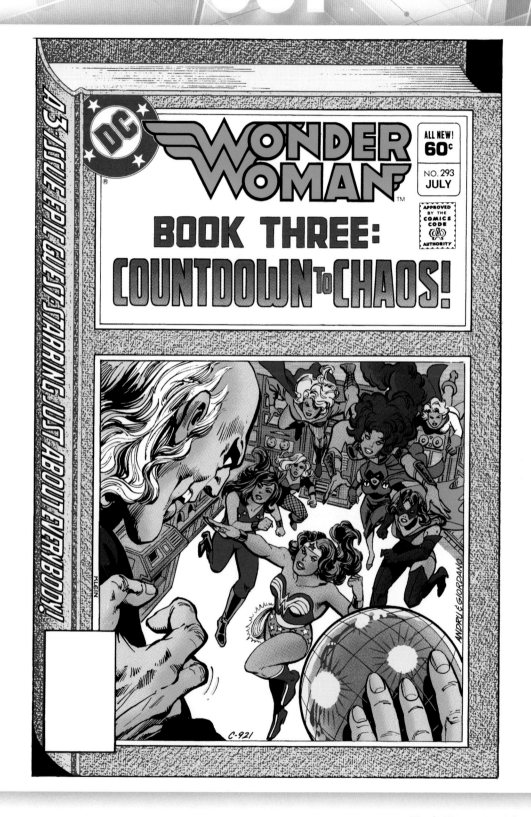

Wonder Woman #293, July 1982
Artists: Ross Andru & Dick Giordano

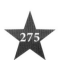

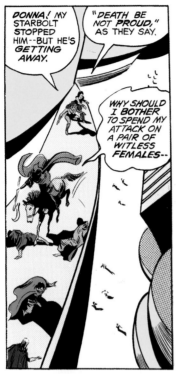

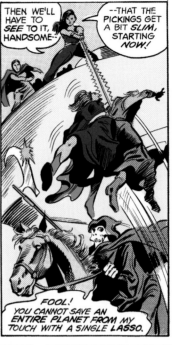

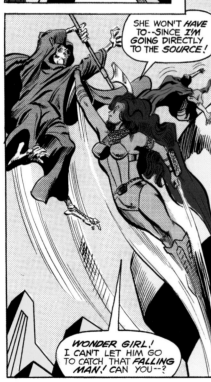

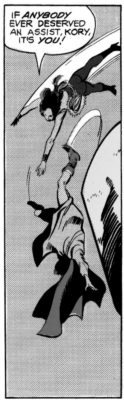

Wonder Woman #293, July 1982
Writers: Paul Levitz & Roy Thomas *Artists:* Gene Colan & Frank McLaughlin

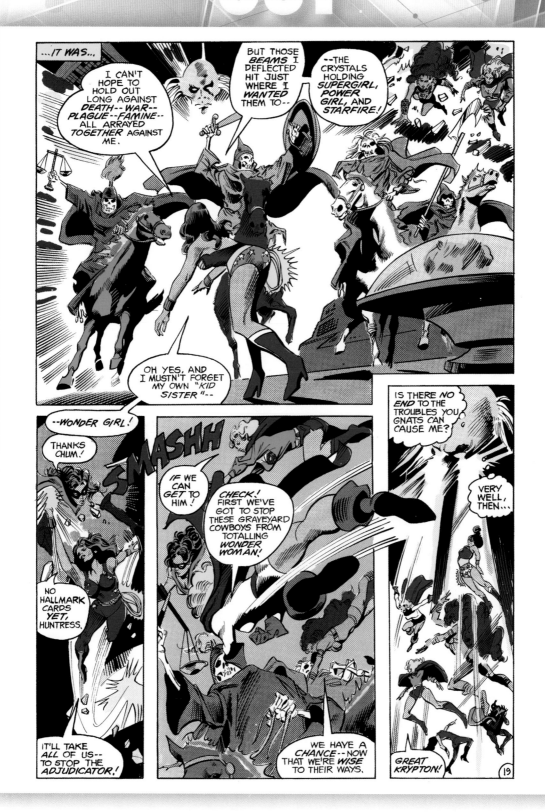

Wonder Woman #293, July 1982
Writers: Paul Levitz & Roy Thomas *Artists:* Gene Colan & Frank McLaughlin

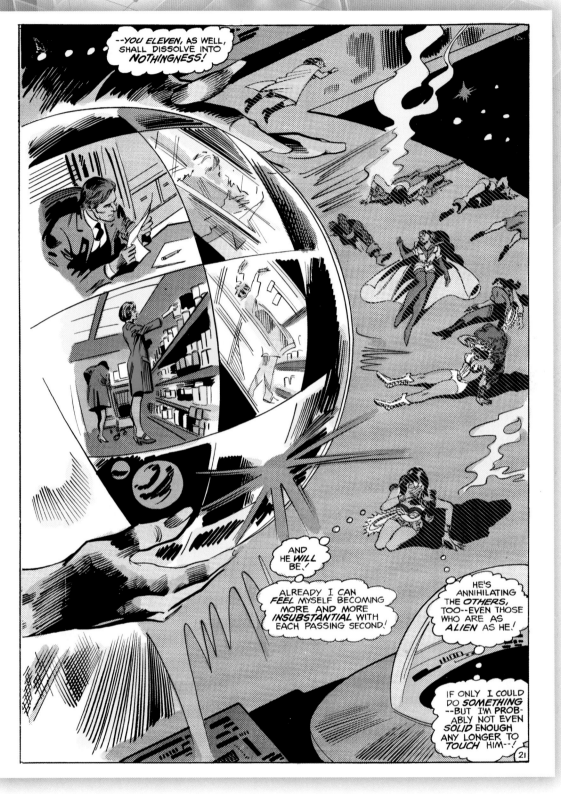

Wonder Woman #293, July 1982
Writers: Paul Levitz & Roy Thomas *Artists:* Gene Colan & Frank McLaughlin

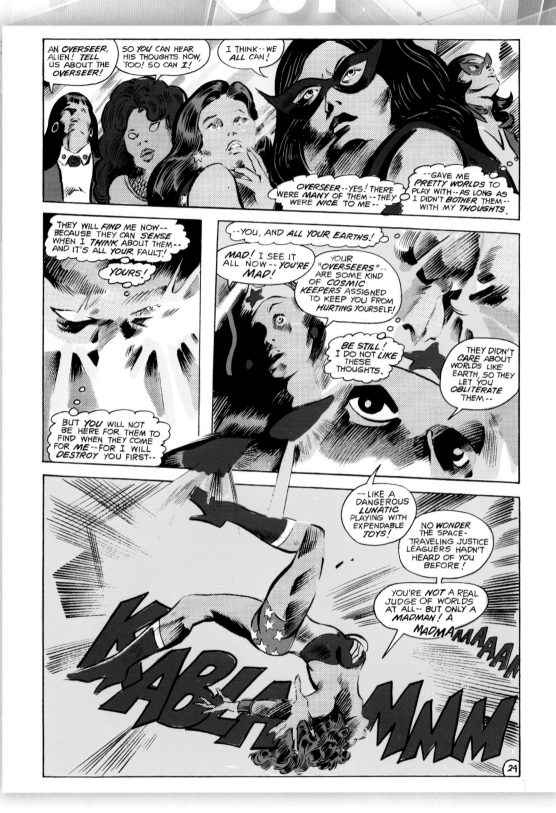

Wonder Woman #293, July 1982
Writers: Paul Levitz & Roy Thomas *Artists:* Gene Colan & Frank McLaughlin

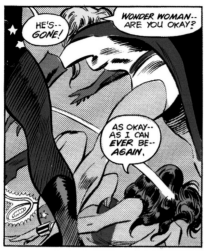

HE'S-- GONE!

WONDER WOMAN-- ARE YOU OKAY?

AS OKAY-- AS I CAN EVER BE-- AGAIN.

WAIT! THIS STARSHIP-- IT'S STARTING TO VANISH, TOO-- EVEN AS WE OURSELVES SOLIDIFY!

HIS KEEPERS-- THE MYSTERIOUS OVERSEERS -- MUST BE CALLING IT BACK AS THEY CALLED HIM BACK--

AND WE'RE GOING WITH HIM-- BACK TO HIS INTERGALACTIC INSANE ASYLUM!

OH, I THINK NOT.

TEL SU RAEPPAER NOPU EHT NOTGNIHSAW LLAM!

POOFF

ZATANNA, IF YOU GOOFED, AND WE END UP SHARING A PADDED CELL WITH THAT MURDEROUS ALIEN MADMAN, I'M GONNA--

--BRAIN YOU!

THE OVERSEERS OBVIOUSLY DIDN'T WANT US, SUPERGIRL-- ONLY THE ADJUDICATOR, BEFORE HE DID ANY MORE HARM.

HUH?

WE'RE BACK ON EARTH-ONE--

--WHILE POWER GIRL AND THE HUNTRESS HAVE DOUBTLESS RETURNED TO EARTH-TWO, AND PHANTOM LADY TO EARTH-X.

SO I GUESS THAT'S THE END OF-- WHY, DONNA! I DIDN'T KNOW YOU CARED.

BIG SISTER, I JUST HAD TO TELL YOU--

--I'VE NEVER BEEN PROUDER OF YOU IN MY WHOLE LIFE!

NEXT ISSUE: BLOCKBUSTER!

Wonder Woman #293, July 1982
Writers: Paul Levitz & Roy Thomas *Artists:* Gene Colan & Frank McLaughlin

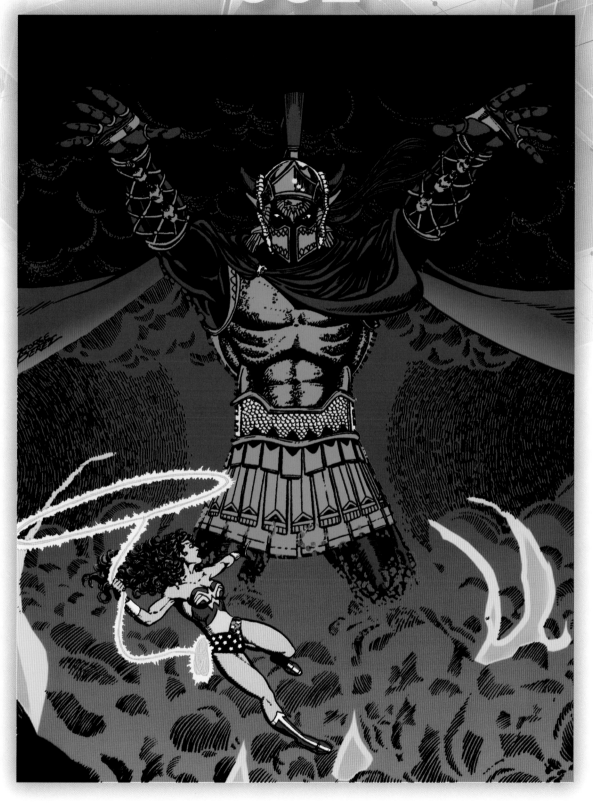

The fate of the world hung in the balance as nuclear missiles were poised to bring Ares's dream of global war to reality. All that stood in his way was Wonder Woman.

Wonder Woman #6, July 1987
Artist: George Pérez

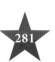

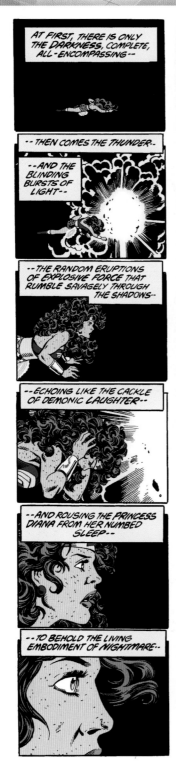

Wonder Woman #6, July 1987
Writers: George Pérez & Len Wein *Artists:* George Pérez & Bruce Patterson

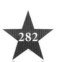

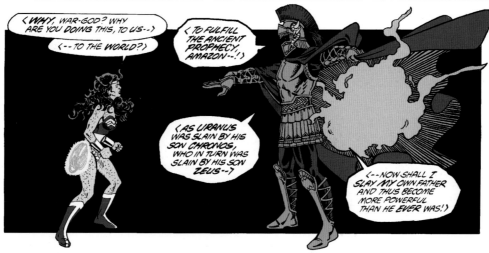

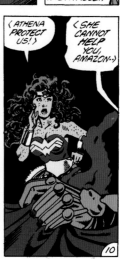

Wonder Woman #6, July 1987
Writers: George Pérez & Len Wein *Artists:* George Pérez & Bruce Patterson

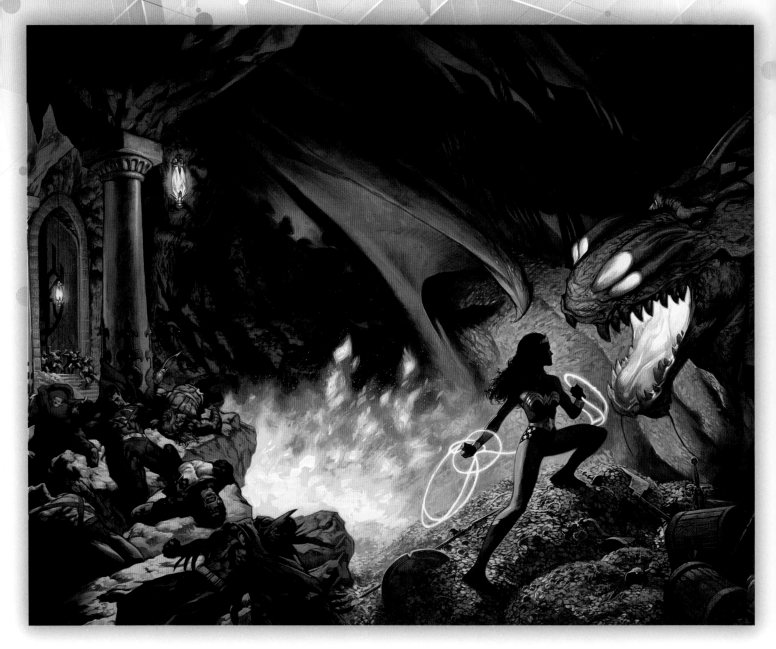

Wonder Woman didn't necessarily want to fight a dragon, but when a prophecy foretold of it killing the Justice League, she became a League of One to save her comrades.

JLA: A League of One, November 2000
Writer/Artist: Christopher Moeller

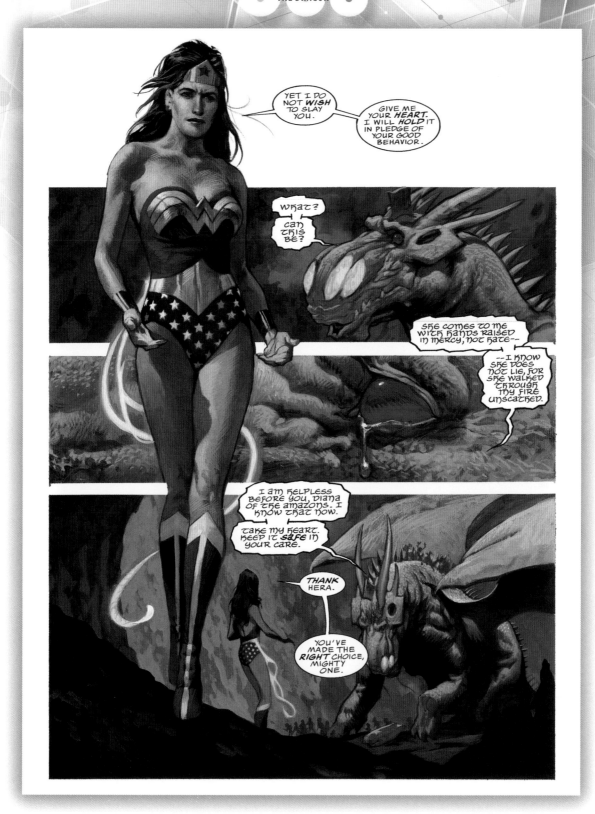

JLA: A League of One, November 2000
Writer/Artist: Christopher Moeller

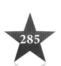

Lois Lane spent a day profiling Wonder Woman, and as the hours wore on, she gained fresh insight into the Amazon, especially when they finally discussed the Kryptonian in the room.

Wonder Woman #170, July 2001
Writers: Phil Jimenez & Joe Kelly *Artists:* Phil Jimenez & Andy Lanning

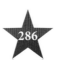

Wonder Woman #170, July 2001
Writers: Phil Jimenez & Joe Kelly *Artists:* Phil Jimenez & Andy Lanning

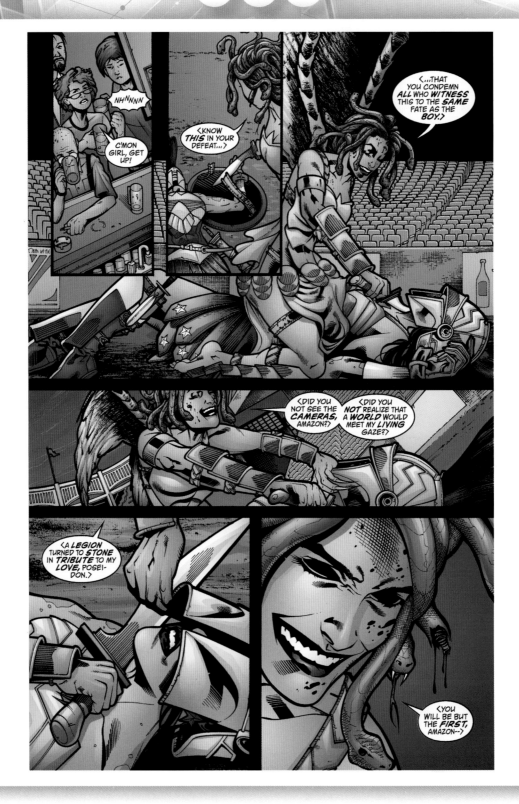

Challenged by Medusa to combat, Wonder Woman tried binding her eyes, but seeing as that was not secure enough, she literally blinded herself with snake acid from the villain's own head.

Wonder Woman #210, June 2010
Writer: Greg Rucka *Artists:* Drew Johnson & Ray Snyder

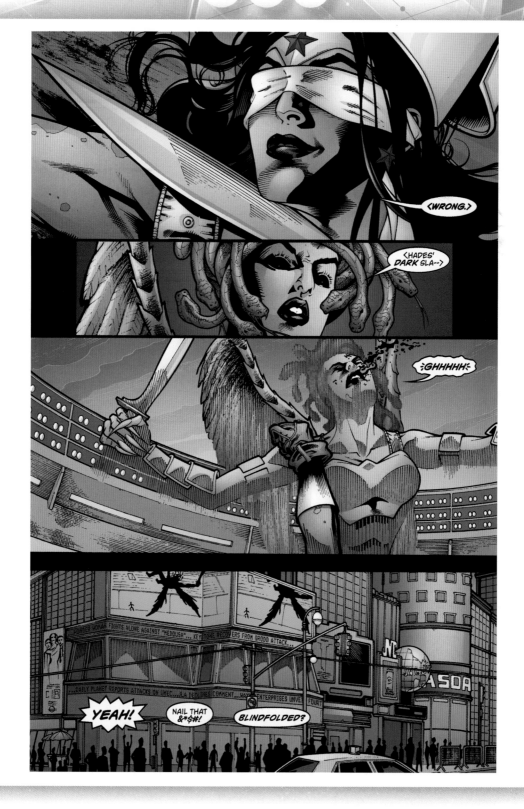

Wonder Woman #210, June 2010
Writer: Greg Rucka *Artists:* Drew Johnson & Ray Snyder

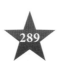

Wonder Woman #210, June 2010
Writer: Greg Rucka *Artists:* Drew Johnson & Ray Snyder

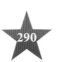

Wonder Woman #210, June 2010
Writer: Greg Rucka *Artists:* Drew Johnson & Ray Snyder

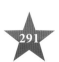

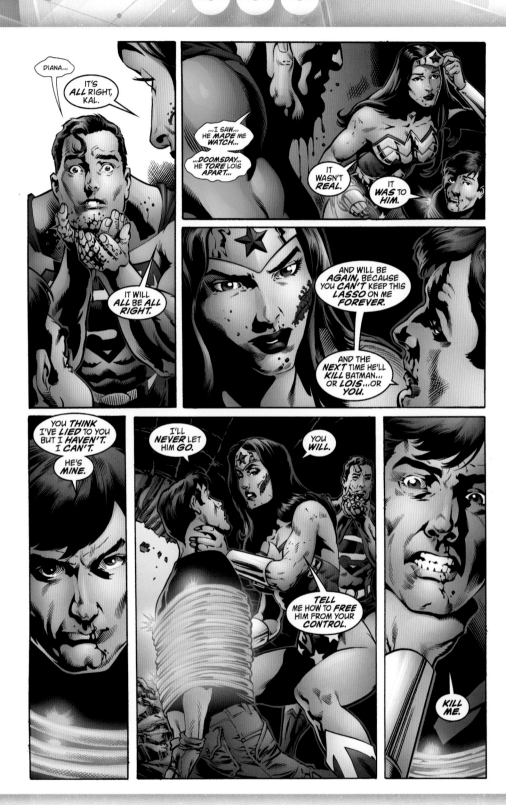

Maxwell Lord controlled Superman's mind, telling Wonder Woman the only way to free him was to kill Lord. Given no choice, she did what she had to for the sake of the world.

Wonder Woman #219, September 2005

Writer: Greg Rucka *Artists:* Rags Morales, David Lopez, Tom Derenick, Georges Jeanty, Karl Kerschl, Mark Propst, Javier Bergantiño, Dexter Vines, Bob Petrecca & Nelson DeCastro

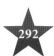

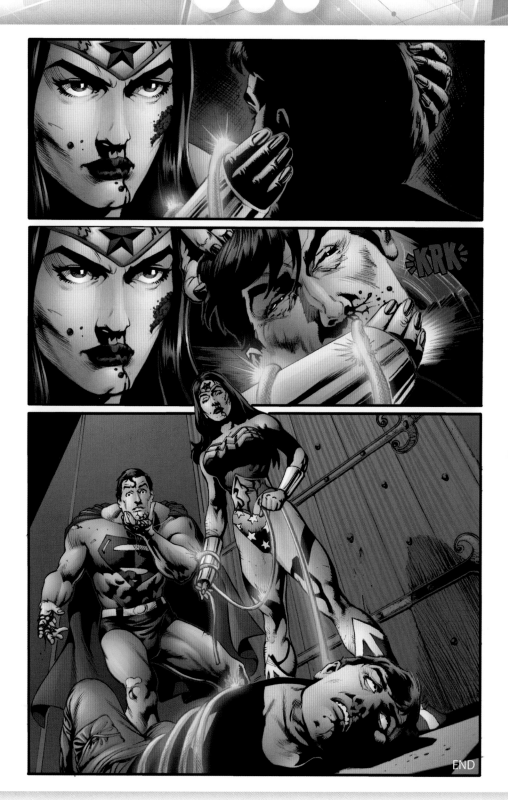

Wonder Woman #219, September 2005
Writer: Greg Rucka *Artists:* Rags Morales, David Lopez, Tom Derenick, Georges Jeanty, Karl Kerschl, Mark Propst, Javier Bergantiño, Dexter Vines, Bob Petrecca & Nelson DeCastro

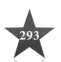

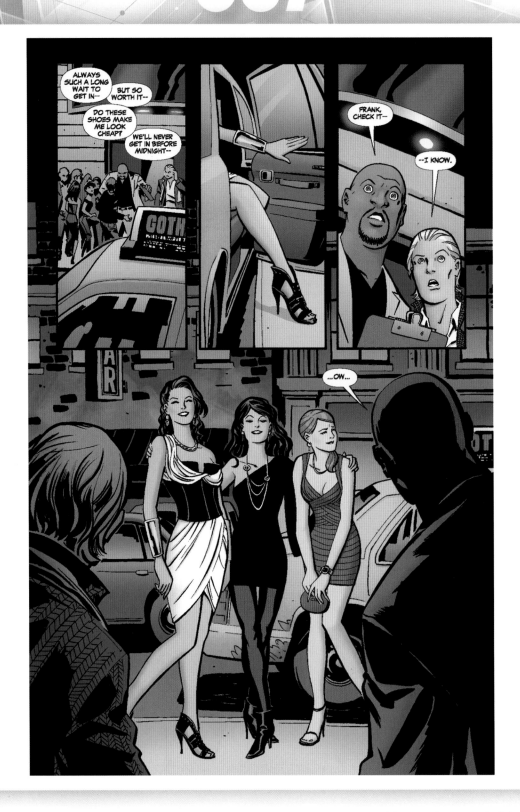

Without letting on that tragedy awaited Barbara Gordon, Diana and Zatanna took her out for a wonderful night on the town, demonstrating the love and compassion that Wonder Woman had for all.

The Brave and the Bold #33, June 2010
Writer: J. Michael Straczynski *Artist:* Cliff Chiang

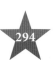

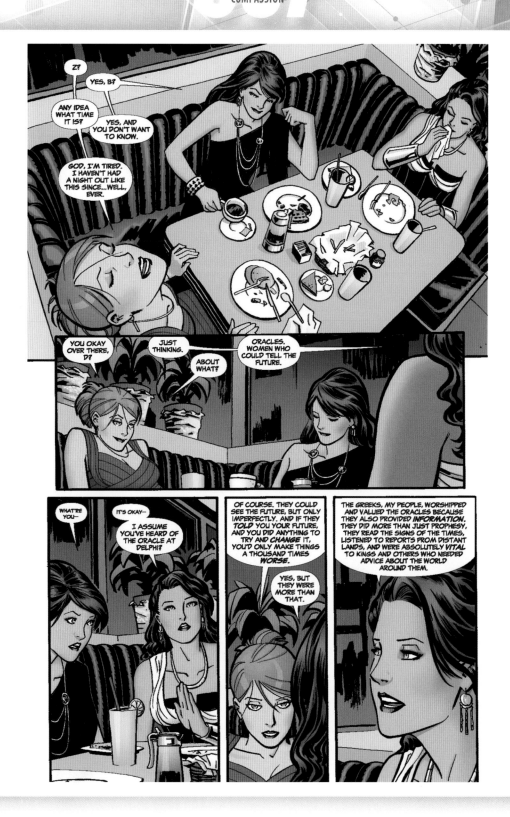

The Brave and the Bold #33, June 2010
Writer: J. Michael Straczynski *Artist:* Cliff Chiang

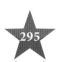

The Brave and the Bold #33, June 2010
Writer: J. Michael Straczynski Artist: Cliff Chiang

At her greatest moment of despair, Diana was given confidence and reassurance from her patron gods, who took animal totem forms, in her cramped prison cell.

Wonder Woman #6, Early November 2016
Writer: Greg Rucka *Artist:* Nicola Scott

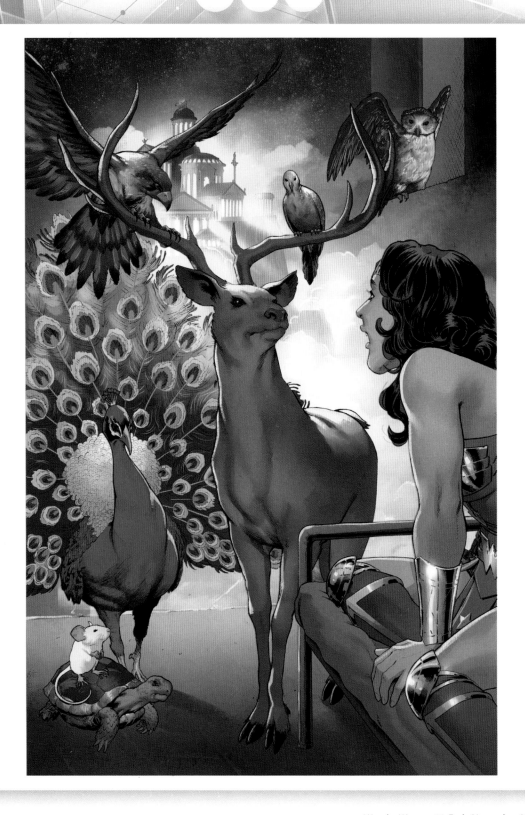

Wonder Woman #6, Early November 2016
Writer: Greg Rucka *Artist:* Nicola Scott

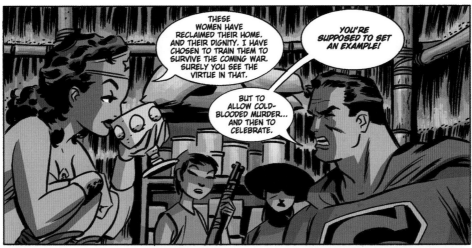

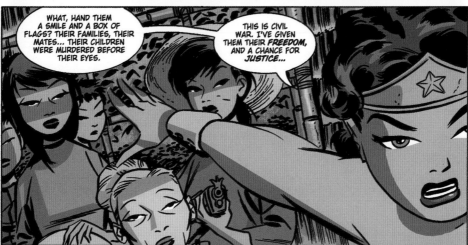

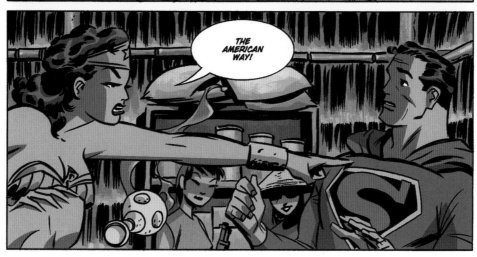

While Superman stood for truth, justice, and the American Way, in this alternate reality, Wonder Woman reminded him about keeping the emphasis on justice for all.

The New Frontier #2, April 2004
Writer/Artist: Darwyn Cooke

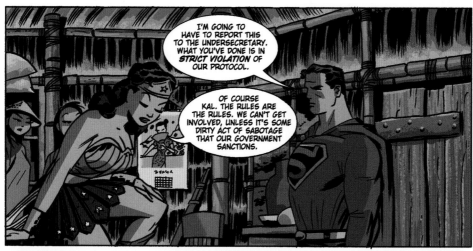

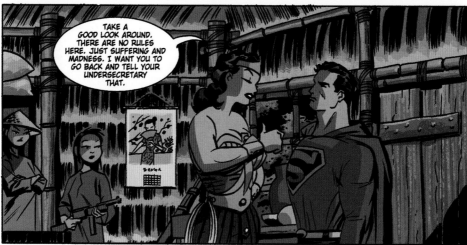

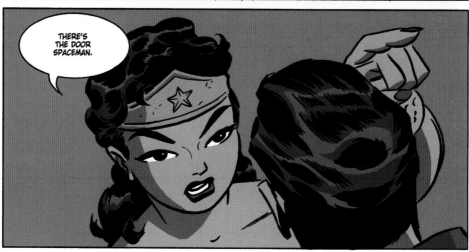

The New Frontier #2, April 2004
Writer/Artist: Darwyn Cooke

ZATANNA

BIT BY BIT, CHARACTER BY CHARACTER, GOLDEN AGE SUPER HEROES WERE BEING REVIVED by Julie Schwartz. In every case, the name and powers were largely the same, but the alter egos were reflective of the 1950s. The most radical revival, of a sort, was Zatanna, who showed up in Midway City, seeking clues to her father's whereabouts. When she encountered Hawkman and Hawkwoman in 1964, she explained that she was the daughter of Zatara, the great magician.

100. RESCUING HER FATHER

Readers were enchanted, so the Maid of Magic reappeared, continuing the hunt for her father in the pages of *The Atom* (1965), *Green Lantern* (1966), and the Elongated Man feature in *Detective Comics* (1966). Stretching out a plot thread like this was rare among DC Comics titles of the era, and readers were clearly expecting the quest to end. Schwartz and writer Gardner Fox decided to wrap things up in—where else?—*Justice League of America*, even though the Elongated Man was not yet a member.

Management wanted Batman prominent everywhere given the success of the ABC television series, so Fox had to find a way to include him. Thankfully, he had written a 1965 story that pitted Batman and Robin against a witch. He retrofitted that by making the witch Zatanna in disguise and under the sway of the powerful Outsider. With the team assembled, they traveled to a magical dimension where Allura held Zatara captive. After a fierce battle, father and daughter were reunited.

Zatanna proved popular enough to be a recurring guest star throughout the line, briefly having her own series, and transitioned to animated shows that were based on the comics, as well as an appearance on *Smallville*.

Regardless of comics continuity, and no matter how many other outfits are designed for her, she always seems to gravitate back to her first tuxedo and top hat.

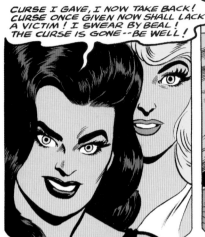

CURSE I GAVE, I NOW TAKE BACK! CURSE ONCE GIVEN NOW SHALL LACK A VICTIM! I SWEAR BY BEAL! THE CURSE IS GONE--BE WELL!

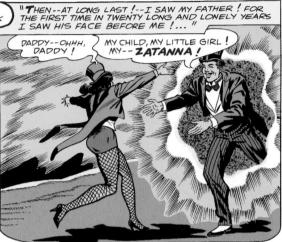

"THEN--AT LONG LAST!--I SAW MY FATHER! FOR THE FIRST TIME IN TWENTY LONG AND LONELY YEARS I SAW HIS FACE BEFORE ME!..."

DADDY--OHHH, DADDY!

MY CHILD, MY LITTLE GIRL! MY-- ZATANNA!

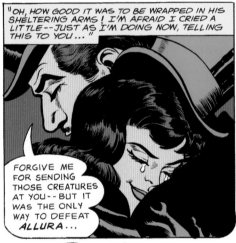

"OH, HOW GOOD IT WAS TO BE WRAPPED IN HIS SHELTERING ARMS! I'M AFRAID I CRIED A LITTLE--JUST AS I'M DOING NOW, TELLING THIS TO YOU..."

FORGIVE ME FOR SENDING THOSE CREATURES AT YOU--BUT IT WAS THE ONLY WAY TO DEFEAT ALLURA...

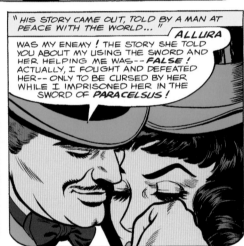

"HIS STORY CAME OUT, TOLD BY A MAN AT PEACE WITH THE WORLD..."

ALLURA WAS MY ENEMY! THE STORY SHE TOLD YOU ABOUT MY USING THE SWORD AND HER HELPING ME WAS-- FALSE! ACTUALLY, I FOUGHT AND DEFEATED HER-- ONLY TO BE CURSED BY HER WHILE I IMPRISONED HER IN THE SWORD OF PARACELSUS!

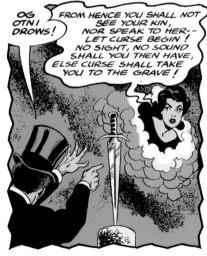

OG OTNI DROWS!

FROM HENCE YOU SHALL NOT SEE YOUR KIN, NOR SPEAK TO HER-- LET CURSE BEGIN! NO SIGHT, NO SOUND SHALL YOU THEN HAVE, ELSE CURSE SHALL TAKE YOU TO THE GRAVE!

I NO LONGER DARED REMAIN ON EARTH LEST BY CHANCE I SEE YOU OR YOU SEE ME! NOR COULD I WARN YOU DIRECTLY OR EVEN INDIRECTLY! IF I SHOULD, I WOULD DOOM US BOTH TO DEATH!

"'I THOUGHT I WAS SAFE WHEN I FLED OFF EARTH TO OTHER REALMS--ALWAYS SEARCHING FOR A WAY TO REMOVE THE CURSE...'"

SOMEWHERE THERE IS A GOOD DOUBLE OF ALLURA! IF I CAN FIND HER, IF SHE WILL AGREE TO FIGHT AND OVERCOME THE EVIL ALLURA-- THE CURSE MAY BE REMOVED!

It took her a long time, years in comic book terms, for Zatanna to finally forge a team to risk their lives in order for her to rescue her father from captivity.

Justice League of America #51, February 1967
Writer: Gardner Fox *Artists:* Mike Sekowsky & Sid Greene

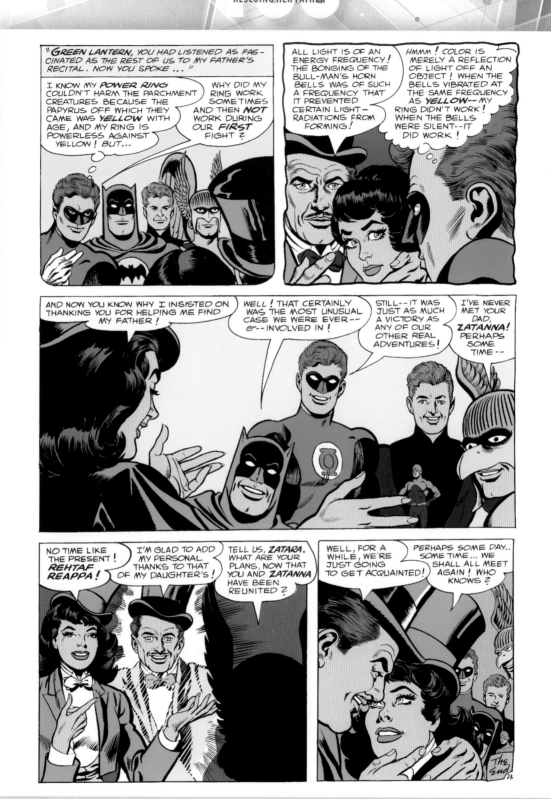

Justice League of America #51, February 1967
Writer: Gardner Fox Artists: Mike Sekowsky & Sid Greene

THE WORLD NEEDS HEROINES

EVERYWHERE YOU LOOK—IN COMICS, IN BOOKS, ON TELEVISION, AND ON THE SILVER screen—DC Comics' heroines are taking center stage after being in the shadows for all too long. It's an overdue trend and a most welcome adjustment, keeping the graphic-storytelling format accessible to all audiences.

The world, and the larger universe, needs heroes, whether they come from Themyscira, Krypton, or the streets of Gotham City. Their courage is on display with increasing regularity, and they serve as role models at a time when Earth could use all the help it can get from its heroes and for generations to come.

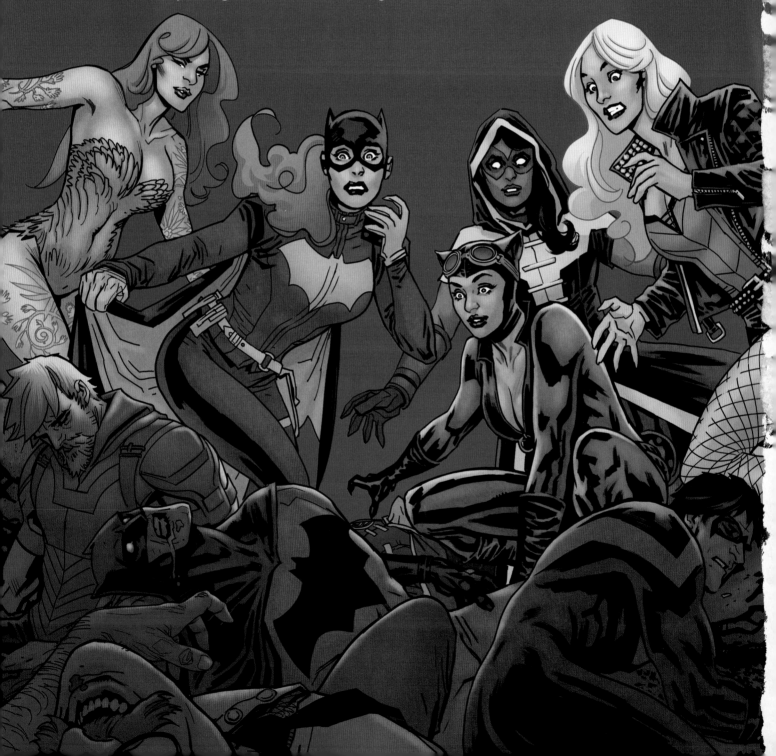